LIGHT
AND
LIGHTING
IN PHOTOGRAPHY

by Andreas Feininger

AMPHOTO
American Photographic Book Publishing
1515 Broadway, New York, New York 10036

Published in New York, New York, by American Photographic Book Publishing,
an imprint of Watson-Guptill Publications, a division of Billboard Publications,
Inc. All rights reserved. No part of this book may be reproduced in any form or
by any means without permission in writing from the publisher.

Library of Congress Catalog Card Number 76-16449
ISBN 0-8174-0585-2

Manufactured in the United States of America

Books by ANDREAS FEININGER

Light and Lighting (1976)
Roots of Art (1975)
The Perfect Photograph (1974)
Darkroom Techniques (1974)
Principles of Composition (1973)
Photographic Seeing (1973)
Shells (1972)
Basic Color Photography (1972)
The Color Photo Book (1969)
Trees (1968)
Forms of Nature and Life (1966)
The Complete Photographer (1965)
New York (Viking, 1964)
The World Through My Eyes (1963)
Total Picture Control (1961)
Maids, Madonnas and Witches (1961)
Man and Stone (1961)
The Anatomy of Nature (1956)
Changing America (1955)
The Creative Photographer (1955)
Successful Color Photography (1954)
Successful Photography (1954)
The Face of New York (1954)
Advanced Photography (1952)
Feininger on Photography (1949)
New York (Ziff-Davis, 1945)
New Paths in Photography (1939)

Table of Contents

Dear Reader . . .

Having paid good money for this book, you are, of course, anxious to get to its "meat"—the practical instructions that tell you how to arrange effective lighting schemes —which are the subject of Part VI. In your understandable impatience, you might even think: Why do I have to wade through all this theoretical stuff before I get my hands on solid facts? What good does it do? Why can't the author put first things first?

But this is precisely what I did—I put first things first. For without a working knowledge of the purpose and principles of photographic lighting, going by the "rules" laid down in Part VI becomes mindless routine. And if a photographer comes up against a case not covered there, he will flounder helplessly since he will have no "rule" to lean on nor the understanding of basic principles of lighting that otherwise would enable him to solve his problem in his own way. It is these vitally important basic principles of lighting which I deal with in Parts I to IV.

Once a photographer understands the nature of light and the purpose of lighting, he can arrange his own lighting schemes and come up with effective solutions any time, any place, whether he works in color or in black-and-white, for the basic principles of lighting apply equally to both. He becomes independent of specific rules that may or may not fit the particular project on which he is working. He will be free to create, secure in the knowledge that he understands what it is all about and is capable of improvising whenever a case demands it. Hence, dear reader, I implore you not to bypass these "theoretical discussions" in your rush to get at the "facts." Suffer, if you must, but don't skip.

Introduction

Why I wrote this book

Every form of creative expression has its dominant medium. That of painting is color, of sculpture space, of dancing rhythm, of music sound. The dominant medium of photography is light.

In view of this fact, it would seem only natural to assume that photographers are conversant with the functions, qualities, forms, and uses of light—the most important factor in their work. Unfortunately, this is not true. Actually, with few exceptions, what photographers know about light can be summed up as follows: Light is an indispensable prerequisite for taking photographs. Therefore, the brighter the light, the better. As long as there is plenty of light, all is well, and there are no serious problems. But watch out when the level of illumination decreases. Then, exposure times increase, the camera can no longer be hand-held to take the picture without risk of objectionable blur through accidental camera motion, the danger of underexposure looms, the photograph or transparency turns out too dark, important subject detail is lost in the rendition, contrast is either too high or too low, the picture fails. And that, in my experience, is about all the average photographer knows —or cares—about light.

What this boils down to is that since a certain quantity of light is indispensable to assure a correct exposure, photographers limit their interest in light to the *quantitative approach:* How much light do we have, how bright? But important as this approach is to the making of technically perfect negatives or transparencies, it does not guarantee the creation of perfect *pictures*. Why? Because any satisfactory photograph is the result of a successful synthesis of technique and art. As far as light is concerned, this requires not only that there must be a sufficient *quantity* of light available to guarantee *technical* perfection, but also that this light must be of a *quality* that is compatible with the nature of the subject, the mood of the scene, the intent of the photographer, and the purpose of the picture before it can be expected to lead to *aesthetically* satisfying photographs. In other words, the *quantitative approach* to light must be complemented by a *qualitative approach,* with the photographer asking himself questions like these: Is the light (or should it be) direct, diffused, or reflected? harsh, normal, or soft? What is (or should be) its angle of incidence, its direction? front-, three-quarter-, side-, or backlight? And what about its color? Is it (or should it be) "white" (like standard day-

light), or is it yellowish, reddish, bluish, or otherwise colored? A single light source or a combination of several lamps? And what about the shadows? Are they acceptable, or are they perhaps too black and need to be "filled-in" in order to lower excessive subject contrast to a reproducible level? How do they fall? do they interfere with important forms of the subject? do they cross one another? do they contribute to, or detract from, the overall effect of the rendition? Does the arrangement of the illumination help to graphically separate subject and background in the picture? And so on.

The importance of considerations like these—of the *qualitative approach* to light—was brought home forcefully to me not long ago while leafing through what at first appeared to be a fascinating book illustrating a painter's approach to nature. There were pages upon pages of photographs of landscapes, the sea, shells, flowers, trees, rocks, pieces of wood, coral, and the like. Unfortunately, however, all had been photographed with such total disregard of the most basic principles of good lighting that the whole point of the book was lost; and what had started as an interesting, ambitious project ended as a pretentious flop. Here was an expensive book primarily addressed to art students—visually oriented people—which had been executed in a way that violated the most elementary prerequisite for a visually effective presentation: clarity. Why? Because pitch-black shadows obliterated the subject's forms or hid important detail; because subject and background blended graphically due to lack of tonal separation in terms of black and white; because the feeling of texture was lost since surface structure either was "burned out" by floods of uncontrolled light or drowned in heavy shadows; because contrast was either too high or too low; and because in close-up shots illuminated by artificial light, shadows crossed one another and the light distribution was often uneven with the result that one side of the picture was overlit and the other one too dark.

Analyzing each picture and pinpointing its faults, I couldn't help but think: How sad! What a waste of effort and time! What a shame that this man who had such a good idea and the time, money, and energy to carry it out was so ill-equipped in regard to the proper use of light that he was unable to bring his work to a successful conclusion. And I wondered how many other photographers might find themselves in the same predicament—having good ideas and the energy and means to execute them, yet lacking the knowledge to do a workmanlike job. And I thought: Why not compile a text devoted to an analysis of light from the viewpoint of the working photographer, a discussion of all the elements of effective lighting? Why not attempt a study of the dominant medium of our craft? At that moment, the idea for this book was born.

12

Organizing my material, I found that for most effective presentation, it had to be divided into six parts:

I. **Light**—what is it, what does it mean to a photographer?

II. **The Functions of Light**—an evaluation in terms of photography.

III. **The Qualities of Light**—brightness, color, direction, contrast.

IV. **The Forms of Light**—radiant, direct, diffused, reflected, and filtered light; continuous and discontinuous light.

V. **The Sources of Light**—the sun, skylight, photolamps, flash, and other light sources.

VI. **The Use of Light**—from an analysis of the principles of good lighting to the use of available light under the most varying conditions.

In the course of developing the theme of this book—light and its ramifications as seen from the viewpoint of the creative photographer—it soon became obvious that it had to be examined from two angles: theory and practice. On the one hand, what are the *theoretical* possibilities available to the photographer—the potential of light? And on the other hand, what are the devices and techniques by means of which these possibilities can be implemented *in practice?* Consequently, in the following, Parts I to IV are devoted primarily to theoretical discussions, and Parts V and VI to practical instructions.

Throughout the book, photographs carefully selected to illustrate specific points complement the text; for indispensable as words are normally in teaching, in photography, the final proof of any statement, opinion, or conclusion is always visual: How does the disputed effect appear in picture form?

"Photographic finger exercises"

It is axiomatic that any subject can be photographed in many different ways. As a result, a photographer always has a choice—a choice between more or less effective forms of *subject approach* as well as a choice between different devices and techniques of *subject rendition*. This, of course, is true also in regard to light. Not only do we have a choice of different types of light, but also of different light sources, natural as well as artificial. Each of these factors can be controlled to a very high degree, modulated, or adapted in different ways in accordance with the requirements of each specific case. To be able to make the right choice, a photographer must be familiar with *all* the

13

possibilities at his disposal. The best way to accomplish this is by means of experiment and test. Systematically photograph specific study objects in different types of light and with different kinds of photolamps, compare the results, and study the effects.

Normally, nobody would make a series of photographs of the same subject differently illuminated or taken through different types of filters. But such *"photographic finger exercises"* (the equivalent of the finger exercises of the pianist or violinist) still represent the best method for any student of photography to familiarize himself quickly with the elements of his craft. It is for this reason that I have included a number of such exercises in this text—series of two, three, or more photographs of the same subject, identical in every respect except one, the variable factor—perhaps variations in the direction of the incident light or the application of different color filters designed to explore the resulting effects in regard to shadow distribution or tonal rendition —being the subject of the particular study.

I hope that the reader will not only study these "finger exercises" carefully, but actually repeat them in the form of original photographs. Care, however, must be taken never to vary more than *one* factor at a time, otherwise results will be confusing and incapable of yielding useful information. Furthermore, notes on *all* the factors involved must be taken in order to extract a maximum of benefits from each test. For example, note the brightness of the light in terms of numerical exposure-meter values, the type and direction of the incident light, the particular color filter if applicable, the exposure in terms of *f*/stop number and shutter speed, the type of film, the type and temperature of the developer, the duration of the development. If circumstances permit, I make it a practice to write all such data on a card and to include the card somewhere in the setup where it does not interfere with the objective of the test. Thus, by making the data part of the actual photograph, I insure that this vital information can never get lost or mixed up with other test results. One thing is all-important: Whenever changing a factor during a test, don't forget to make the respective change in the data card, otherwise the test becomes valueless.

Save all these photographs, including (and particularly!) the ones "that didn't come off," and mount them together with their data side by side on boards, because a photographer can usually learn more from his failures than from his successes. Over the years, the results of such "photographic finger exercises" can be built into a priceless reference library—a source of information that keeps its value forever—one of the best investments a photographer can make in furtherance of his work.

14

I. Light—What Is It?
What Does It Mean to a Photographer?

What is light? The answer depends upon whom we ask: the physicist, the photographer, the "man in the street," the blind. To each, light means something different, and each will have a different answer.

Light in terms of the physicist

Unfortunately, although much is known about light, its very nature still eludes us. This, in essence, is how a physicist would define the phenomenon we call light.*

The two basic components of the universe are matter and energy. Matter can be transformed into energy (proof: the atom bomb) and energy can be transformed into matter (for example, in a particle accelerator). The two are interchangeable and probably the same thing in different forms. Thus, in the last analysis, every phenomenon of the physical world is a manifestation of energy—even you and I. What energy really is, we do not know.

Radiant energy is produced by atomic changes in the physical structure of matter. It flows from its source in all directions and is propagated in the form of waves. Two characteristics of any wave are wavelengths and frequency. Wavelength is the distance between the crests of two adjoining waves. Frequency is the number of waves that pass a given point within a given time. The product of wavelength and frequency is the speed of propagation.

Physicists distinguish a large number of different forms of radiant energy, each characterized by a specific wavelength. These form the *electromagnetic spectrum,* a continuous band of waves of steadily decreasing length but increasing energy, with the radio waves and technical alternating currents with wavelengths of many miles at one end, and at the other end, the X-rays and cosmic rays whose wavelengths are so short that they have to be measured in millionths of a millimeter. One such form of radiant energy is light.

* I give this brief summary of the scientific findings about light because they make fascinating reading. But as far as a photographer and his work are concerned, this kind of knowledge is largely irrelevant.

Light is a rather mysterious force. It is radiant energy that travels as a wave but on impact also displays the characteristics of a shower of minute, hard particles. This seems to be established as a fact, although it is as inconceivable to the human mind as "granulated water." What light really is, we do not know.

The wavelength of light (or *visible* electromagnetic radiation) ranges from slightly less than 400 nanometers* for blue light to somewhat more than 700 nanometers for red. Its frequency is of the order of 600,000 billion; that is, if we used sufficiently sensitive instruments, we would find that the intensity of light varies periodically at the rate of some 600,000 billion times per second.

Light is propagated in a straight line although its path can be bent by a sufficiently strong gravitational field. Its speed of propagation is approximately 186,000 miles per second in a vacuum, somewhat slower in denser media like air, water, or glass. Traversing the 93 million miles between the sun and Earth takes light about 8 minutes.

The intensity of light—its brightness—diminishes steadily with distance, a fact that is of importance to photographers who work with artificial light. This intensity falloff is governed by *the inverse-square law*, which says that the brightness of a flat surface at right angles to a point source of light is inversely proportional to the square of the distance between surface and light source:

$$\text{Intensity} = \frac{1}{\text{distance between subject and light source}^2}$$

Distance	1	2	3	4
Intensity	1	1/4	1/9	1/16

In other words, a surface at a distance of 2 units from a pointlike light source receives only ¼ the illumination that a surface 1 unit away from the light source would receive; a surface 3 units away, 1/9; 4 units away, 1/16; 5 units away, 1/25.

* The *nanometer*, abbreviated nm, is one-billionth of a meter. It was formerly called the *millimicron*, abbreviated mμ. Another frequently used measure for the wavelength of light is the Ångström; one Ångström unit is the ten-millionth part of a millimeter or one-tenth of a nanometer and is usually abbreviated "Å."

Note, however, that the inverse-square law is strictly applicable only to *pointlike light sources,* and the only truly pointlike light sources are the stars. All photographic light sources have more or less pronounced diameters; they are *small-area light sources* to which the inverse-square law applies only approximately. Nevertheless, this law is used in calculating the guide numbers for flashbulbs and electronic flash and the formula according to which exposure must be increased in extreme close-up photography.

In practice, doubling the distance between subject and photolamp diminishes brightness at the subject plane somewhat less than can be expected according to the inverse-square law, particularly if the light is parallel or nearly parallel as that produced by a spotlight. Experienced photographers know this and check the brightness of their lighting schemes with photoelectric light meters, not yardsticks. Although, according to theory, both methods should give virtually the same results, in practice they don't.

What we perceive as "white," or "colorless," daylight (or, for that matter, the seemingly "white" light emitted by an incandescent light bulb, a gaseous discharge tube, or a fluorescent lamp) is not a homogeneous medium. It is a mixture of all the wavelengths from approximately 380 to 760 nanometers. It is an "accord," an accord of radiant energy. But whereas a trained ear can single out, and distinguish between, the different components of an accord in music, no human eye can resolve a light accord into its constituents and name the individual components—the different *colors* that combine to produce "white" light—for each wavelength of light generates its own specific color. This is another of the strange qualities of light—the fact that a correctly constituted mixture of differently colored light rays can produce "white," or "colorless," light.

That this *is* a fact is easily proved with the aid of a prism which, by resolving the "accord" of "white" light into its individual components, reveals, in the form of a *spectrum,* the colors latent in "white" light. This is the moment when the physics of light become important to a photographer, because if properly utilized, knowledge of this kind enables him to exert a considerable amount of control over the outcome of his pictures, both color and black-and-white. How he can accomplish this will be explained later in this book.

p. 64

Light in terms of the photographer

At the beginning of this chapter, I said that the question "What is light?" would probably be answered differently by different people. Since we are concerned here with photography, I will now rephrase my question more specifically: What is light as far as the photographer is concerned? and answer it as best I can.

17

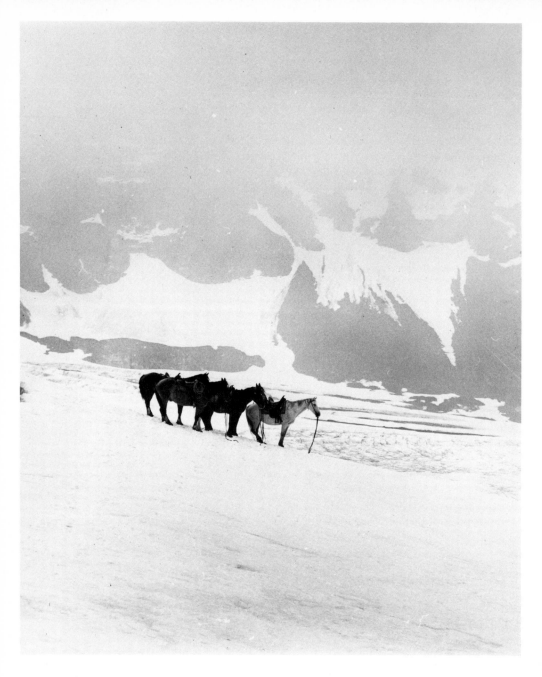

Athabaska glacier, Canada. The impact of this photograph is almost entirely due to the unusual light conditions under which it was made. In sunshine, this scene would have appeared banal, but low-hanging clouds, driving through the pass, and swirling snow produced an all-enveloping whitish light which convincingly creates a feeling of loneliness, howling wind, and biting cold.

Light is the dominant photographic medium. It is the most important single factor in the making and outcome of a photograph, and not only as far as film exposure is concerned. It is infinitely variable and malleable, and in specific cases, some of its manifestations are more likely to enable a photographer to produce good pictures than others. In other words: *He has a choice.* All light is not the same. There are important differences in regard to such qualities as brightness, direction, diffusion, contrast, color, arrangement and number of individual light sources. Therefore, to make the most of the almost infinite potential of light, a photographer must learn to evaluate it not only *quantitatively* (how much light?), but also *qualitatively* (what kind of light?).

Before you take the final step by releasing the shutter of your camera, ask yourself three questions: What kind of light am I confronted with? What kind of light would give me the best results in a specific case? What kind of light can I have, considering the present circumstances and the means at my disposal? Then, do the best you can.

To help you make your choice, here is another thought you may want to consider: As creative photographers—photographers conscious of their privilege of choice—we have a choice of three different forms of illumination:

Ordinary illumination
Unusual illumination
Fantastic illumination

Ordinary illumination is "everyday light"—sunlight from morning to afternoon or light from an overcast sky, ordinary interior illumination—the kind of light we are accustomed to and notice no more consciously than the air we breathe. This kind of light normally gives best results in situations where clarity, familiarity (for identification), and naturalness are important considerations—for example, in family and record shots, documentary and scientific photographs, or the average type of color picture. But only rarely will this form of light lend itself to the creation of graphically exciting or memorable pictures.

Unusual illumination is the result of light which, although by no means "abnormal," deserves to be called rare—"rare" insofar as it is not constantly seen either in actuality or in photographs: low, slanting sidelight casting long, expressive shadows very early or late in the day; flaming sunset skies; the subtle, pearly light of rainy, hazy, or foggy days; the graphically powerful, contrasty yet controlled form of illumination known as Hollywood glamor lighting. Also, most photographs shot directly into a source of light are characterized by an "unusual illumination" as are most pictures in which contrast is either abnormally high or low. Unusual types of illumination lend themselves particularly well to the creation of photographs with "eye appeal"—pictures

that must stand out from the mass of ordinary photographs, that are intended to create unusually strong impressions, that deserve to be seen. Creative photographers will instinctively be attracted by this form of light.

p. 98

Fantastic illumination is light that startles the observer of the picture. It is abnormal light rarely or never encountered by the average person; for example, light from below—a form of illumination that is extremely rare in nature and in a photograph always creates a "fantastic" impression. Other fantastic forms of illumination are: light from a welder's torch, which can make an ordinary commercial operation look like a scene from hell; the glow radiating from molten steel during the tapping of an open-hearth furnace or the pouring of ingots; the psychedelic illumination in a discotheque, created by flickering strobes and sweeping beams of colored lights. A fantastic illumination is subject to no rules and can be almost anything "abnormal" in the realm of light. Sometimes, however, it may be difficult to decide whether the result is fantastically good or fantastically bad. People will rarely agree among themselves, and what seems like a stroke of genius in one case can be plain awful in another. Here, a photographer is on his own.

Conclusion

p. 61

There is more to light than that which consultation of an exposure meter or compliance with the so-called Zone System can reveal. Correct film exposure is, of course, an indispensable prerequisite for any technically satisfactory photograph, but the resulting image can still be the world's most boring picture. Almost invariably, it is *the character of the illumination* (and not the correctness of the exposure) that, in the rendition, gives the subject "depth," makes it stand out from its background, endows it with sparkle, gives it "eye appeal," defines its mood, and makes it come to life. If this is what he expects from his pictures, a photographer must first of all familiarize himself with the functions, qualities, forms, sources, and uses of light. These are discussed in the following chapters.

II. The Functions of Light

Light is the photographer's medium. Without light, he is as stymied as a painter without colors and canvas, a sculptor without clay or stone. But give him light, and he becomes a potential creator.

It is light that enables a photographer to realize his visions on film and sensitized paper, communicate with people, express himself in picture form. But there is a catch—a catch inherent in any kind of creative work: although indispensable, it is not the medium that creates the work—the colors, the clay, the stone, the light; rather, it is the mind that guides the hand that guides the tool of the creator. In this sense, "mind" is synonymous with talent, imagination, and theoretical knowledge; "hand" stands for practical knowledge and manual dexterity and skill; and "tool" obviously represents, in our case, the cameras, lenses, filters, photolamps, and other equipment of the photographer.

Give a young hopeful a rainbow of color or a mountain of the finest clay and he still may be unable to turn out inspired work—unless he knows how to use his medium. One of the clues to success is in the meaning of the term "use." Look up its various definitions—utilize, apply, employ, exploit, take advantage of, manipulate—then apply them to your medium, "light." But even this is still no guarantee for the creation of memorable photographs, because to reach this final goal, three additional requirements—talent, knowledge, and hard work—must combine. Of these indispensable ingredients, talent is a heavenly gift a photographer either does, or does not, have; no outsider can help him there. How hard he works is entirely up to him. But knowledge can be gained from books.

It was with this in mind that I sat down to write this text, this introduction to the potential and usage of light. But to do a workmanlike job, I must begin with fundamentals—no matter how obvious they may appear at first—and start by discussing the functions of light which, as far as a photographer is concerned, are fourfold:

Light makes the subject visible
Light symbolizes volume and depth
Light sets the mood of the picture
Light creates designs of light and dark

21

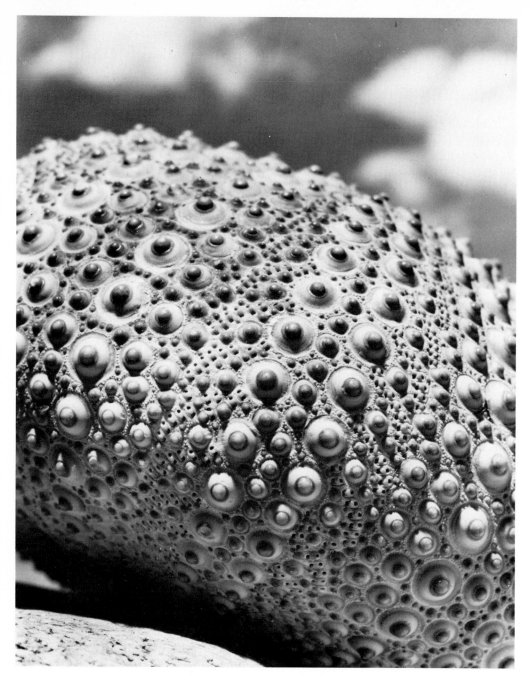

Sea urchin cast upon the beach. Raking 10 o'clock (p. 89) 60-degree sunlight brings out the interesting surface texture (p. 242) of this beautiful object.

LIGHT MAKES THE SUBJECT VISIBLE

In the absence of light, we cannot see. Hence, in a deeper sense, light and seeing are synonymous. Seeing is the most important bridge between reality and the mind. And: "Seeing is believing."

However, there are different degrees of seeing and different connotations to the concept "light": the indifferent glance, the interested look, the curious investigation, the search for understanding and knowledge. We say: What does he *see* in her? He *saw* her in a new *light*; suddenly he *saw* red; it *dawned* upon him—to mention only a few of the different meanings of "seeing" and "light" that a photographer should keep in mind when considering a potential subject for a picture.

Why? Because it is primarily the degree of intensity of his seeing that decides the outcome of his work. How much does he care? how great is his involvement? how penetrating the depth of his "seeing"? What, precisely, did he "see" in his subject? For unless he sees something special, something that interests both him and the audience for which he makes his pictures, he may as well abstain from making photographs for all the good it might do.

"Light makes the subject visible." That truism, unfortunately, seems sufficient for most photographers. It is the quantitative approach. They know that as long as they can see a subject, they can also photograph it. Rarely do they ask themselves whether "seen in a different light"—literally as well as figuratively speaking—it might have made a better picture. In other words, the fact that light has made the subject visible, and thereby photographable, is only the first step on the road to good photography. The next step is to make the best of this opportunity by looking at the subject from different angles, again in the literal as well as figurative sense, to "see" it not only with the eyes, but also with the eye of the mind. To ask: *Precisely* what is it? What does it mean to me as well as to a potential viewer of my picture? Why do I want to photograph it? How can I best accomplish my goal? How can I graphically isolate and emphasize my subject's most important features, bring out its implications, its ramifications, its significance? How can I "see" it in terms of photography: to select the most suitable type of camera and lens; make up my mind whether to shoot it in color or in black-and-white; consider contrast, light, perspective, diminution, and scale; texture rendition; motion symbolization, sharpness, unsharpness, directional blur? Always remember that if a subject is worth photographing at all, it is worth photographing well.

In my opinion, the statement "light makes the subject visible" is more than merely a truism. It is a statement of fact that reminds me of my responsibility as a photographer. In my mind, I associate "seeing" with "showing"— seeing on behalf of other people, showing them, via my pictures, how I see

23

the world and the things that turn me on. This, in turn, makes it imperative that I "see well," so that what I have to show can be meaningful, informative, interesting, aesthetically enjoyable. I see no point in cluttering up the world with additional "so what?" pictures; we already have too much visual garbage that doesn't mean anything to anyone. Light gives us photographers a chance to see reality with new eyes. It is up to us, through our photographs, to help other people to "see" and to provide them with "illuminating" experiences.

LIGHT SYMBOLIZES VOLUME AND DEPTH

One of the first things an art student learns in school is that "shading" adds depth to his drawings. The same is true in photography: Illuminated by frontlight, which casts few or no shadows visible from the camera position, a subject appears "flat"; but seen in side- or backlight—forms of illumination that cast pronounced shadows relative to the camera position—this same subject suddenly acquires "depth."

"Depth" in photography is, of course, only an illusion; the print as well as the image of the subject is two-dimensional, or flat. That it is still possible to achieve at least a resemblance of three-dimensionality and depth is due to certain "optical illusions," graphic depth symbols such as perspective (the apparent converging of actually parallel lines that lead away from the observer), diminution (the apparent decrease in object size with increasing distance from the observer), overlapping, aerial perspective. But the most powerful and convincing of all photographic depth symbols is light.

pp. 116-
117

So great is the depth-suggesting power of light, that wrongly placed shadows can create impressions that are contrary to fact. Study, for example, the two accompanying photographs of miniature formations in sand (actually, the same negative printed twice, the second time upside down): Illuminated with light from the upper left, the crater and the tiny sandpile appear as they really are. But illuminated with light coming from the lower right, the impression is reversed; what actually was a depression (the crater) now looks like an elevation or miniature mountain, while the tiny sandpile seems to be a hole.

These effects are due to the fact that we are so used to the appearance of objects in sunlight, which always comes from above, that we automatically assume any illumination comes from that direction unless, of course, it is obvious that it does not. As a result, in photographic form, a crater illuminated with light that seems to come from the direction of the upper edge of the picture looks indistinguishable from a mountain illuminated with light that seems to come from the picture's lower edge. Why? Because in both cases,

Two prints from the same negative showing an antlion crater (made by the larva of an ant-eating insect) in sand. For explanation, see the text at left.

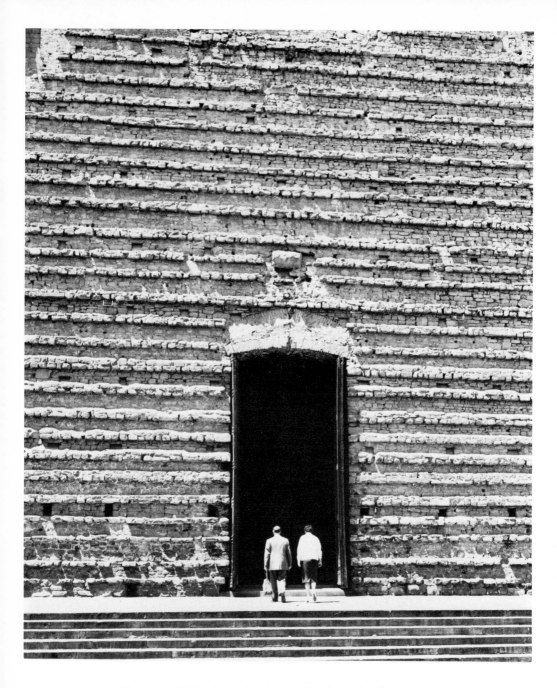

The never-finished facade of a medieval basilica in Rome. Raking toplight (p. 98) brings out the interesting texture (p. 242) which fifteen minutes earlier would have been "burned out" by light, ten minutes later, lost in shade.

the illuminated side of the respective formation faces the top, and the shaded side the bottom, of the picture, creating precisely the effects we would expect to see in reality in daylight. A moment's study of the two accompanying photographs should prove the correctness of this statement.

Accordingly, it should be obvious to any thinking person that one of the prime requisites for the making of effective photographs is light control. Unfortunately, as I said before, the only kind of light control photographers normally practice concerns the exposure. Outdoors, they accept light and shadow as they are, for how can one argue with the sun? And indoors, the confusion of shadows is usually so great that any attempt at bringing order into chaos seems futile.

This is a hopelessly defeatist attitude and, incidentally, one of the main causes for the poor showing of millions of ineffective photographs. In contrast, creative photographers carefully control the effect of their illumination by one of the following means:

<div align="center">

Discrimination and self-discipline
Patience and time
Subject position
Choice and arrangement of photolamps

</div>

Discrimination and self-discipline

Two of the most valuable assets of any photographer are discrimination and self-discipline. The first is the ability to distinguish between photogenic and unphotogenic subjects, to know what will make effective pictures. The second is the ability to have will-power enough to resist the temptation to "shoot" when a subject is graphically "hopeless." Specifically, if the illumination does not seem right—as effective as it could be—and there is nothing a photographer can do (as often happens when working with daylight), he will forsake the shot rather than bring home a picture he can never be really happy with; because no matter what, he always has the choice to select or reject.

Occasions for using this privilege are manifold: the sun is either too high or too low in the sky; the light is too harsh or too soft; the direction of the light is unsuitable to bring out important features of the subject (like the significant texture of an ancient wall that demands a raking sidelight); or shadows are wrongly placed or too harsh, obscuring important subject detail or creating unpleasant light-and-dark designs. It is in such instances that self-discipline—abstaining from making an unrewarding shot—pays not only by saving the photographer the money and material he would otherwise have spent on film, developing, and printing, but also by raising his batting average as a craftsman.

Brooklyn Bridge, New York. Differences in illumination create differences in mood. All pictures taken from the same camera position are *not* alike.

Patience and time

If, on first encounter, an important subject appears unsatisfactory as far as the illumination is concerned, a determined photographer will pass it up only to return later when conditions are more favorable. This, of course, requires time and patience, prerequisites that are invaluable when, for example, it is either too late or too early in the day to make a certain shot because the sun is already too far gone or not yet far enough; when the light is too harsh and the shadows too black, and returning on an overcast or hazy day would lead to better pictures; when it rains but the subject requires sunshine, or vice versa; or when a sunset is dull instead of dramatic.

As a matter of fact, many photographers deliberately visit a favorite subject repeatedly in order to see it under different light conditions, as illustrated by the three accompanying views of New York's Brooklyn Bridge photographed in early morning haze, at dusk in the fog, and in the darkness of night. Neither one of these pictures is "better" than the others; each is merely different. But together they give a better idea of this particular subject than any one of them could by itself.

Subject position

If the source of illumination is beyond the photographer's control (the sun, fixed indoor lamps), and he encounters a portable or movable subject in bad light, a discriminating photographer would not be content to shoot it under such unsatisfactory conditions. Instead, he would move the subject into a better light; or turn it into a better position relative to the light source; or ask a person to step from, say, harsh sunlight into diffused shade; or simply make the person turn his head until the distribution of light and shadow in the face was satisfactory. In other words, discriminating photographers don't rush in and shoot; instead, they study their subject in regard to light and shadow and, if not satisfied, move or turn it into a better position.

Choice and arrangement of photolamps

Experienced photographers are well aware of the high degree of control of illumination that can be theirs simply by choosing the right type of photolamp and using it to best advantage. Light ranging from harsh and contrasty to soft p. 101 or totally diffused can be theirs by making the proper choice between different sizes of spotlights and photoflood lamps with or without diffusers; wider or p. 184 narrower reflectors for softer or more contrasty light; subject-to-lamp distances varied from nearer to farther for total brightness control; lamp placement altered relative to the subject for directional effects—from almost shadowless frontlight to boldly modeling sidelight to contrasty and dramatic p. 91

29

p. 113
p. 108 backlight; shadows—black and graphic, normal, or transparent and fully detailed, through judicious use of auxiliary shadow fill-in lamps or reflecting panels, and so on. Manifold indeed are the means and devices at the disposal of any discriminating photographer. With these, he can control his illumination in virtually every respect with the ultimate aim of creating photographs in which the subject appears three-dimensional, space seems to have depth, and reality is effectively mirrored in picture form.

LIGHT SETS THE MOOD OF THE PICTURE

Everything light and bright evokes joyous feelings; everything dark calls forth more somber and reflective moods. Since these are normal reactions shared by all, in photography, lightness and darkness are symbols of mood, which creative photographers can use advantageously to make their pictures express specific feelings. Proof of this can be found in the two accompanying photographs, which show the same negative printed twice, once relatively light, the second time somewhat darker. The first version clearly evokes a lighter mood than the second. Thus, simply printing a negative somewhat lighter or darker provides a means for influencing the mood of the picture in one direction or another; light becomes a symbol of mood.

As a matter of fact, we constantly find that it is the mood of a scene—the character of the light rather than the nature of the subject itself—that makes a photographer reach for the camera. Photographically speaking, a forest, for example, can be a pretty uninspiring tangle of branches and trees. But seen during an early morning walk when rays of light burst through green boughs and transform a stand of timber into a cathedral of light, it becomes an unforgettable experience, a subject worthy of the camera of a master. And this transformation from a "nothing" subject to one of inspiring beauty is accomplished solely by light.

Again and again, we find that it is light—the special character of the illumination—that aroused our interest rather than the thing itself. And in the last analysis, it is the special quality of light that gives, say, a landscape or an interior its particular "atmosphere." The rosy light of dawn, for example, with wisps of mist laying in the hollow, can transform a cow pasture into a magic place; the drama of a sunset can turn an ordinary lake into a sea of fire; a smoke-filled convention hall, pierced by shafts of light and lamps surrounded by halos, can become a dramatic place where history is made, yet this same hall, seen in the sober light of the following morning, can be photographically dull.

30

Light sets the mood of the picture. Therefore, it makes a difference whether a negative is printed lighter or darker.

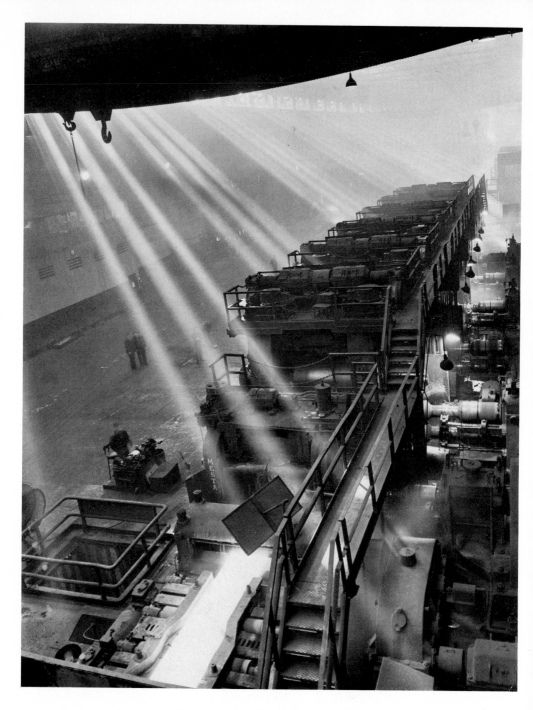

Blooming mill. On an overcast day, without the luminous shafts of light, I would not have thought this scene worth a picture.

Realizing the importance which the character of the illumination has in regard to the effect of the picture, experienced photographers, sensitive to subtle shades of mood, take great care to preserve in their renditions the "atmosphere" that is typical for their subjects. They know how easy it is to kill a subtle mood with floods of uncontrolled light; they realize that the flash of a speedlight can be as devastating and mood-destroying as firing a gun in church. They go to great lengths to preserve in their photographs the delicate shades or colors of "available light," even if this means making a time expo- p. 160 sure or risking blur due to subject motion. They know that unless they capture the light-induced mood of a scene—its special "atmosphere"—they have nothing.

Photographers who are obsessed with "technique"; who believe in "correcting" every tinted illumination no matter what the occasion, and who, with the aid of filters, bring it back to the type of light for which their color film is balanced; who insist that every shadow must show detail in the print, even if this means the use of flash; who indiscriminately employ auxiliary illumination in an effort to penetrate the farthest corners of a room with light—in other words, photographers who tamper with the quality of the existing light —those photographers will never bring home the kind of picture that makes a viewer "feel." By reducing all their subjects to a standard denominator— normalcy—they produce pictures that are stereotyped—alike in regard to sharpness, contrast, and "naturalness" of color and tone. And by this uniformity, they obliterate everything that gave their subjects character and made them unique—a one-time experience—the atmosphere and mood created through the magic of light.

LIGHT CREATES DESIGNS OF LIGHT AND DARK

Let's assume we have to photograph a complex, white object, for example, the plaster model of a housing project. We take it out into the open and study it in direct sunlight, set it down and walk around it, watching closely as the incident light changes from flat frontlight through modeling sidelight to dramatic backlight. And while doing this exercise, we try to forget what this object represents, close one eye (to switch from our stereoscopic vision to the flat, monoscopic vision of the lens), and analyze what we see in terms of black and white. We should learn some interesting and useful facts.

We learn, for example, that the interplay of light and shadow creates a graphic design of light and dark; that evaluated on a strictly aesthetic basis (that is, independent of the nature of the object as such), this design can have

33

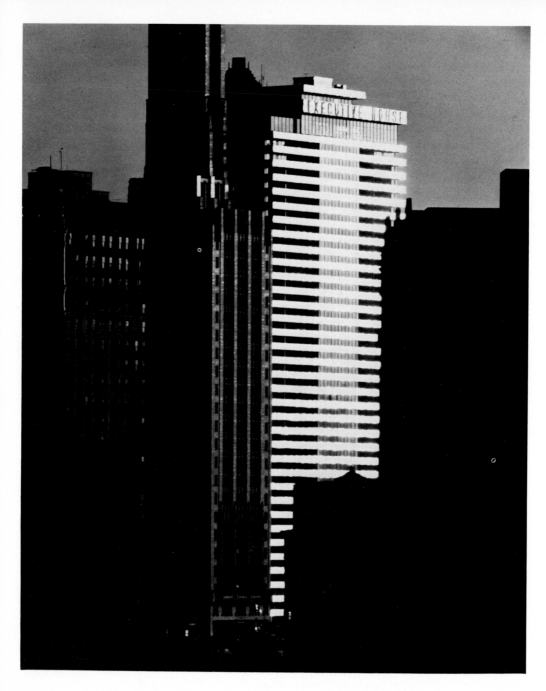

High-contrast light at sunset turns a "nothing" subject into a powerful picture. Correctly used, "detailless" shadows are beautiful.

34

an abstract beauty of its own, similar to that of a black-and-white work of modern abstract art; that it can have a definite organization, a pattern based on rhythm in black-and-white (created, perhaps, by the dark forms of empty windows arranged in a regular array) or, conversely, that it can be nothing but a meaningless jumble of patches of light and dark; that predominance of light forms (frontlight rather than backlight) evokes more joyous feelings than predominance of dark forms (shadows created by backlight); that white, because it is the most brilliant "color," seems to "jump off the paper," is "aggressive," and normally (because there are exceptions) attracts the eye more strongly than black; that black, due to its darkness, seems to recede (a black area in a picture can give the impression of a hole), is "heavy" and "passive." And if the "design" also contains gray shades (perhaps shadows partly "filled-in" by light reflected into them by adjacent areas of white), which would permit relative evaluations, we would also learn that white appears at its brightest when adjacent to black and, conversely, that black appears "blackest" when placed next to white.

Evaluating these findings in practical terms, we then could draw the following conclusions in regard to another role light plays in photography:

Independent of its subject content, every photograph, whether in color or in black-and-white, can be experienced as an abstract design in color or shades of light and dark. If this design is aesthetically pleasing, that is, if these shades conform to a pattern, are well organized, have rhythm, or fall into a design, the picture will make a stronger impression than if its "design" is a shambles.

A single powerful light or dark form around which the rest of the picture is arranged can hold the entire composition together. By the same token, a photograph consisting of a multitude of more or less equal light and dark forms scattered all over the place easily "falls apart."

Keeping the center of the picture lighter than the edges (which might even form a dark or black "frame" in the form of, say, a doorway, or the silhouetted branches of trees) automatically draws the viewer's attention toward the middle where, presumably, the interest belongs; conversely, small, bright areas touching the edges of the picture act like "visual magnets" and detract from the centér of the image.

Unfortunately, this ability of light to create abstract designs is largely scorned by those photographers who see in photography nothing but a "realistic" medium of rendition. And by this attitude, they forsake needlessly and by default a powerful means for improving the aesthetic quality of their pictures. How powerful should be obvious to anyone who is familiar with the published works of photographers like Avedon, Karsh, Mili, or Penn, each of whom is a master in the art of designing with light.

Conclusion

I repeat here for emphasis that there is more to light than what a reading of the correctly adjusted dials of an exposure meter can reveal. By now, this should be obvious to anyone but an artistically insensitive person. But how can a student photographer find out what this mysterious "more" is?

In my experience, the best way for anyone to increase his understanding of the role light plays in regard to the outcome of a picture is to analyze photographs that impressed him by their illumination. This is easily done by examining the shadows, the direction and depth of which unmistakably reveal direction and contrast of the illumination. For example, if the shadows are relatively long, the light source was relatively low above the horizon or the floor, and the light struck the subject more horizontally than vertically, and vice versa. If the shadows run more or less forward—toward the observer or the camera—the illumination was a more or less extreme form of backlight; on the other hand, if the shadows seem to emanate from behind the subject, a more or less frontal illumination was used. If the shadows are black and sharply delineated, the light was rather contrasty (direct sunlight or light from a spotlight); if gray, the light source was more or less diffused (light from a hazy sky or photoflood lamps). Absence of pronounced shadows indicates either straight frontlight (in which case there will still be vestiges of more or less sharply defined shadows) or an almost totally diffused kind of illumination (in which case no sharply delineated shadows occur at all). This indicates, in outdoor shots, that the picture was taken under an overcast sky or in the open shade; and in indoor shots, that it was made by reflected light—either flash directed at the ceiling ("bounce light") or light otherwise reflected from ceiling or walls.

p. 143

Being able to analyze a photograph on the basis of clues inherent in the picture itself makes a photographer independent of the "technical data" that hidebound editors of photo magazines still persist in printing with each picture. In my experience, such data are usually fabricated, always incomplete, and generally misleading—a relic from the days when photo technique was still difficult. Fabrication is the result of an editor's insistence on "technical data" as a condition for accepting a picture for publication, even though the photographer by that time has long since forgotten which f/stop and shutter speed he used; so, to appease the editor, he invents them. Incompleteness is due to the fact that the brightness of the incident light is never given in the form of an exposure-meter reading; so what good does it do anyone to know that a picture was taken at, say, f/16 and 1/125 sec., if he does not know how bright the light was at the time of exposure? Omission of important factors such as the use of a color filter, a polarizer, auxiliary flash for shadow fill-in, a reflecting panel, and the like makes this kind of "information" not only worthless, but actually misleading.

36

III. The Qualities of Light

Beginners and snapshooters may distinguish between only two kinds of light—bright enough to take a picture, and too dark—but experienced photographers know that these two "types" are merely different manifestations of the same quality: brightness. They also know that brightness is only one of the five photographically important qualities of light, which are:

> **Brightness**
> **Color**
> **Direction**
> **Contrast**
> **Shadow**

Each of these qualities plays an important, and sometimes decisive, role for the outcome of the picture. Each can be controlled, often to a surprisingly high degree. This chapter tells you what any ambitious photographer must know about the qualities of light before he can make pictures that say what he had in mind.

BRIGHTNESS

Brightness (intensity) is the most obvious quality of light. It ranges all the way from the almost unbearable glare of direct sunlight on ice and snow to the virtual absence of light at night. As far as the photographer is concerned, brightness plays a double role:

> **It influences the mood of the picture**
> **It determines the exposure**

Brightness influences the mood of the picture

p. 30 I showed earlier that a lighter print makes a more joyous impression than a darker one. Similarly, a bright, well-lit surrounding puts people in a lighter, more carefree mood than a gloomy one. Photographers sensitive to this kind of "mood"—whether the subject is a landscape, an object, or people—take advantage of this fact and make sure that in their pictures the degree of brightness is in harmony with the character and "mood" of the subject and compatible with the effect they wish to achieve. To accomplish this, they have three different controls at their disposal:

1. Selection and rejection. If light conditions are such that they fit the intended mood of the picture, go ahead and make the shot. Otherwise, restrain yourself, come back when conditions are more suitable, and try again.

2. Arrange an artificial illumination in such a way that it creates the mood you wish to express. Choose your photolamps and their placement in accordance with the desired effect: bulbs of higher or lower wattage, lamps placed closer to, or farther from, the subject for complete control of the "effective" brightness of the illumination at the subject position.

3. Vary the print exposure during enlarging. Shorter exposures produce lighter prints than longer ones. By making use of this, any effect from very light to very dark can be created, regardless of the density of the negative.

Brightness determines the exposure

Any photographer knows that the brighter the light, the shorter the exposure, and that correct exposure is an indispensable prerequisite for any technically perfect negative or slide. But what, if you please, is a "correct exposure"? And how does one go about achieving one?

A correct exposure is one that admits *precisely* the amount of light to the film, which is required to produce a negative of the right density (neither too thin nor too dense) or a slide (transparency) with natural-appearing colors (neither too light nor too dark).

Underexposure (not enough light admitted to the film) produces negatives that are too thin, which, in turn, yield prints that are deficient in regard to shadow detail, usually too contrasty, and always unsatisfactory as far as tonal gradation is concerned. In slides, the lighter colors appear too dark and the darker colors almost or totally black.

Overexposure (too much light admitted to the film) produces negatives that are too dense, which, in turn, yield prints that have too little contrast,

38

require abnormally long exposure times during enlarging, are often excessively grainy, and always unsatisfactory in regard to tonal gradation. In slides, the darker colors appear too light and the lighter colors partly or entirely washed out.

The ideal exposure. In black-and-white photography, the best negative is usually *the thinnest* negative that still shows satisfactory shadow detail; this means that the thinnest areas should still be detailed and not merely gray due to film-base color or chemical fog.

In comparison to denser negatives, thin negatives have the following advantages: They are sharper, due to the absence of light scattering in the emulsion, which becomes increasingly pronounced as the emulsion density increases. They are less grainy. They are easier to print because the enlarger image is more brilliant and exposure times are shorter; alternatively, the enlarger lens can be stopped down more to counteract the effect of buckling of the film if glassless negative carriers are used, with the result that prints will be consistently sharper. In addition, negatives exposed for minimum density enable a photographer to fully exploit the maximum speed of his film. Practically, this means shorter exposure times than would be required for more generously exposed negatives, which, in turn, means less danger of unsharpness due to accidental camera motion, greater subject motion-stopping power, or smaller f/stops for more extensive sharpness in depth.

The only risk in utilizing the maximum speed of a film is that the photographer works close to the edge of underexposure; one step further, and he begins to lose shadow detail. Whether or not this is serious is, of course, another question. Sometimes it is, other times it is not. But just to be on the safe side in cases in which shadow detail is important, in addition to the minimum exposure, experienced photographers take one or two additional shots with slightly longer exposures whenever possible. This practice, which is called *bracketing*, will be discussed in more detail later. p. 58

The best way to consistently produce minimal-exposed negatives is to adjust the film-speed dial of the light meter (or camera) accordingly. In this respect, it is important to know not only that the ASA speed posted by the film manufacturers for their products usually includes a greater or lesser safety factor, but also that the "effective" speed of any film (as opposed to its "listed" speed) is to a considerable degree affected by the type and temperature of the developer and the time of development. In this respect, more or less workmanlike procedures can result in a corresponding gain or loss of film speed. A few well-planned and executed tests should quickly determine the "ideal" speed rating a photographer should feed into his light meter (or camera)—the rating which, once established, should give him ideally exposed negatives every time.

Practical exposure determination

Three different methods of exposure determination exist, the first of which is extremely limited, and the last—the only one based on actual brightness measurements—gives the most reliable results. The three methods are based on:

<div align="center">

Guessing

Exposure tables

Photoelectric light meters

</div>

Guessing the exposure is practiced mostly by amateurs who don't know any better and professionals who know enough to realize the limitations of this method. Guessing is adequate under light conditions that are always more or less the same but fails miserably as soon as the illumination is no longer "standard." For example, the brightness of direct sunlight not weakened by haze or clouds is more or less constant during the hours when the sun is more than 20 degrees above the horizon. Under such conditions, exposures made by front- or moderate sidelight will always be the same, minor differences in brightness being easily absorbed by the exposure latitude of the film. But guessing an exposure under almost all other conditions, and particularly indoors when working with artificial light, is photographic madness. Why? Because the eye rapidly and automatically adapts to different levels of illumination with the result that normally we are not even aware of any change. Unless the difference is dramatic, brightness appears to be more or less the same, even though in one situation the light may be perhaps ten times as bright as in another. My advice to beginners: Except in cases in which light conditions are more or less standard, don't try to guess your exposures (unless, of course, you like to gamble; the odds are fairly high). Instead, consult an exposure table or, better still, use a photoelectric light meter.

Exposure tables interpret light conditions in terms of everyday experience: bright or hazy sun on light sand or snow; bright or hazy sun (distinct shadows); cloudy bright (no shadows); heavy overcast; open shade on a sunny day, to mention only the most commonly encountered light conditions, beginning with the brightest. Other published tables are computed for exposure by flash, with proper allowances made for differences in regard to type of flash, type of reflector, mode of synchronization, and shutter speed.

Such tables are reliable only within the limits of their applicability. But precisely because of their simplicity, they are often more useful to beginners than photoelectric light meters. The latter, although much more accurate and versatile, are also more difficult to use since the data they yield frequently

have to be modified in accordance with specific situations. Simple but practical and always handy, exposure tables are part of the instructions that accompany each roll of film.

Photoelectric light meters are instruments that measure brightness and display their data in photographic terms—in the form of *f*/stop numbers and shutter speeds. Although not applicable in every situation, and despite the fact that their accuracy is normally no greater than plus or minus half an *f*/stop (several identical meters used side by side will usually give as many different results as there are meters, although the variations should be slight), they are unquestionably the best means for arriving at a correct exposure. For practical purposes, distinguish between two categories, each of which again comes in two types:

> Light meters built into the camera (usually through-the-lens, or TTL, meters)
>> Meters for fully automatic exposure control
>> Match-needle light meters
> Hand-held light meters
>> Meters for measuring reflected light
>> Meters for measuring incident light

Built-in, fully automatic exposure-control systems. All a photographer has to do is adjust the film-speed dial in accordance with the ASA speed of his film, choose the *f*/stop (with some models, the shutter speed) most suitable to the occasion, aim the camera, focus, and shoot, secure in the knowledge that the meter will do the rest: automatically select the corresponding shutter speed (or *f*/stop) required for a perfect exposure. And should he wish to try for some nonstandard effects, a manual override control permits him to bypass the automatic system and set *f*/stop and shutter speed by hand.

Built-in match-needle light meters. Set the film-speed dial in accordance with the ASA speed of your film, aim the camera, focus the lens, then turn either the diaphragm ring or the shutter-speed dial until the light-meter needle visible inside the viewfinder is centered in a slot. Now, you are ready to shoot and should get a correctly exposed negative or slide.

The main difference between this and the previous metering system is that the first requires you to set *one* control (*f*/stop or shutter speed, depending on the respective design) only *once*; from then on, you can shoot in any direction, with front-, side-, or backlight or in the shade, and the meter will automatically adjust the exposure to the different brightness conditions. But if

your camera is equipped with a match-needle light meter, whenever the light intensity changes, you have to center the needle anew to get a perfect exposure.

Hand-held light meters are instruments small enough to fit into the palm of a hand. In my opinion, they are indispensable in cases in which the camera is not equipped with a built-in light meter. As a matter of fact, many professional photographers, even when working with cameras equipped with built-in light meters, make it a practice always to have a hand-held meter handy to check periodically the accuracy of the data turned out by the meters of their cameras.

Hand-held light meters for measuring reflected light measure the brightness of the *light reflected by the subject.* To take a reading, the meter must be pointed from the camera position at the subject. A valuable advantage of this type of meter over an incident-light meter (see below) is that a meter measuring reflected light permits a photographer to take separate (close-up) readings of selected areas of the subject in order to establish its contrast range.

Hand-held light meters for measuring incident light automatically integrate all the light that falls upon the subject while measuring *the intensity of the illumination itself.* To take a reading, the meter must be pointed from the subject position at the camera. This type of meter is especially suitable for use in the studio or in conjunction with any artificial illumination involving several light sources. On the other hand, the disadvantage incident-light meters have is that they do not permit a photographer to take individual brightness readings of specific subject areas and can therefore not be used to establish contrast range. For example, brightness readings taken of the face of a model (a relatively light tone) and her black sweater (a very dark tone) would be identical if illuminated identically.

Because of the advantages inherent in either type of light meter, accessory attachments are nowadays available for most meters. With the aid of these attachments, a meter designed for measuring reflected light can be converted into one that measures incident light; conversely, an incident-light meter can usually be converted for use as a reflected-light meter. However, it must be pointed out that a converted meter is never quite as accurate as a meter originally designed to measure either reflected or incident light.

Selenium or CdS (cadmium-sulfide) cell? The majority of light meters built into cameras are equipped with CdS cells, a few have silicon blue cells, and one or two even have selenium cells. About one out of four hand meters

features selenium cells, the rest CdS cells. What, precisely, are the advantages and drawbacks of each?

Selenium-cell-equipped light meters have the great advantage of not requiring batteries since they are powered by light. As a result, they are more reliable, require no maintenance, can never run out of power, and are always ready for use.

On the other hand, the sensitivity of a selenium cell is directly proportional to its size—the larger the cell, the more sensitive the meter. This, incidentally, explains why the best selenium-cell-equipped hand meters are always relatively large, and why virtually no light meters built into cameras feature selenium cells; there simply isn't enough space inside a 35mm camera body for a cell of sufficient sensitivity. Furthermore, the relative weakness of the current generated by a selenium cell requires a measuring unit that is very responsive; this, in turn, makes it more delicate and sensitive to shock than the more rugged galvanometers of CdS-cell-equipped light meters.

CdS-cell-equipped light meters have the following advantage over selenium-cell meters: They are powered, not by relatively feeble light, but by a battery. As a result, much larger amounts of current are available to activate the galvanometer which, in turn, makes CdS-equipped light meters much more sensitive than selenium meters; a good CdS meter gives reliable readings even in light so dim that it would have no effect at all on a selenium cell.

But there are also drawbacks: If accidentally (or deliberately) exposed to very bright light, a CdS-cell-equipped light meter becomes temporarily "blinded," with the result that for a time, which can last up to an hour and more, depending on the severity of the overexposure, pointer readings are more or less "wild." Unfortunately, there is no way of checking whether a meter is "blinded" except by comparing its readings with those of a meter known to be accurate. Moreover, temporary "blindness" can set in quite unexpectedly, for example, when a CdS meter set for low-light reading is carelessly exposed to bright light or a built-in meter is accidentally pointed at the sun. And only in extreme cases is the photographer likely to notice this calamity in time, which, if undetected, could ruin the results of hours of shooting. To avoid this possibility, experienced photographers usually carry a separate selenium-cell-equipped light meter against which they check their camera's meter periodically.

Another shortcoming of CdS-cell-equipped light meters is "memory": If a photographer takes point readings in order to establish the contrast range of a subject and quickly scans from a very bright area to deep shade, the meter "remembers" for a while the bright light to which it was exposed and yields a reading that is too high. (Silicon cells have virtually no "memory.")

And finally, CdS-cell-equipped light meters are "lazy": Their pointers are much slower in reaching their final positions than the needle of a selenium-cell-equipped meter, and the dimmer the light, the longer it takes before the pointer finally stops. Because of this kind of "needle creep," taking a hasty reading with a CdS light meter is a sure way to overexposed pictures.

Through-the-lens meter or hand-held meter? Although, at first, light meters built into the camera may seem like the answer to a photographer's prayers, they also have drawbacks that can lead to disappointing results unless the photographer is aware of them and knows how to cope. In this respect, the following must be considered:

Through-the-lens light meters, the vast majority of which are equipped with CdS cells, have two often decisive advantages over hand-held meters: (1) They greatly speed up the process of picture-taking by eliminating the need for a separate light meter, the readings of which subsequently would have to be transferred to the diaphragm and shutter controls of the camera. (2) They p. 48 take into account certain factors that influence the exposure, which, in the case of a hand-held light meter, would first have to be calculated and incorporated into the primary exposure data before these could be fed into the camera. As a result, photographers working with cameras featuring through-pp. 51, 52 the-lens metering can forget about filter factors, slip-on lens factors, and the p. 50 influence that subject distance has upon the exposure in close-ups.

Against these advantages, the following drawbacks must be weighed: Since most through-the-lens light meters are equipped with CdS cells, they are subject to temporary "blindness," "memory," and "laziness" (needle creep), p. 43 inconveniences I discussed earlier. Another drawback which, at least at the time of writing, is common to most through-the-lens meters, is the fact that they have no zero adjustment (and the few so equipped carry it deep inside the mechanism where it is accessible only to an expert repairman). In contrast, hand-held meters usually have an outside zero-adjustment screw, and if accidentally jarred, their accuracy can easily be checked by covering the cell window (if it is a selenium-cell meter) or removing the battery (if it is a CdS meter) and watching the needle; if everything is in order, the needle should then come to rest at zero. If the needle is off zero, it usually can be brought back to zero (and the accuracy of the meter restored) simply by turning the zero-adjustment screw accordingly. With present-day TTL meters, this accuracy check and adjustment is not possible. If the camera has been dropped or jarred (which might have occurred without the photographer's knowledge), he has no way of knowing whether the light meter is still reliable or perhaps way, way off. And should comparison with a meter of known accuracy show that the camera's meter is "off," there is no easy way of readjusting it. The entire camera must be sent off for repair.

44

And then, there is the possibility of light leakage through the eyepiece of the viewfinder. Stray light so admitted can reach the meter cell and affect its accuracy. This problem is particularly acute in the case of eyeglass wearers who cannot achieve as lighttight a connection between eyepiece and head as photographers who don't wear glasses. Although most cameras have built-in devices that allegedly compensate for such leakage, in my experience this problem is still not completely solved.

Hand-held light meters, in comparison to built-in meters, are clumsy, heavy, and less convenient from the viewpoint of the fast-moving photographer. But they are also more sensitive, more accurate, more reliable, and easier to adjust and less expensive to repair if damaged. These qualities should be particularly valuable to studio operators and commercial photographers to whom speed of operation usually is less important than accuracy.

How to use a light meter correctly

Although every new light meter comes with instructions for use, this kind of information is usually biased in favor of the good points of the respective meter but says little or nothing about possible weaknesses. Correctness of exposure, however, plays such an important role in the outcome of a photograph that I feel a digression into the peculiarities of light meters is justified here. Accordingly, the following facts deserve the reader's attention:

Reflected-light meters "think average"

If we had to photograph a subject that includes white, black, and medium gray, we would, of course, expect to see these tones reproduced as faithfully as possible in the picture. To assure success, we would take an overall brightness reading with a light meter, expose accordingly, and would probably get the desired result.

However, if we subsequently had to take close-ups of each of the three areas of different brightness—the white, the black, and the gray—and exposed on the basis of close-up meter readings taken of each, we would be in for a surprise: Only the shot taken of the gray area would have been correctly exposed and would yield a natural-appearing picture. The shot of the white area would turn out to be drastically underexposed and the negative much too thin; the one of the black area would be severely overexposed and the negative much too dense. And if printed normally, all three "subjects"—the white, the black, and the gray—would appear, in picture form, in more or less the same shade of gray. Why? Because light meters are designed to "think average," to yield exposure data that lead to pictures which render the measured subject, scene, or area in shades or colors of *medium brightness*.

The girl's blouse was white, the drape black. The rectangle is a medium-gray Kodak Neutral Test Card. The numbers indicate light values established with a Weston light meter. For further explanation. see the text on the previous page and below.

On second thought, this is easily understandable: The "average" subject is a composite of light, medium, and dark shades or colors. Now, in the process of "reading," light meters integrate all the shades and colors of the subject and come up with an average brightness value, a process which alone can insure that the brightest areas are not overexposed nor the darkest ones underexposed. But since light meters cannot think, they cannot know when a subject is, for example, uniformly white, or all black, and should be rendered accordingly. Instead, they "assume" that it is "average" in regard to tone values and come up with a set of data that would cause it to appear as such in the picture, that is, a medium gray.

In our example, in combination the three areas of white, black, and gray represented a "subject of average brightness"—a subject with which light meters "know" how to deal. As a result, the shot of the girl, exposed on the basis of an overall brightness measurement, turned out successfully. However, if we "misuse" a light meter by forcing it to "read" an abnormally light or dark subject, the poor thing, not knowing what it's all about, again comes up with a set of data that would produce a picture in average tones. Consequently, it should not come as a surprise that in our series of three, the shot that was exposed in accordance with a brightness reading taken from the white area turned out underexposed and much too dark (because the "white" had to be rendered as a medium gray); and that the picture which was exposed in accordance with a brightness reading taken from the black area turned out overexposed and much too light because, again, the measured area —the black—had to be rendered as a medium gray because light meters are programmed to "think average."

46

Now, you may say: "All this is very interesting, but why tell me?" I'll tell you why: Because it is the key to successful use of any meter measuring reflected light, which, among others, includes all light meters built into cameras. Specifically, this information should be invaluable in the following cases:

1. When measuring light intensities in outdoor shots, make sure that your meter does not "see" an excessively large area of sky which, because of its brightness, could inflate the reading with the result that the rest of the scene would be more or less underexposed and subsequently turn out too dark in the picture. Instead, tilt the meter slightly toward the ground when taking a reading.

Incidentally, it is for this reason that many light meters built into cameras are either "center-weighted" or even "bottom-weighted," which means that they favor those subject areas which normally are relatively dark to compensate for the excessive brightness of the sky. However, if a photographer takes a vertical shot with a camera equipped with a bottom-weighted light meter, a curious situation results: Now, the most sensitive area of the bottom-weighted light meter no longer favors the (darkest) bottom part of the subject (the camera designer obviously thought primarily in terms of landscapes), but one of its sides halfway between bottom and top. This is something owners of such cameras must consider each time they make a vertical shot.

2. A few 35mm cameras are equipped with light meters of modified spot-meter design, which have only a relatively narrow angle of acceptance. Such meters do not measure the entire subject area, only a relatively small part that appears either in the center or near the bottom of the viewfinder image, depending on the respective design. Owners of such cameras must be particularly careful when taking brightness readings to make sure that the metered area is representative of the subject as a whole.

3. Some hand-held light meters, the so-called spot meters, measure only within the extremely narrow angle of one degree. These are highly specialized instruments intended primarily for establishing the contrast range of a scene by precisely measuring its lightest and darkest areas. For obvious reasons, their users must be particularly aware of the fact that light meters are programmed to "think average."

4. Instructions for use of light meters often advise photographers to take close-up readings of the most important part of the subject to make sure that it at least is correctly exposed. This is good advice, provided the measured subject area is of average brightness. However, if this area is, say, the face of a very light-complexioned girl, the exposure meter, which can only "think average," will come up with data that would lead to underexposure (in order to satisfy the rule that the measured area must be rendered "average"). As a consequence, the face would appear a medium instead of the expected lighter tone in the picture. Therefore, whenever exposure is based on the spot mea-

surement of a selected subject area, make sure that this area is of "average brightness" and that the result which one can expect is also compatible with the intentions of the photographer in regard to the overall lightness or darkness of his picture.

5. It should be obvious from the foregoing that correct exposure of subjects which in their entirety are either abnormally light or abnormally dark requires some thinking on the part of the photographer. If the subject is "above average" as far as overall brightness is concerned (for example, a snow scene in hazy sunlight), exposing it in accordance with a reflected-light meter reading will produce an underexposed negative or color transparency; the glaringly white snow will appear gray, that is, too dark. Conversely, if the subject is "below average" as far as overall brightness is concerned (for example, a dark and moody scene consisting almost entirely of somber colors or shades), exposing in accordance with a reflected-light meter reading will result in an overexposed negative or color transparency; the actually dark scene will appear in medium tones, that is, too light. Why? Because exposure meters are programmed "to think average." In such cases, a photographer must increase or decrease the meter-indicated exposure by ½, 1, 1½ or even 2 f/stops, depending on the overall brightness of the subject and his intentions in regard to the brightness or darkness of the picture.

Factors that influence the exposure

In addition to the brightness factor discussed above, a number of other factors exist, which might have to be considered when calculating the exposure if the result is to be not only a correctly exposed negative or slide, but also a satisfactory picture. In other words, the data furnished by the light meter must be evaluated and sometimes modified before they can be fed into the camera. Here is a checklist followed by a brief explanation of each factor:

Film speed
Camera motion
Depth of subject
Motion of subject
Contrast of subject
Color of subject
Distance of subject
Filter factor
Polarizer factor
Slip-ons lens factor
Type of developer
Reciprocity factor

Film speed. Since, other factors being equal, slow films require a longer exposure than fast films, it should be obvious that film speed is one of the most influential exposure factors. Consequently, the first thing a photographer must do before taking a brightness reading is to make sure that the film-speed dial of the light meter or camera is set in accordance with the rated ASA speed of the film with which the camera is loaded.

Camera motion. To avoid unsharpness due to accidental camera motion during the exposure, the slowest shutter speed usually considered "safe" for shooting with a hand-held camera is 1/125 sec., although some people with steady hands can go as low as 1/60 sec. and even 1/30 sec., particularly if circumstances are such that the photographer can brace himself against a rigid support. In situations where light conditions are marginal yet the shot must be made with the camera hand-held, shutter speed becomes the dominant factor, and the f/stop must be adjusted accordingly.

Depth of subject. Since the extent of the sharply rendered zone in depth is determined by the diaphragm aperture—the smaller the aperture, the deeper the sharply rendered zone—it should be obvious that for satisfactory rendition, a subject of great depth requires an f/stop with a higher number than a shallow one. Hence, in cases where sharpness in depth is an important factor, the diaphragm stop should be chosen as the basis for the exposure and the shutter speed adjusted accordingly.

Motion of subject. If a subject in motion is to appear sharp in the picture, its motion must be "frozen" in the film. This can be accomplished by making the exposure with a shutter speed that must be higher, the more rapid the apparent motion of the subject (its angular velocity relative to the camera). The shutter speeds required to "freeze" specific subjects in motion can be ascertained from published tables (like the one in the author's book *Successful Photography*, Revised Edition [Prentice-Hall], p. 115). In cases where subject motion is involved, the decisive factor in exposure determination is shutter speed, and the f/stop has to be chosen accordingly. This is true also in the event that a certain degree of blur in the rendition is desirable to graphically symbolize the concept "speed." In such cases, the shutter speed must also be selected in accordance with the desired form of rendition—neither too much blur, which would make the moving subject unrecognizable, nor too little, which would fail to evoke the feeling of speed—and the f/stop adjusted accordingly.

Contrast of subject. Light meters are designed to furnish correct data for subjects of average contrast. In black-and-white photography, if subject contrast is considerably higher or lower than "average," better results can often

be achieved if normal procedures are modified as follows: If subject contrast is *much higher than average*, increase the exposure 50 to 100 per cent above the meter-indicated value; subsequently, decrease the duration of film development by 10 to 30 per cent. In this way, negative contrast will be lower than if regular procedures had been followed, with the result that the gradation of the print will appear more normal.

Conversely, if subject contrast is *much lower than average*, decrease the exposure 25 per cent below the meter-indicated value; subsequently, increase the duration of film development by 10 to 50 per cent. In this way, negative contrast will be higher than if regular procedures had been followed, with the result that gradation in the print will appear more normal.

Needless to say, these procedures can be followed only if either sheet film or film pack is used (which permits individual development of exposures), or the entire roll of film is devoted to a subject of abnormal contrast.

In color photography, matters are different. There, contrast reduction or increase through modification of exposure and development is impossible. Instead, the best a photographer can normally do as far as overly contrasty subjects are concerned is to calculate the exposure for best rendition of the *lighter* colors and let the darker ones go too dark or black. And if subject contrast is very low, there is no way to strengthen the gradation.

p. 45 **Color of subject.** As explained before, reflected-light meters are designed to give correct data for subjects of average brightness. Therefore, if a subject's overall color is either very light or very dark, proper allowance must be made for this fact. Contrary to what might at first seem natural, *uniformly light-colored subjects* must be exposed somewhat *longer*, and *uniformly dark-colored subjects* somewhat *shorter*, than a meter measuring reflected light would indicate. The amount of the deviation should range from ½ to 1½ f/stops, depending on the degree of overall brightness above or below "average."

Distance of subject. Since f/stop values are calculated on the basis of the distance between lens and film when the lens is focused at infinity, any change in this distance must, of course, affect the value of the f/stop and consequently the exposure. Fortunately, the effects of minor changes in this distance are so small that they can be ignored because they are absorbed by the exposure latitude of the film. In close-up photography, however, when the subject-to-lens distance is equal to or shorter than approximately five times the focal length of the lens, the discrepancy between the indicated and the effective value of f/stops becomes too great to be ignored if underexposure is to be avoided. The simplest way to establish the applicable exposure factor —the number by which the established exposure of the light meter must be multiplied—is with the aid of the handy, inexpensive *Effective Aperture Koda-*

50

guide, which is available in photo stores. Alternatively, the *actual* value of the indicated *f*/stop can be calculated on the basis of the following considerations:

If a lens is focused at infinity, the distance between lens and film is the shortest at which this particular lens can still produce a sharp image. For normal lenses (that is, *not* telephoto lenses or retrofocus wide-angle lenses), this distance is equal to the focal length of the respective lens. If the distance between subject and lens is *less than infinity*, however, the distance between lens and film must be *increased* accordingly if the picture is to be sharp. The amount by which this distance between lens and film must be increased is called the "lens extension."

Lens extension and image scale are related. For example, if the image is ¼ the size of the subject (scale 1:4), lens extension is ¼ of the focal length; if the image is the same size as the subject (rendition in natural size, scale 1:1), lens extension equals focal length; and if the image on the film is, say, four times as large as the subject (magnification 4:1), lens extension is four times the focal length.

Now for the payoff: In close-up photography, the *effective* value of the indicated *f*/stop (that is, the *f*/stop with which the picture will be taken) can be found with the aid of the following formula:

$$\textit{effective f/stop number} = \frac{\textit{indicated f/stop number}}{\text{focal length}} \times (\text{focal length } + \text{ extension})$$

Example: We want to take a picture of an insect in natural size. We use a standard lens with a focal length of 2 inches (in conjunction with an extension tube) and want to stop down to *f*/11. To find the *actual* value of *f*/11 under these conditions, we use the following formula:

$$\textit{effective f/stop number} = \frac{11}{2} \times (2 + 2) = \frac{11 \times 4}{2} = 22$$

Consequently, although our lens is set at *f*/11, we must expose as if it were set at *f*/22. The simplest way to do this is to take a light-meter reading and expose at the shutter speed that applies to *f*/22.

Of course, if the exposure for a close-up shot has been established by means of the light meter built into the camera, you can forget about the distance factor, since TTL light meters automatically compensate for it. p. 44

Filter factor. All filters absorb a certain amount of the incident light that otherwise would have been available for the exposure. This light loss must be taken into account when calculating the exposure if underexposure is to be avoided. Exposures determined with cameras equipped with TTL light me-

51

ters automatically take care of this, provided the light was measured with the filter in place. But exposures established with the aid of hand-held light meters must be multiplied by the applicable filter factor before they are valid.

Filter factors depend on the color and density of the respective filter, the type of film in conjunction with which it is to be used, and the type of illumination. These will be given later.

pp. 80, 85, 86

Polarizer factor. If a polarizer is used for glare control, the exposure must be multiplied by a factor which, for most polarizers, is 2½. Cameras with built-in light meters will automatically take care of the polarizer factor if the polarizer is in place during the reading, provided they don't feature either a semi-silvered mirror or a semi-silvered prism surface, either of which would falsify the reading. In such cases, a brightness reading must be taken without the polarizer and the data subsequently multiplied by the factor of the respective polarizer.

Slip-on lens factor. The purpose of slip-on lenses is to change the focal length of the primary lens in cases in which the camera does not permit alternative use of true wide-angle or telephoto lenses. However, they change not only the focal length, but also the effective value of the diaphragm stops of the primary lens, the combination of primary lens plus wide-angle (positive) slip-on lens being faster, and the combination of primary lens plus telephoto (negative) slip-on lens being slower, than the primary lens by itself. Instructions for use, including the respective exposure factors (which apply only if the exposure is established with the aid of a hand-held light meter, since TTL meters automatically compensate for them) are always provided by the manfacturer.

Type of developer. ASA film-speed ratings are valid only if the film is developed in a standard developer. However, a few fine-grain developers achieve their purpose because they only partly develop the exposed silver salts; others do not penetrate the emulsion all the way but confine their action more or less to the surface. Such developers don't make use of the full inherent speed of a film, and unless the photographer compensates for this speed loss by rating the film at a lower than its listed ASA speed, the result will be underexposed negatives. The factor by which the exposure must be multiplied if a film is going to be developed in one of these fine-grain developers depends on the specific brand of developer and is given in the manufacturer's instructions.

On the other hand, a few developers exist, which work more energetically than standard developers. As a result, they increase the film speed above the listed ASA value. If a film is going to be developed in such a developer, for purposes of exposure calculation, it must be rated at a higher than its listed

ASA speed if overexposure is to be avoided. The factor by which the light-meter derived exposure must be shortened is usually listed in the developer manufacturer's instructions but can also be determined by test.

Reciprocity factor. In the normal course of photography, the effects of exposure in regard to negative density are the same whether the film is exposed for 1 second at 100 footcandles or 100 seconds at 1 footcandle. However, if exposure times become either abnormally long (as in time exposures) or abnormally short (as in speedlight photography), this ratio no longer applies. Then, the straight-line relationship between negative density and exposure time breaks down, the law of reciprocity fails, and the result is underexposure unless appropriate measures are taken.

Fortunately, the effects of reciprocity failure are normally of little interest to amateur photographers whose work, as a rule, does not involve them in situations where such failure might occur. But professional photographers, particularly those who work in color, where reciprocity failure not only affects the density, but also the color balance of the film, must be prepared to cope with this phenomenon which can be done by appropriate increases in exposure, if necessary in combination with appropriate filtration. Since not only different brands of film, but also different batches of the same type of film (which can be distinguished by their emulsion numbers) respond differently to the law of reciprocity, only tests can reveal the specific course of action that should be followed in a specific case. As an aid to photographers, both Kodak and GAF include with their positive (reversal) color sheet films instructions suggesting appropriate exposure increases and, if required, specific color filters.

The probability of reciprocity failure is particularly acute in extreme close-up photography where, for example, a camera magnification of, say, 10 times, may require increases in exposure by as much as 500 times beyond the time established with the aid of a light meter. To give the reader an idea of what is involved, here is a table that can be used as a basis for tests with black-and-white films:

Indicated exposure time	Either adjust f/stop	Or adjust exposure time	Adjust film development
1/10,000 sec.	+ ½ stop		+ 15%
1/1000 sec.	—		+ 10%
1/100 sec.	—		—
1/10 sec.	—		—
1 sec.	+ 1 stop	2 seconds	− 10%
10 sec.	+ 2 stops	50 seconds	− 20%
100 sec.	+ 3 stops	1200 seconds	− 30%

Multiple factors. If *more than one* factor is involved in the computation of an exposure, the respective figures must be *multiplied* by one another—*not* added to one another—and the exposure *multiplied* by this new figure if the result is to be a correctly exposed negative or slide.

For example, make a close-up of a flower in natural size, and to achieve a better separation between flower and sky, use a polarizer. According to a brightness reading taken with a hand-held light meter, exposure on Kodak Ektachrome film in bright sunlight is 1/125 sec. at *f*/11. However, because of the special circumstances, this value must now be multiplied by the distance factor (which in the case of rendition in natural size is 4) and the polarizer factor, which is 2½. Consequently, we multiply 4 × 2½ × 1/125 sec. and arrive at a correct exposure of 1/12 sec. at *f*/11 (or, which in terms of film density and color rendition would be the same, 1/50 sec. at *f*/5.6, or 1/125 sec. at *f*/3.5, in case wind motion might make it desirable to take the shot at the highest practical shutter speed in order to avoid blur).

How to use a reflected-light meter

Start by setting the film-speed dial in accordance with the listed ASA speed of your film. Make sure that film-speed rating and light-meter calibration conform to the same system since many foreign films do not use the ASA system. If this is the case, their ratings must be converted to ASA ratings before the exposure can be established with an ASA-calibrated light meter; see the following table:

American ASA and English BSI Arithmetic film-speed numbers

800	640	500	400	320	250	200	160	125	100	80	64	50	40	32	25	20
30°	29°	28°	27°	26°	25°	24°	23°	22°	21°	20°	19°	18°	17°	16°	15°	14°

Equivalent German DIN film-speed numbers

Note: Different systems use different methods of measuring film speed; as a result, it seems doubtful that any reliable conversion table can be compiled. Therefore, the values given here must be considered only as approximations that have to be confirmed or corrected by individual tests.

p. 52 If you intend to develop your film in a developer that, in effect, changes the film speed, the best way to once and for all make allowance for the respective exposure factor is to make a corresponding change in film speed when setting the film-speed dial of the light meter or camera.

Overall brightness reading. Aim the meter at the subject from the camera position. Consider, however, the fact that any abnormally bright area or light source within the acceptance angle of the meter is bound to inflate the read-

ing and thus may cause underexposure of relatively dark subject areas. To avoid excessive data inflation by skylight when outdoors, aim the meter at a point halfway between the horizon (or subject) and the (dark) foreground, especially on overcast days when the brightness of the sky is abnormally much higher than that of the ground. Similarly, scenes that include brilliant reflections on water or other sources of strong light, large patches of snow, very light sand, or unusually bright foreground matter, for instance, a sunlit cement walk, will yield inflated meter readings if incorrectly measured. This leads to underexposure because, as we should know by now, light meters "think average." If necessary, use your hand to cast a shadow over the meter p. 45 cell to shield it from direct sunlight or the glare of photolamps, particularly when measuring the brightness of backlighted subjects, but be careful that your hand does not cut off part of the meter's view of the scene.

An overall brightness reading gives best results when subject contrast is more or less average; if the scene is uniformly illuminated; if it contains about equal amounts of light and dark subject matter more or less evenly distributed; and if the brightness difference between foreground and background is not too great.

Selective brightness reading. Approach the subject and hold the light meter 6 to 8 inches from the area you want to measure. Be careful that the shadow of neither the hand nor the light meter falls upon the spot you are measuring since this would make the reading worthless.

By selectively measuring the brightness of the lightest and darkest areas of the subject, a photographer can establish its contrast range. In doing this, p. 99 however, he must disregard obvious highlights and the "colors" white and black since, in the ordinary course of photography, highlights and white cannot be overexposed nor black underexposed. Only those subject areas in the picture which must show detail should be considered.

This method of establishing the exposure is particularly recommended in cases in which subject contrast is abnormally high and may exceed the contrast range of the film. This is most likely to occur if subject (or foreground) p. 104 and background differ greatly in regard to brightness; if a light subject is surrounded by very dark, or a dark subject by very light, areas; if parts of the subject or scene are in bright sunlight and others in deep shade; and if the subject is unusually contrasty—for example, backlighted scenes or scenes in which patches of bright sky alternate with dark foliage. If black-and-white film is used, the subject contrast range should not exceed 64:1, corresponding to a difference of 6 f/stops. For reversal (positive) color film, the maximum subject contrast range compatible with natural-appearing color rendition is 8:1 or 3 f/stops; for negative color film, it is 16:1 or 4 f/stops.

If a series of selective brightness measurements reveals that subject con-

trast exceeds the contrast range of the film, a photographer has a choice of several possibilities:

If he is in control of the illumination, he can use fill-in light (flash, diffused photoflood lamps, or reflecting panels) to lighten heavy shadows and thereby reduce contrast. Alternatively, he can move the offending lamp or lamps that created the "hot spots" to new positions farther away from the subject.

If light control is impossible, he can adjust the exposure so that the lighter areas and colors of the subject will be rendered satisfactorily while the darker ones turn out too dark. This is usually the best compromise if a reversal-type (positive) color film is used. Alternatively, he can adjust the exposure so that the dark subject areas or colors will be rendered satisfactorily while the lighter ones turn out too light or overexposed. This is called "exposing for the shadows" and is usually the best compromise if black-and-white or negative color film is used and shadow detail is important. Subsequently, in printing, highlights will have to be burned-in as best they can.

And finally, a photographer can select an exposure halfway between the two previous alternatives: sacrifice a little both at the top and bottom of the exposure scale and expose for the middletones and colors of the subject. In this way, he will gain some shadow detail (but not everything) while being able to save some highlight detail through "burning-in" during printing.

Gray-card reading. By measuring the brightness of the light reflected from a Kodak Neutral Test Card instead of the light reflected by the subject itself, a photographer can, in effect, make incident-light measurements with a reflected-light meter. To do so, hold the neutral-gray card in front of and close to the subject and take a reflected-light reading of it from a distance of 6 to 8 inches. Care must be taken so that the shadow of neither the hand nor the light meter falls upon the card while the measurement is being made. If the subject is illuminated by frontlight, the card should face the camera during the reading; if the subject is illuminated more or less from the side, the position of the card must be such that it faces halfway between the camera and the light source. Since the reflectance of a Kodak Neutral Test Card is 18 per cent—the same as that of an "average indoor subject"—this method provides a convenient way of producing accurate exposure data and is particularly well suited to portraiture and close-up photography.

p. 104 A second advantage of gray-card reading is that it enables a photographer to establish the *lighting-contrast ratio* of a scene by taking two separate readings: once with the card fully exposed to the incident light; the other time with the card placed in the area of deepest shade that can be seen from the camera position. If a reversal-type (positive) color film is used, the lighting-contrast ratio should not exceed 3:1 (equivalent to 1½ f/stops on the light-meter scale). For negative color film, the lighting-contrast ratio can vary from

56

4:1 (2 *f*/stops) for best to 8:1 (3 *f*/stops) for acceptable color rendition; and for black-and-white film, it can range from 8:1 to 16:1 (3 to 4 *f*/stops) with the higher figure still giving good results whenever subject contrast is low. The precise meaning of the terms "subject contrast," "lighting-contrast ratio," and "reflectance" will be explained later. pp. 104, 105

A third unique feature of the gray-card reading method is that indoors it enables a photographer to check the degree of uniformity of the illumination. All he has to do is take a meter reading of the gray card in different places within the picture area, with the card facing the camera at all times. If he gets the same reading everywhere, the illumination is even; otherwise, by using fill-in light in areas that are too dark according to meter (perhaps the background), or reducing the light level in areas that are too bright by placing his lamps farther away, using weaker light bulbs, or employing diffusers, he can easily arrange a uniform illumination.

White-card reading. In situations in which the light level is so low that it is impossible to get a reliable brightness reading by any of the previously described methods, it is often possible to obtain results if a "white card" is substituted for the gray Kodak Neutral Test Card and the reading multiplied by 5 (since the reflectance of a white card is five times as high as that of a gray card of 18 per cent reflectance). White cards suitable for this purpose are, among others, the backside of the Kodak Neutral Test Card (which is white), the back of an 8″ × 10″ sheet of white enlarging paper, or a sheet of white *matte* stationery. Procedures for white-card brightness determination are otherwise identical to those previously described for gray-card light measurements.

The simplest way to provide for the five-time increase in exposure required for white-card readings is to divide the listed ASA film-speed number by 5 and set the film-speed dial of the light meter accordingly. Alternatively, the exposure time can be multiplied by 5, and if the light meter indicates, say, 1/125 sec., the shot can be made with 1/25 sec., or the diaphragm aperture can be increased by 2½ stops beyond the one indicated by the meter. Note, however, that if the subject is relatively *dark*, exposure must be further increased by ½ stop for reversal (positive) color film, and 1 full *f*/stop for negative color and black-and-white films.

How to use an incident-light meter

Start by setting the film-speed dial of the light meter as described before. p. 54 Indoors, take the light reading from a position immediately in front of the subject, with the light-collector hemisphere of the meter *aimed at the camera* (since this is the direction from which comes the light that is available for

subject illumination, even if the "actual" illumination is backlight). Outdoors, when photographing scenery or subjects relatively far away from the camera, provided the illumination at both the subject and the camera position is more or less the same, the reading can be taken from a point immediately behind the camera, with the collector hemisphere of the meter facing in the opposite direction to the lens. If overall brightness of the scene is *lighter than "average,"* the meter-indicated exposure must be *decreased* by 1 stop (or its equivalent in shutter speed) for black-and-white and ½ to 1 stop for color film. Conversely, if the overall brightness of the scene is *darker than average,* the exposure must be *increased* by the same amounts.

Bracketing

The more a photographer learns, the more he realizes that phography is not a science, and that no matter how careful the preparations and how accurate the measurements, the result is not always predictable. This is particularly true in regard to exposure, where too many potentially imprecise factors are involved: shutter speeds are hardly ever what they are supposed to be; film speeds vary with the method of development; tilting the light meter a little bit more or less when taking a reading can make a difference of 2 f/stops; film developer, depending on its degree of exhaustion, is more or less energetic; variations as small as half a degree in the developer temperature can change the color rendition and effective speed of a film; and in color photography, slides that please one photographer may be too light or too dark to satisfy another. Besides, instructions for "correct" exposure always apply to subjects of "average brightness and contrast." But what, precisely, is "average"? It is to counteract the potentially disastrous (if cumulative) influences of these and other uncertainties inherent in the photographic process that experienced photographers resort to *bracketing* their exposures; that is, instead of taking only a single shot of a specific subject, they take several—a series with different exposures under otherwise identical conditions, grouped around the one exposure which, according to the light meter (or experience), is most likely to be correct.

The number of shots in each "bracket" depends on what we might call the uncertainty factor of the situation; the more different from "standard" the case, the more shots with different exposures should be taken. Normally, in addition to the supposedly "correct" exposure, taking a second one with a somewhat shorter, and a third one with a somewhat longer, exposure should be sufficient. In more difficult cases—if subject contrast is extreme, the illumination very dim, or if backlight is involved—the bracket may have to consist of four or more different exposures.

58

Bracketing

Three views of an improvised photographic darkroom exposed 10, 60, and 300 seconds, respectively, convincingly illustrate the power of the light-accumulating ability of film. In dim light or near-darkness, the longer you expose, the more you see in the negative.

The difference between consecutive exposures should normally be 1 f/stop for black-and-white and negative color films, ½ f/stop for color transparencies and slides. Changes in exposure should be made by varying the f/stop, not the shutter speed. Exposure differences smaller than the ones suggested here are wasteful; larger ones may result in missing the best exposure. If reversal (positive) color film is used, the number of shorter-than-normal exposures should normally exceed the number of longer-than-normal exposures; if negative color or black-and-white film is used, more longer-than-normal than shorter-than-normal exposures should be made, "normal" here meaning "exposure according to light meter." Photographers who consider bracketing wasteful should remember that film is their least expensive commodity, that virtually all professional photographers bracket their exposures if at all possible, and that trying to "save" on film, at least in my opinion, is stupid. Besides, due to the often considerable exposure latitude of film, it is likely that despite minor differences in density or color, more than only one step of the bracket can be used. If this is the case, as a result of bracketing, the photographer has two or more negatives or slides instead of only one—a valuable reserve in case of accidental damage or loss, and a bonus for those who participate in competitions where slides have to be submitted.

Exposure determination with Polaroid film

When a difficult exposure must be "on the nose" the first time—perhaps because a shot can never be repeated, expensive model time is involved, or speed is of the essence, and in case of failure, waiting for the results of a second attempt is out of the question—in order to be "right" first crack out of the barrel, professional photographers often resort to Polaroid film, which, as anybody knows, yields finished prints in seconds. Here is how they proceed:

A trial shot of the scene is made with the camera loaded with black-and-white Polaroid film (special Polaroid film adapters are available for use with 4" × 5" cameras, Hasselblad, Rolleiflex SL66, and others). Seconds later, the result of the exposure is known. If satisfactory, fine; if not, a second, revised exposure is made, and if necessary, a third one, and so on, until the perfect exposure has been established. The data for this perfectly exposed shot are then used to calculate the correct exposure for the film with which the actual shot is going to be made, in accordance with the following formula: ASA speed of the Polaroid film divided by ASA speed of the film with which the final shot will be made equals the exposure factor with the aid of which the correct exposure of the final shot can be established. We proceed as follows:

60

The correct exposure for the test shot on Polaroid film which, in our case, has an ASA speed of 200, is, say, 1/250 sec. at f/16. The final shot is to be made on Kodak Professional Ektachrome Film, Type B, which has an ASA speed of 32. Now, in accordance with the formula given above, 200 ÷ 32 = 6.25, the exposure factor by which the Polaroid exposure must be multiplied to yield an equivalent exposure on the Ektachrome film under otherwise identical conditions. And since the correct exposure with Polaroid film is 1/250 sec. at f/16, the Ektachrome shot must be exposed 6.25 times as long, which means either 6.25/250 = 1/40 sec. at f/16; or, since the camera probably does not have this shutter speed, 1/60 sec. at an f/stop about halfway between f/11 and f/16; or, alternatively, 1/250 sec. at an f/stop about halfway between f/5.6 and f/8.

If this sounds too complicated (although it really is quite simple), here is another exposure-determination method with Polaroid film. The principle is this: Instead of multiplying the Polaroid exposure by a factor that represents the speed differential between Polaroid and Ektachrome films, we use a neutral density (N.D.) filter, which does not affect the color rendition, to reduce the "effective" speed of the faster film (Polaroid) until it is equal to the speed of the slower film (Ektachrome, Type B). To find the appropriate N.D. filter, we again divide the ASA speed number of the faster film by that of the slower film: 200 ÷ 32 = 6.25. Then, consulting a published table of Neutral Density Filters, we would find that the N.D. filter 0.80, which transmits 16 per cent of the incident light, has a factor of 6.29—close enough for our purposes. Now, by making our test shots on Polaroid film through an 0.80 neutral density filter, we achieve results that can be duplicated *directly* on Kodak Ektachrome film *without* the filter, because thanks to the N.D. filter, the "effective" ASA speeds of both films are now the same. All we have to do when making the final shot is to reload the camera with the Ektachrome, remove the N.D. filter, use the same exposure data as for the Polaroid test shot, and presto, a perfect exposure.

The Zone System

I deliberately omitted discussing the so-called Zone System of film exposure determination in this book because in my opinion it makes mountains out of molehills, complicates matters out of all proportions, does not produce any results that cannot be accomplished more easily with methods discussed in this text, and is a ritual if not a form of cult rather than a practical technical procedure.

Devotees of the Zone System proclaim that it offers complete tonal control. This, in my experience, is simply not true. Except for flat copy reproductions, negatives that yield optimal results without at least some amount of dodging do not exist. And if somebody claims to have produced such negatives (probably with the aid of the Zone System), I claim that a better printer could make still better prints from such negatives by holding back a little bit here and burning-in a little bit there. True, by using a paper of relatively soft gradation, anybody can make of almost any negative "straight" prints that show detail in both highlights and shadows. But the tonal effect of such prints is never what I call beautiful. Richness of tone—juicy blacks and luminous whites complemented by a wealth of intermediary grays—can only be achieved if the paper gradation is not too soft. But to yield their best, such papers require dodging. And if anybody tells me otherwise, I'd like to see him prove it.

It is for these reasons that readers who still wish to know more about the Zone System will have to look elsewhere for information.

Subjects that cannot be light-metered

Subjects whose brightness cannot be measured directly with ordinary light meters must be exposed on the basis of published tables. The data given in the following are based on suggestions made by Kodak and apply to medium-fast panchromatic film with a speed of ASA 400. If a film of a different speed is used, the data must be multiplied by one of the following factors: if the film has an ASA speed of 1600, expose ¼ as long; ASA 800, expose ½ as long; ASA 160, expose 2½ times as long; ASA 64, expose 6 times as long; ASA 25, expose 16 times as long.

Brightly illuminated downtown street scenes at night: 1/60 sec. at $f/3.5$

Brightly illuminated nightclub or theater districts and Times Square, New York: 1/60 sec. at $f/4.5$

Neon signs and advertising "spectaculars" at night: 1/60 sec. at $f/5.6$

Floodlighted buildings and monuments: 1/15 sec. at $f/2$

Amusement parks and fairs at night: 1/30 sec. at $f/3.5$

Night baseball and racetracks at night: 1/125 sec. at $f/3.5$

Indoor and outdoor Christmas lighting at night: 1/30 sec. at $f/2$

Camp fires and burning buildings at night: 1/60 sec. at $f/4.5$

Fireworks (aerial display): keep shutter open for several bursts at $f/8$

Lightning at night: keep shutter open for one or two strokes at $f/11$

62

To insure success, bracketing by one or two stops above and below the p. 58 exposures suggested here is strongly recommended. Exposures longer than 1/30 sec. must be made with the camera braced or firmly supported if unsharpness due to accidental camera shake is to be avoided.

The Magic 16

In case you have left your light meter at home or lost the exposure table that was part of the instruction sheet which came with your film, here is a formula that can save the day: In bright sunlight, for frontlighted subjects of average brightness, the normal exposure time at $f/16$ is 1/ASA speed second. For example, if you work with Kodak Ektachrome-X film, which has an ASA speed of 64, in bright sunlight the correct exposure would be 1/64 sec. at $f/16$; with Kodak Tri-X Pan film, which has an ASA speed of 400, it would be 1/400 sec. If your shutter-speed dial does not include the exact required fraction of a second, use the one closest to it. For practical purposes, there is no noticeable difference between exposures made at, say, 1/60 and 1/64 sec., 1/100 and 1/125 sec., and even 1/400 and 1/500 sec., since the exposure latitude of the film takes care of the small variations in density that would result. Besides, shutter speeds are almost never *precisely* what they are supposed to be.

Given this basis, it is very easy to calculate the approximate exposure that would be required in a different kind of light. If shooting in hazy sunlight, for example, calculate your exposure as shown above, then open up the diaphragm by ½ to 1 full f/stop; if the day is "cloudy bright, no shadows," open the diaphragm by 2 f/stops; and if the overcast is heavy or when shooting on a sunny day in the open shade, by 3 full stops.

Conversions to different f/stops or shutter speeds can be made with equal ease. For example, if the formula requires you to expose 1/60 sec. but to avoid blur you would prefer to shoot at 1/125 sec., all you have to do to adjust the exposure for this new speed is to open the diaphragm by 1 full stop and shoot at $f/11$; because in terms of exposure, 1/60 sec. at $f/16$ is the same as 1/125 sec. at $f/11$. Conversely, if you want to stop down more in order to extend the zone of sharpness in depth, perhaps to $f/22$, compensate for the resulting light loss at the film plane by doubling the exposure time; instead of 1/60 sec., you now would have to expose 1/30 sec. In other words, if you want to double the shutter speed, you must open the diaphragm aperture by 1 full stop; quadrupling the shutter speed requires opening the diaphragm by 2 full stops. Conversely, closing down the diaphragm aperture by 1 stop requires an exposure time that is twice as long; closing down the diaphragm by 2 stops requires an exposure time that is 4 times as long. And that's all there is to it.

63

COLOR

As photographers, we know that most of the color effects with which we are concerned are created by two media, which at first appear totally unrelated: *pigments* (the coloring matter in paints, inks, and dyes) and *colored light* (for example, the reddish light of sunset, which gives everything it touches a rosy glow). Actually, however, *all* colors have their origin in light and, as far as the photographer is concerned, can be controlled by the same technique: filtration. Even though some colors (for example, the pigments and dyes mentioned above) are the product of *absorption* whereas others are the result of other color-producing processes, such as *selective reflection* (all metallic colors), *dispersion* (the rainbow, the spectrum), *interference* (opals and oil slicks on asphalt), *diffraction* (the colors visible in a long-playing record), *scattering* (the blue color of a cloudless sky), *electric excitation* (colorful neon signs), or *ultraviolet excitation* (fluorescent minerals), if we take a deeper look, we find that all these color effects are caused by the same medium, light, for color and light are the same.

Color in terms of the physicist

What we experience as "color" is a psychophysical phenomenon induced by light. Its effect in terms of color sensation is the combined result of three factors:

> **The spectral composition** of the incident light
> **The molecular structure** of the light-reflecting or transmitting
> (filtering) substance
> **Our color receptors,** the eyes and the brain.

In the absence of light—in darkness—anything turns black, no matter how colorful in daylight. Objects lose their colors in darkness. This must be taken literally. It does *not* mean that their colors still exist but cannot be seen because there is no light to illuminate them. It literally means that in darkness, color ceases to exist. Why? Because *color is light.*

This is easily proven: in "white" daylight, a white sheet of paper appears white; not because it "is" white, but because the light makes it "appear" white. In the darkroom, the same sheet, held close to the green safelight used for processing panchromatic film, appears green; held next to a red safelight, it looks red. In other words, it changes color with every change in light. For the same reason, a green object examined in red light—a near-complementary color—turns black, as does a blue object seen in yellow light, or a yellow object in blue light. And any woman knows that the colors of a fabric appear

64

Bracketing, provided circumstances permit its application, is the surest way to technically perfect photographs. Why? Because too many variables—particularly inaccuracies in regard to light-meter readings and exposure, variations in processing, and preferences on the part of the photographer in regard to lightness and darkness—make it impossible *precisely* to predict the outcome of a color photograph. The "bracket" of six different exposures taken under otherwise identical conditions shown here should prove my point. Although the darkest and the lightest versions will probably be rejected by most people, each of the remaining four is a valid representation of this subject, the contrast range of which is so great that simultaneous satisfactory rendition of the lightest and darkest colors is impossible. Which do you prefer, saturated colors, even though the darkest are rendered too dark, or detail in the darkest tones, despite the fact that the lightest colors begin to wash out? If you cannot make up your mind at the moment of exposure or have difficulty visualizing the final effect, bracketing will enable you to make this important decision later when editing your slides. More about bracketing on p. 58.

65

Three types of light

As mentioned before, natural-appearing color rendition can be expected only if the type of light matches the type for which the color film is balanced.

Of the accompanying pictures, all of which were made on daylight color film, the first was made in standard daylight, the second in incandescent light, and the third in fluorescent light.

Although, to the eye, all three types of light appeared "white" and the colors of the leaves the same in each illumination, the film reacted sharply to differences in the spectral composition of these different types of light. Only where light and film matched (top picture) do the colors appear natural. But the shot made in incandescent light appears too red and "warm," while the shot taken by fluorescent light appears too green.

With the aid of appropriate filtration, of course, acceptable results could have been produced even in the last two cases. More about this on pp. 76, 80, and 169.

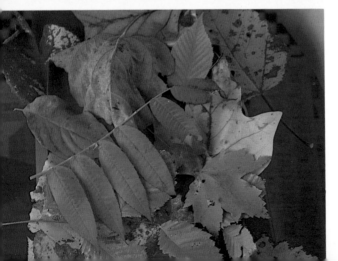

Color control through filtration

Daylight-type color film yields natural-appearing colors only in *standard daylight* (see p. 165). If daylight is not standard (see the following spread), the slide is bound to have a "color cast." If such a color cast is undesirable, it can be avoided if the appropriate correction filter is used (see pp. 76–82).

Of the two accompanying photographs, both of which were made on daylight color film, the upper one was made without, and the lower one with, a light-balancing filter (see p. 79).

Accordingly, as a result of a thin, high overcast, which filtered out many of the red-producing wavelengths of light, the upper picture has a more bluish overall tone, while the lower, filtered picture makes a warm and sunny impression.

Neither one of these two renditions is "better" than the other; they are merely different. Whether a photographer prefers a warmer or colder form of rendition is solely up to him.

"White" standard daylight Yellow, late afternoon light

The different colors of daylight

Only *standard daylight* is colorless or "white"; it can be defined as *a combination of direct sunlight and light reflected from a clear blue sky with a few white clouds during the hours when the sun is more than 20 degrees above the horizon.* And only in standard daylight illumination can daylight color film be expected to yield transparencies in natural-appearing colors.

The reddish light of sunset Blue light in the open shade

Photographed in most other types of daylight, a subject will appear to have a color cast, as illustrated above. Although the same white plaster figurine was used in all four pictures, it appears white only in the first one—the one that was made in standard daylight. In all the others, the little statue has acquired a color—yellow in later afternoon light, red at sunset, blue in the open shade. If such a color cast is not wanted, in most cases it can, of course, be "corrected" with the aid of the appropriate filter, as described on pp. 76–82. Often, however, a more interesting effect will result if the photographer deliberately makes use of such colored illumination to produce a more unusual kind of picture—the kind that better reflects the immense variety and beauty of different types of light.

The left one of these photographs was made on daylight color film, the right one on Type B. As always in cases in which we deal with a mixture of daylight and artificial light, neither one accurately represents the colors of the subject. The shot made on daylight-type film is somewhat too red and "warm," the one on Type B film too blue and "cold." Pictorially, neither one is "better" than the other and, as so often in photography, the choice is up to you.

Daylight color film, Type A, or Type B?

Normally, the choice of whether a color shot should be made on daylight color film, Type A, or Type B is easy: in daylight, use daylight color film; in incandescent light, use Type A or Type B, respectively, depending on the particular type of photolamp. But which type of film should a photographer use in cases in which daylight is mixed with artificial light?

On such occasions, the choice depends on whether he likes his slides on the "warm" or "cold" side, more toward red or more toward blue. In the first instance, he must use daylight color film; in the second, either Type A or Type B. Neither one will produce completely natural-appearing colors, not even with the most sophisticated filtration.

70

Sunlight streaming through a large window was combined here with photoflood illumination for shadow fill-in. The left picture was made on daylight color film, the right one on Type B film. Of the two, the left photograph, although somewhat too "warm," seems to create an impression more in harmony with the subject than the right one, which appears rather cold.

This picture pair was made in fluorescent light, the left shot on daylight color film, the right one on Type B. Neither one shows "true" color because, as pointed out before, fluorescent lights are basically unsuited to color photography. Filtration, of course, would have somewhat improved the color rendition, but not to the point where color would be rendered as correctly as if photographed on the proper film in the proper type of light.

Sky tone control. The left picture was taken without, the right one with, a polarizer. Note the difference in the tone of the sky. More on p. 151.

Sky tone and glare control through use of a polarizer

Glare control. The left picture was taken without, the right one with, a polarizer. Note the difference in the reflections. More on p. 147.

different in "white" daylight than at night in incandescent light, and different still in fluorescent light. Why? Because it is the light that gives an object its color, and if the light changes, so do the object's colors. Here is what actually occurs:

"White" daylight which, as we learned before, is really a mixture of all the p. 17 colors of the spectrum, illuminates an object. What this means is that waves of electromagnetic radiation emanating from the thermonuclear furnace of the sun or the incandescent filament of a photolamp make contact with the molecules of the object they illuminate. In the process of this encounter, some of the wavelengths (representing specific colors) penetrate the object's surface, are *absorbed* by the material and converted into heat. Other wavelengths (representing other colors) remain unaffected by the molecules that form the object's surface and are *reflected*. It is these wavelengths which, if they happen to meet our eyes, cause us to experience the sensation we call color.

More specifically, "colorless" ("white") light falls upon a piece of blue fabric and infiltrates the tangle of semitransparent fibers that have been impregnated with a dye. The molecular structure of this dye is such that it absorbs the red-, yellow-, and green-producing wavelengths of the incident "white" light but leaves the blue-producing component unaffected. As a result, the blue-producing wavelengths remain free either to penetrate through the material or be reflected by it. In either case, should they happen to strike the eye of a person, they would evoke in his brain the sensation "blue."

Other body colors are produced according to the same principle: Light interacting with matter undergoes a change as a result of selective absorption by the surface molecules. Some of its wavelengths are absorbed and converted into heat; others remain unaffected and free either to penetrate the material (as in color filters) or be reflected by it (as in the case of pigments, paints, and dyes). It is these "free" wavelengths of light which give an object its color.

Color in terms of the photographer

A photographer's interest in color will of necessity be determined by the kind of work he does—whether he uses black-and-white or color films. The difference can be summed up as follows:

In black-and-white photography, a subject's colors are transformed into shades of gray. Since this process is automatic, there seems at first no reason why anybody should want to interfere with it; in other words, leave it to the film. Unfortunately, such an attitude would more often than not result in unsatisfactory pictures, for two reasons:

1. Although panchromatic films are sensitive to all colors, they do not necessarily transform every color into the gray shade that corresponds in

brightness *precisely* to the degree of brightness in which a specific color appears to us. For example, all panchromatic films are unproportionately sensitive to blue and some to red. As a result, these colors would normally be transformed into gray shades that seem to us too light. While this may often be inconsequential, sometimes it is not—for instance, in landscape photography where a pale blue sky may turn out so light that its tone is almost indistinguishable from that of clouds which consequently are "lost" in the picture; or in portraiture, where red lips may appear as light as the skin—a rather unpleasant effect. In such cases, the transformation of color into shades

p. 85 of gray can be controlled with the aid of *correction filters*. These enable a photographer to render all colors simultaneously in the form of gray shades which in regard to brightness correspond to the colors they represent. How

this is done will be explained later.

2. In reality, subject differentiation is primarily based upon color contrast, regardless of the lightness or darkness of the colors involved. For example, to the human eye, red and blue form a strong contrast, even in cases where their brightness is the same. Not so to panchromatic film, which would render both colors as gray shades of similar, if not identical, brightness. This, of course, would totally destroy the feeling of contrast which, to our way of seeing, is perhaps the most outstanding quality of the combination red-blue. And while we experience this combination as something vibrant and vital, when transformed into black-and-white, the effect would be one of drabness. To avoid this kind of misrepresentation of a subject and the feelings evoked by it,

p. 85 discriminating photographers control color rendition with the aid of *contrast filters,* which enable them to render selected colors in the form of gray shades that are either lighter or darker than they would have appeared in the picture if no filter had been used. The possibility of taking corrective measures of this kind will be particularly appreciated in cases in which an uncontrolled rendition would be unsatisfactory because subject and background, although different in color, are the same as far as brightness is concerned, and would blend one into another unless graphically separated in black-and-white with the aid

of the appropriate *contrast filter.* How this is done will be explained later.

In color photography, a photographer's prime concern is normally to achieve as natural-appearing a color rendition as possible. Please note that I said "natural-*appearing*," not simply "natural." For there is a difference, the outcome of certain characteristics of our color perception, which can be summed up as follows:

One of several peculiarities of our vision is that the eye adapts itself automatically (that is, without our becoming conscious of it) not only to changes in the *brightness,* but also to changes in the *color* of the incident light (unless, of course, such changes are drastic). As a result, the light continues

to appear to us colorless, or "white," relative to the colors of the objects seen in it, even when it is tinted. Add to this another characteristic of our vision, *color constancy*—a kind of color memory that makes us see objects in the colors in which we remember seeing them most often, that is, in standard daylight—and it should not come as a surprise to hear that most people have very definite ideas about "how things should look" in color photographs. Take, for example, the notion that snow is always white (or possibly gray if dirty or in the shade), even though on a sunny day under a clear blue sky, snow in the shade actually can be intensely blue; it can also look yellow in the golden light toward evening, or rosy-red at sunset. But no, in color photographs, no matter what the color of the light at the moment the picture was made, people expect to see snow rendered white, and if this is not the case, they reject the slide as "unnatural."

A similar attitude is very common in regard to skin tones: Unless, in a color portrait, the skin is rendered precisely as it would have appeared in standard daylight, it will seem "unnatural" to most people, even though the deviation from "normal" may be due not to a substandard film emulsion or faulty development, but to perfectly natural causes like, for example, the fact that the portrait was taken outdoors in the beautifully soft light of open shade where it was illuminated exclusively by blue skylight; or made in the late afternoon when the light was golden and mellow; or in a pergola in light filtering through leaves, which, obviously, must give the face a greenish cast. "But never mind the excuses," most people would think, "a face with bluish, yellowish, or greenish overtones cannot possibly be natural,"regardless of the fact that anybody with eyes in his head could clearly see that these color shades actually existed at the moment the picture was made, if only he took the trouble to look.

The result of this attitude is that most (but not necessarily the best) color photographers strive to produce transparencies and slides that conform as much as possible to a preconceived "standard image": the appearance of the respective subject as seen in "white," or standard, daylight. To achieve this p. 165 deal—to control the rendition of color in their slides—they have two means at their disposal:

1. Films color-sensitized for three different types of light are available, which, if used in the kind of light for which they are intended, will render the subject approximately as it would have appeared to the eye in "white," or standard, daylight. More about this later. p. 76

2. Filters of different kinds are available, and with their aid the color balance of the future transparency or slide can be controlled under conditions under which neither one of the three different types of color film would yield a natural-appearing rendition. More about this later. pp. 80-82

Color control in practice

It should be obvious from the foregoing that color control is an indispensable requisite to successful photography, whether the photographer works in black-and-white or color. The "Why?" of color control thus having been resolved, the only questions that still remain would then be when to do what and how. Here are some of the answers:

p. 165

In color photography color control begins with the selection of the right kind of color film—the type that under existing light conditions will render the subject as it would have appeared in "white," or standard, daylight. In this respect, a photographer has the choice of three differently sensitized emulsions:

Daylight color films are designed to produce "natural-appearing" colors in conjunction with standard daylight, blue flashbulbs, and electronic flash. To yield natural-appearing colors if used in artificial light, these films must be used in conjunction with a *Kodak Color-Conversion Filter* in accordance with the following table:

80A if the film is going to be used in 3200 K tungsten light
80B if the film is going to be used in 3400 K photoflood light
80C if the film is going to be used in clear flashbulb light

Note, however, that use of these filters considerably reduces the listed ASA speed of the film. Specific information can be found in the manufacturer's instruction sheets that accompany the film.

Type A color film, which at present is made only for 35mm cameras, is designed to produce "natural-appearing" colors in conjunction with 3400 K amateur photoflood lamps. If shots must be taken in standard daylight, "natural-appearing" color rendition can only be achieved if a *Kodak 85 Color-Conversion Filter* is used and the exposure multiplied by the filter factor in accordance with the instructions that accompany the film.

Type B color film is designed to produce "natural-appearing" colors in conjunction with 3200 K professional tungsten lamps. If shots must be taken in standard daylight, "natural-appearing" color rendition can only be achieved if a *Kodak 85B Color-Conversion Filter* is used and the exposure multiplied by the filter factor in accordance with the instructions that accompany the film.

The Kelvin scale

The attentive reader will have noticed that the different types of photolamps listed in the previous paragraphs are preceded by a number followed

76

by the letter K. These numbers are the measure of the color ("color tempera-ture") of the respective light expressed in Kelvins (formerly degrees Kelvin, abbreviated °K) and indicate its *color temperature.* The scale according to which color temperature is measured is the Celsius scale of the decimal system, except that on the Kelvin scale, zero (called "absolute zero") equals -273 C, the lowest theoretically possible temperature in the universe, at which all thermal activity ceases.

The term color temperature is indicative of the fact that a definite relation-ship exists between the *temperature* of an incandescent body (the sun, the glowing filament of a photolamp) and the *color* of the light it emits. The color temperature of the light emitted by specific light sources is found by heating what is known as a *black-body radiator* (a hollow sphere with a circular aperture that absorbs all outside light entering into it) until the color of the light emitted by the glowing sphere matches the color of the light source under examination. At this point, the temperature of the black-body radiator is taken in Kelvins. The resulting figure is the color temperature of the examined light.

Color temperature manifests itself the moment a heated substance begins to glow. It starts as a dull-red (a piece of iron heated to approximately 750 K) and, as the temperature rises, gradually changes to cherry-red (at about 1000 K), yellow (at about 1500 K), and white (at approximately 5500 K), continuing into blue-white and blue as exemplified by the color of light emitted by the hottest stars, which burn at temperatures of 60,000 K and higher.

True and false color temperatures. Since the concept of color tempera-ture is based upon the observed uniformity in relationship between the tem-perature of an incandescent body and the color of the light it emits, it should be obvious that only incandescent light sources can have a color temperature in the strict meaning of the term. The so-called color temperatures of nonin-candescent light sources, such as the different forms of skylight listed in the table below, are, of course, not true color temperatures since the sky, ob- p. 78 viously, is not radiating at temperatures of tens of thousands of degrees C above absolute zero. Such "color temperatures" are only approximate pro-jections—empirical interpretations of the colors reflected by different types of sky in an attempt to aid the photographer in the selection of the filter that is most likely to convert the illumination at the film plane to the standard for which the color film is balanced.

Color and spectral composition. Since color temperature is based upon visual comparison between the light emitted by a glowing black-body radiator and the light emitted by the incandescent filament of a lamp, it provides a measure of color but gives no information about the spectral composition of the examined light. Now, different types of "white" light exist which, to the eye, have the same color (and therefore the same color temperature) but

differ considerably in regard to spectral composition (the relative proportions between the different colors of the spectrum, which together form "white" light). Unfortunately for the photographer, however, color films are very sensitive to deviations in the spectral composition of the incident light relative to the kind of light for which they are balanced and react with more or less pronounced color casts. For example, the color temperatures of standard daylight and light emitted by a daylight-type fluorescent tube may be identical, with the result that both appear identical to the eye. But since the spectral composition of one is quite different from that of the other, and since color film reacts strongly to such differences, the colors of the same subject photographed on the same film, once in standard daylight and again in fluorescent light, would look very different indeed.

Since the quality of color rendition is so strongly dependent on the color temperature of the illumination, it stands to reason that an instrument which measures the color temperature of light (analogous to the way a light meter measures its brightness) would be of great practical value to any discriminating photographer. In fact, such color temperature meters exist. Unfortunately, their applicability is restricted to measuring the color temperature of incandescent photolamps—lamps that have a continuous spectrum—but they give more or less erroneous results if applied to gaseous discharge tubes (speedlights) and fluorescent lamps. And they are all but valueless if used to establish the "color temperature" of light that has been filtered, scattered, reflected, or otherwise altered since its emission, like, for example, skylight. Under such conditions, selection of the corrective filter that is most likely to produce a "natural-appearing" color rendition should be based on data taken from published tables like the following, which lists both the true color temperatures of incandescent light sources and the empirically established equivalent values of light sources that have no true color temperatures.

Color temperatures of incandescent lamps

Light source	Kelvins	Decamired value
40-watt general-purpose lamp	2750	36
60-watt general-purpose lamp	2800	36
100-watt general-purpose lamp	2850	35
250-watt general-purpose lamp	2900	34
500-watt projection lamp	3190	31
500-watt professional tungsten lamp	3200	31
250-watt photoflood lamp (amateur color)	3400	29
500-watt photoflood lamp (amateur color)	3400	29
all daylight photoflood lamps (blue glass)	4800–5400	21–19

Note: These color temperatures apply only if the lamps are operated at the voltage for which they are designed.

Color temperatures of miscellaneous artificial light sources

Candle flame	1500	66
Standard candle	2000	50
Clear flashbulbs (press type)	3800	26
White-flame carbon arc	5000	20
Daylight flashbulbs (blue lacquered)	6000–6300	17–15
Speedlights	6200–6800	16–15

Color temperatures of different types of daylight

Morning and afternoon sunlight	5000–5500	19
Sunlight through thin overall haze	5700–5900	18
Noon sunlight, blue sky, white clouds	6000	17
Sunlight plus light from clear blue sky	6000–6500	16
Light from a totally overcast sky	6700–7000	15
Light from a hazy or smoky sky	7500–8400	12
Blue skylight only (subject in shade)	10,000–12,000	9
Blue sky, thin white clouds	12,000–14,000	7
Clear blue northern skylight	15,000–27,000	4

Selection of the correct light-balancing filter—the filter that, in effect, will convert a given type of incident light to the type of light for which a specific color film is balanced—can be facilitated enormously if the photographer avails himself of the **mired system.** The mired value is the reciprocal of the color temperature multiplied by 1,000,000. Division of the result by 10 then converts the mired value into the decamired value. For example:

To determine the decamired value of a professional tungsten lamp with a color temperature of 3200 K, multiply 1/3200 by 1,000,000. The result, of course, is 313, which, to be converted to the decamired value, must now be divided by 10, resulting in a decamired value of 31 for any photolamp operated at a color temperature of 3200 K.

Now, since Type B color film is balanced to give a "natural-appearing" color rendition in light with a color temperature of 3200 K, which, as we just established, has a decamired value of 31, it could be said that this particular type of film also has a decamired value of 31. For the same reason, any type of color film can be said to have the same decamired value as the kind of light for which it is balanced. The decamired values that apply to the three types of color film available at present are listed below:

Daylight-type color film	17
Type A (3200 K photoflood light)	29
Type B (3200 K tungsten light)	31

Light-balancing filters likewise have specific decamired-shift values, which, together with the factors by which they increase the exposure, are for the Kodak Filters Series 81 and 82 listed in the accompanying table. With the aid of these filters, the "effective" color temperature of any light can be

modified, with *reddish* filters, which have a positive shift value, *lowering* the color temperature of the light, and *bluish* filters, which have a negative shift value, *raising* the color temperature of the light. Whenever a filter of sufficient shift value is not available or does not exist, two or more filters can be used together, the shift value of the combination being equal to the sum of the individual values.

Kodak filters	Approximate conversion power in decamireds (precise values in parenthesis)	Exposure increases in f/stops (approx.)
Reddish		
81	+1 (1.0)	⅓
81A	+2 (1.8)	⅓
81B	+3 (2.7)	⅓
81C	+4 (3.5)	½
81D	+4 (4.2)	⅔
81E	+5 (4.9)	⅔
81EF	+6 (5.6)	⅔
81G	+6 (6.2)	1
Blue		
82	−1 (1.0)	⅓
82A	−2 (2.0)	⅓
82B	−3 (3.2)	⅔
82C	−5 (4.5)	⅔
82C + 82	−6 (5.5)	1
82C + 82A	−7 (6.5)	1
82C + 82B	−8 (7.6)	1 ⅓
82C + 82C	−9 (8.9)	1 ⅓

To find the correct light-balancing filter, calculate the difference between the decamired values of the film you wish to use and the type of light in which you wish to use it. The resulting figure is the decamired value of the filter that must be used. But should it be a reddish or a blue filter?

To find the answer, remember that reddish filters have a positive mired shift, they raise the mired value and therefore lower the color temperature; conversely, blue filters have a negative mired shift, they lower the mired value and therefore raise the color temperature. Consequently, if the light has a higher mired value than the color film, a blue filter (Kodak Filter Series 82 in the appropriate density) must be used. And if the light has a lower mired value than the color film, a reddish filter (Kodak Filter Series 81 in the appropriate density) must be used. Use of the Color Filter Nomograph on the opposite page, which is based on a chart designed by C. S. McCamy of the National Bureau of Standards in Washington, should make selection of the appropriate light-balancing filter even easier.

Light Source	Filter Needed	Film Type

open shade (blue sky)

Standard Daylight — 5800 K

yellowish (reddish) filters

86

85B
85
85C

500 Watt Photoflood — 3400 K

81A — No Filter Needed

500 Watt Profess. Tungsten — 3200 K

82A

100 Watt Household Bulb — 2850 K

blue filters

80D
80C
80B
80A

Type B

Type A

Day

To find the required filter, place a straightedge across the Nomograph connecting the type of light in which the shot will be made (left-hand column). with the type of color film that will be used (right-hand column) The correct filter can then be found at the point where the straightedge crosses the center column. Example: The combination of Type B color film and standard daylight requires an 85B filter.

81

Color-compensating, or CC, filters are a third type of filter designed to give the color photographer additional control over his medium. They are available in six (and some colors in seven) different densities in the colors red (R), yellow (Y), green (G), cyan (C), blue (B), and magenta (M). Their purpose is to effect a change in the overall color balance of a transparency or slide deliberately. Such a change may be desirable for any one of the following reasons: to compensate for accidental deviation from normal in the color balance of the emulsion of a specific batch of color film which, if uncorrected, would give the transparency an overall color cast; to rectify deficiencies of the illumination, for example, the effect of tinted plate glass when taking indoor color shots in daylight, which cannot be corrected with the aid of the light-balancing filters described before; to compensate for color deficiencies of fluorescent light; to correct the color shift that often accompanies reciprocity

p. 53 failure resulting from abnormally long or abnormally short exposure times; or purposely to alter the overall color balance of a transparency or slide to achieve a specific effect.

> **A note of caution:** Now that the reader has all the facts necessary to produce photographs in "natural-appearing" colors, I feel I have to sound a warning: In the long run, reducing everything to the same denominator can get awfully dull. As a matter of fact, oftentimes we find that it is the nonstandard color photograph which not only attracts our attention, but also satisfies our aesthetic needs because it is more beautiful and stimulating than run-of-the mill stuff. Nobody denies that it is often necessary to correct an undesirable color cast or work toward the highest degree of naturalism (for example, if photographs are made for the purpose of identifying flowers, insects, birds, and the like). But that doesn't necessarily mean that the value of *every* photograph is directly proportional to the degree of "naturalness" of its colors. Besides, most so-called color casts are "natural" insofar as they only reflect the actual color of the illumination as it appeared at the time the picture was made. So, let's go easy on "natural-appearing" color rendition and enjoy instead the never-ending variety of differently colored light that enhances our world from sunrise to sunset and also the whole range of man-made colored light indoors and at night.

In black-and-white photography color control begins with a critical analysis of the colors of the subject, with the aim of evaluating them in terms of black and white: How light or how dark will dominant colors appear in the rendition? Does the subject contain colors that should be rendered lighter, or perhaps darker, than they would normally appear in the photograph, like, for example, the pale blue of a slightly hazy sky? Is there any danger that two important colors, which appear adjacent in the picture (representing, per-

82

haps, subject and background), are so similar in regard to brightness that in terms of black and white they would be more or less identical, causing the objects to which they belong to merge in the rendition? And if two adjacent colors should be graphically separated in black-and-white, which of the two should be darkened, which made lighter? And so on.

Changes in the degree of brightness in which specific colors will be rendered in black-and-white can be accomplished with the aid of filters in different colors and densities. To be able to use them to best advantage, a photographer must know the following:

The purpose of filtration is to produce pictures that are clearer, more accurate, more effective, more interesting, more beautiful, or graphically more exciting than they would have been if a filter had not been used. Since the precise meaning of most of these terms is subject to the personal interpretation of the photographer—what one calls "beautiful" may be "exaggerated" or "unnatural" in the eyes of another—nobody can tell anybody *when* to use filters. All this or any other book can do is to tell the reader what filters can and cannot do. The rest is up to him.

How color filters work. Color filters are light modulators. Depending on p. 73 the optical properties of the dyes with which they are impregnated, they absorb certain wavelengths (colors) of the incident light and transmit others. More specifically, any color filter transmits light in its own color (and to a greater or lesser degree in colors related to its own) while absorbing (blocking) light in the color that is complementary to its own (and to a greater or lesser degree in colors that are near complementary to its own). Any two colors which, when added to one another in the form of colored light, combine to produce "white" light are called *complementary*. Such complementary color pairs are, among others:

> Red and blue-green
> Yellow and blue
> Green and magenta

For example: In black-and-white landscape photographs, the rendition of clouds and sky is often unsatisfactory because the respective gray shades are too similar. This is due to the fact that most black-and-white films are unproportionally sensitive to blue, which they consequently render too light (in our case, the brightness of the gray shade representing the blue of the sky would be too similar to that of the clouds, with the result that separation between the two would be insufficient). This deficiency can be corrected with the aid of a yellow filter which, as we now know, absorbs blue, thereby preventing it from reaching the film and making an impression on the emulsion. As a

Fontana Steel Mill, Utah. Use of a contrast filter (red) enabled me to translate color contrast effectively into black-and-white contrast, thereby enhancing the clouds.

result, those areas of the subject which were blue (here, the sky) would form a *weaker*, more transparent image in the negative than they would have if no filter had been used. This, of course, means that these areas will be rendered *darker* in the print, thereby giving the less-affected white clouds a chance to stand out boldly against a darker background. The reason why white clouds are proportionally less affected by a yellow filter than blue sky is that a higher percentage of the light reflected by the clouds is transmitted by the filter (all the colors of the spectrum, except blue, which together produce white light), while virtually all the light reflected by the sky (which is almost pure blue) is absorbed by the yellow filter and thereby prevented from reaching the film.

The degree to which color transformation into shades of gray can be controlled is governed by two rules:

1. The purer and more saturated a color, the more responsive to change through filtration. Conversely, "muddy" colors and colors that are either comparatively light (pastel shades) or very dark are less responsive to corrective filtration or do not respond at all.

2. If two adjacent colors must be graphically separated in terms of black and white, the highest degree of contrast between the two can be achieved if they are complementary to one another, the lowest if they are closely related and similar. In this sense, distinguish between two groups of related colors: on one hand, the "warm" colors—red, orange, yellow, brown; and on the other, the "cold" colors—blue, blue-purple, and blue-green.

Color filters for black-and-white photography. Two groups of filters are at the disposal of any discriminating photographer, and by using these, he can exert almost complete control over the outcome of his picture in terms of color translation into shades of gray, tonal separation, and contrast:

<div align="center">

Correction filters
Contrast filters

</div>

Correction filters are designed to change the response of panchromatic films in such a way that they reproduce *all* colors in the form of gray shades of more or less the same brightness as the colors they represent. The following table lists the correction filters together with their exposure factors, which must be used in conjunction with Kodak panchromatic films if an accurate translation of color brightness into shades of gray is important:

Illumination	Kodak filter	Filter factor
daylight	K2	2
photoflood	X1	3

Contrast filters. Whereas correction filters are designed to improve the accuracy of color translation into shades of gray, contrast filters are intended to accomplish exactly the opposite: planned falsification of gray tones in the interest of a freer, graphically stronger, and more effective interpretation of color in terms of black and white. Whereas correction filters preserve subject contrast, contrast filters, as their name implies, increase it. In specific cases, the contrast filter most likely to produce the desired result can be chosen from the following table, which lists the Kodak filters most commonly used for contrast control and color separation in terms of black and white. Wherever several filters are listed in one group, the first will have the least, and the last the greatest, effect.

Color of subject	Kodak filter that will render color lighter	Kodak filter that will render color darker
red	G, A, F	C5, B
orange	G, A	C5
yellow	K2, G, A	80, C5
green	X1, X2, B	C5, A
blue	C5	K2, G, A, F
purple	C5	B

pp. 73, 83 For reasons explained before, all color filters prolong the exposure, the factor by which exposure must be multiplied depending on the color and density of the filter, the type of film in conjunction with which it will be used, and the color of the light. The following table lists the filter factors and resulting increases in diaphragm aperture for the most popular Kodak filters used in conjunction with panchromatic film.

Color of filter	Filter designation	DAYLIGHT		PHOTOLAMPS	
		Filter factor	Open lens by f/stops	Filter factor	Open lens by f/stops
light-yellow	6 (K1)	1.5	2/3	1.5	2/3
yellow	8 (K2)	2	1	1.5	2/3
dark-yellow	15 (G)	2.5	1 1/3	1.5	2/3
yellow-green	11 (X1)	4	2	4	2
light-red	23A	6	2 2/3	3	1 2/3
red	25 (A)	8	3	5	2 1/3
dark-red	29 (F)	16	4	8	3
green	58 (B)	6	2 2/3	6	2 2/3
blue	47 (C5)	6	2 2/3	12	3 2/3
polarizer (gray)		2.5	1 1/3	2.5	1 1/3

Instead of making allowance for the necessary exposure increase by opening the diaphragm the specified number of f/stops, it is also possible to

86

Red pepper on green leaf. Left: shot through a blue filter; center: no filter; right: red filter. The high degree of control that appropriate filter selection gives a photographer over the rendition of color in terms of black-and-white is obvious.

achieve the same effect by changing the shutter speed accordingly. For example, if the filter factor is 2, instead of increasing the diaphragm aperture from, say, $f/16$ to $f/11$, the shutter speed can be doubled and the shot made at, say, 1/125 sec. instead of 1/250 sec.

If the filter factor is very high (or if a filter is used in conjunction with a polarizer, or if a close-up factor must be considered, in which case all the factors must be multiplied by one another and the exposure in turn multiplied by this new combined factor), it is often more advantageous to divide the required exposure increase between $f/$stop and shutter speed. For example, if the exposure according to light meter is, say, 1/400 sec. at $f/16$ (panchromatic film with an ASA speed of 400 in bright sunlight) and a dark-red 29 F filter with a factor of 16 should be used, instead of opening the diaphragm the required 4 stops and shooting 1/400 sec. at $f/4$ (which might make the sharply covered zone in depth too shallow) or, alternatively, shooting 1/25 sec. at $f/16$ (which might result in a blurred image due to subject or accidental camera motion), the photographer could compromise and expose, say, 1/100 sec. at $f/8$, or 1/50 sec. at $f/11$, both combinations being equivalent to the other two as far as negative density is concerned, although very different in regard to depth of field and motion-stopping power. Here, as everywhere else in photography, "know-how" must be complemented by "know-why" if the result is to be a satisfactory picture.

The psychological effects of color

Effective use of color, whether in the form of actual color photographs or color translations into black-and-white, presupposes that the photographer knows how to handle color successfully in two respects: in regard to technical requirements—the paraphernalia of color rendition, such as light and photolamps, filters, film, and the like; and in regard to aesthetic demands with emphasis on the choice and use of color.

The technical requirements for effective use of color have been pretty thoroughly covered in the preceding chapters, the aesthetic requirements not at all. The reason: This is a subject which, I feel, is already beyond the scope of a book devoted to Light and Lighting in Photography. Besides, it has already been treated to some extent in the author's book *The Color Photo Book* (Prentice-Hall), pp. 302–319, to which interested readers are referred. But to completely disregard here the aesthetic aspects of color would, I feel, be wrong. Why? Because already too many photographers are convinced that all they have to do to produce effective pictures is to master "the technique." That this is not enough is convincingly proven by any number of photographs, both in black-and-white and color, which, although "technically" unassailable, fail to make an impression. And the reason for such failure is often the nonchalant treatment of color.

The degree to which thoughtful selection and treatment of color is important can be assessed by the many associations that specific colors evoke. We speak, for example, of *red*-blooded Americans, or of a *red*-hot temper. Somebody is a *yellow*-belly or has a *yellow* streak. We also talk of a *blue* mood and a *brown* study. Somebody has the *blues*, which is more or less the opposite of "seeing *red*." And then there are "warm" colors and "cold" colors, complementary, harmonious, and related colors. And so on. This should be enough to give the reader a taste of what's in store for him should he decide to delve further into the magic and mystery of color.

But I can't help adding one more bit of concrete advice: If a photographer has decided that in the best interest of a black-and-white picture it is necessary to separate graphically two colors of different hue but more or less equal brightness, the warmer, more aggressive color should normally be rendered as a lighter, and the cooler, more passive and receding color as a darker, gray shade in the photograph, in accordance with the following table:

Warm, aggressive colors	Neutral colors	Cool, passive colors
red	green-yellow	blue-green
orange	green	blue
yellow	red-purple	purple-blue

88

DIRECTION

Color may be the most important characteristic of light as far as color photographers are concerned, but to a black-and-white photographer, the most important quality of light is *direction*. Why? Because it is the direction of the incident light relative to the subject which determines the extent and direction of the *shadows* (which in black-and-white photography play a much p. 116 more important role than in color). And as we know by now, it is the shadows that evoke the illusion of three-dimensionality in a photograph—that feeling of roundness and volume which seems to make the subject tangible and creates the impression of depth. And in conjunction with light, shadows are the means by which photographers graphically separate the subject's forms from one another, define its outline, and enliven its surface with texture. But before we can intelligently discuss the role the direction of the incident light plays in regard to the outcome of a photograph, we must first agree on a formula by which we can describe direction. I suggest we use the scheme in the illustration, which is based upon the design of a clock.

This is the principle of the light-position clock.

According to this scheme, the subject is always assumed to be positioned at the center of an enormous clock lying flat on the ground. The face of this clock is always turned in such a way that a line connecting the numerals 12 and 6, if prolonged, would intersect with the camera position. An imaginary line is then drawn between the light source and the center of the clock. This line represents the *direction* of the incident light, and the number next to its point of intersection with the edge of the clock defines its angle of incidence in the horizontal plane relative to the subject-camera axis. Accordingly, straight frontlight would be 6 o'clock light; straight backlight would be 12 o'clock light; pure sidelight could be either 3 or 9 o'clock light; and three-quarter frontlight would be either 4:30 or 7:30 o'clock light. Direction in the vertical plane would be indicated by the angle which the axis of the light beam forms with the horizontal face of the clock. Straight overhead light, for example, would be 90-degree light; light parallel to the ground would be 0-degree light; and three-quarter overhead light could now be defined precisely as, say, 45-degree or 60-degree, or 65-degree light. The position of the photolamp in the accompanying drawing would, according to this scheme, be such that the subject is illuminated with 8 o'clock 50-degree light. Could anything be more precise?

The ratio of light to shadow, as seen from the camera position, is a function of the direction of the incident light: the more frontal the illumination (the ultimate: 6 o'clock light), the larger the illuminated area relative to the total area covered by shadow; conversely, the more toward backlight (the ultimate: 12 o'clock light), the larger the area covered by shadow relative to the illuminated area. The terms referring to light direction, like *frontal* or *back*light, are always to be understood relative to the subject, *not* the photographer. Although this should be obvious, I mention it here because beginners are sometimes under the impression that "frontlight" means "light from in front of the photographer," and "backlight" light coming over the photographer's shoulder, the light source being somewhere behind his back. This, as we now know, is just the opposite of what these terms actually mean.

Conclusion: If the overall tone of a photograph should be relatively light

p. 248 (perhaps even high-key), a more or less frontal type of light must be used; if a darker impression is required, a more or less pronounced form of backlight is usually more likely to yield the desired result.

Light from different directions

Light can strike a subject from five main directions: front, side, back, above, and below, and if several light sources are involved, from several directions at once. Consequently, in regard to direction, photographers must distinguish between six basic types of light, each with its own characteristics:

90

Frontlight
Sidelight
Backlight
Toplight
Light from below
Multi-directional light

Frontlight. Any illumination between 4:30 and 7:30 o'clock (on our imaginary position clock, of course) is a form of frontlight, pure frontlight being 6 p. 89 o'clock light. The shadows which frontlight casts are increasingly less visible from the camera position the closer to the 6 o'clock position the direction of the light. The consequences of this paucity of shadow, as I mentioned before, is a feeling of flatness—frontlighted pictures seem to have little or no "depth." Whether or not this is desirable depends entirely on the intentions of the photographer, the nature of the subject, and the purpose of the picture.

Normally, it will be found that frontlight gives the best results in cases in which shadows are either unimportant or undesirable. For example:

If color is the most important subject quality and must be rendered as accurately as possible, frontlight gives the best results because the contrast latitude of color film is relatively limited, shadows increase subject contrast, and frontlight produces only few and inconsequential shadows.

If subject contrast is already high, that is, if very light and very dark colors occur simultaneously in the same subject, "flat" frontlight does not aggravate the contrast problem by casting heavy shadows (as side- or backlight would).

If the subject contains a great amount of fine detail, extensive shadows would only make an already busy situation worse.

If the subject is characterized by a graphically strong design, extensive shadows might interfere with the design and thereby weaken the impression of the picture.

If the most subtle form of modulation is required (as in certain cases of figure photography), black, extensive shadows would make the rendition "coarse."

If a high-key rendition is planned, shadows spell unmitigated disaster.

On the other hand, all the undesirable effects of frontlight appear in their most pronounced form in photographs taken with flash at the camera: chalky-white, overlit faces and foreground; and underexposed backgrounds, cavernous and dark—convincing demonstrations of the fact that the intensity of light diminishes in accordance with the inverse-square law. Needless to say, p. 16 this is the worst possible kind of light. However, in close-up photography, because light from a special type of flash at the camera—electronic ringlight illumination from a flashtube, which encircles the lens—produces true shadowless light, it can be very effective, provided, of course, a shadowless illumination is what the occasion demands.

Light from different directions

Top left: Frontlight.
Top right: Sidelight.
Left: Light from below.

Above: Backlight.
Top right: Toplight.
Right: Shadowless illumination.

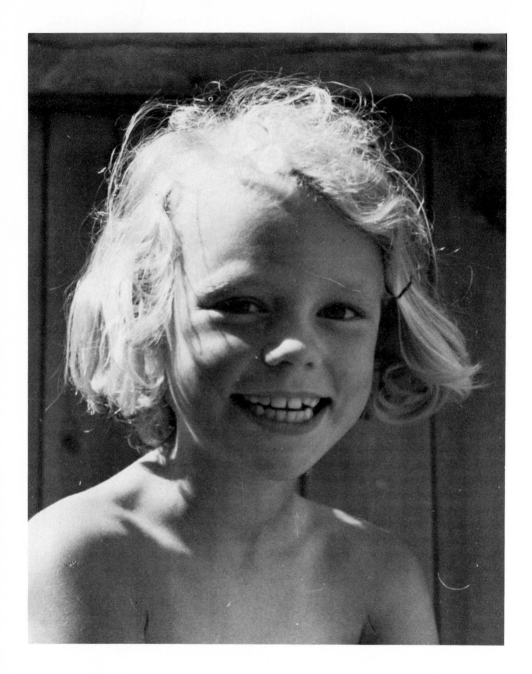

Backlight is beautiful, contrasty, graphically simplifying, aesthetically exciting, potentially extremely rewarding—and technically difficult.

Sidelight. Any illumination between 3 and 4:30 and 7:30 and 9 o'clock on our "position clock" is a form of sidelight. Although pure 3 or 9 o'clock sidelight is rarely used, sidelight in more or less pronounced form (usually as 45-degree to 60-degree light) is the most common type of photographic illumination. It produces strong and generally well-positioned shadows and thereby creates convincing illusions of three-dimensionality, volume, and depth. This form of light is almost never wrong, but because of its popularity, it is too often seen in pictures to be suitable for the creation of graphically exciting effects, although exceptions are possible. For example, very early or late in the day, low-skimming sidelight can produce enormously elongated shadows that can be rather spectacular and, if deftly handled, lead to unusual but valid pictures.

p. 89

Backlight. Any illumination between 9 and 12 and 12 and 3 (on our position clock, of course) is a form of backlight (pure backlight is 12 o'clock light). Backlight is outstanding in two respects: It is the form of light that, phototechnically speaking, is most difficult to handle; and it is potentially the most exciting, creative, and beautiful form of light.

p. 89

The difficulties stem from the fact that with backlight illumination, the light source faces the camera, and as any photographer should know, direct light striking the lens can cause undesirable halation and flare effects on the film. Although modern lens-coating techniques have made this problem less serious than it used to be, it still occurs if uncoated or single-coated lenses are used. Furthermore, since backlight is the most contrasty form of light, the contrast range of a backlighted subject or scene often exceeds the contrast latitude of the film, particularly if the shot is made in color. In such cases, unless the lighting-contrast ratio can be lowered sufficiently with the aid of auxiliary shadow fill-in illumination, the photographer must adjust his exposure in such a way that either the lighter, or the darker, areas of the subject or scene will be correctly exposed, since correct simultaneous exposure of both is impossible. In color photography, the first, and in black-and-white photography and when working with negative color film, the second, of these two choices will normally produce the better results.

p. 104
p. 103

On the other hand, precisely because of the dramatic contrast between light and shadow, backlight permits the creation of illusions of depth and space unmatched by any other type of light. And if flare and halation are used creatively to symbolize the radiance of direct light, the effect can be stunning. As a rule, beginners should avoid working with backlight until they are more adept, but in the hands of experts, it is the stuff of which masterpieces are made.

p. 125

Water, ice, and clouds—
three subjects that, photo-
graphically speaking, appear
best in backlight, because
only backlight illumination

gives sparkle to water and ice and makes clouds appear luminous. High contrast and a strong silhouette effect provide an additional bonus.

Toplight. Any illumination striking the subject at an angle between 60 and 90 degrees must be considered toplight (true toplight, of course, results when the light source is directly overhead). Normally, this is an undesirable form of illumination, particularly in portraiture where it leaves the eyes in deep shade, produces a long and ugly nose shadow and, if the person wears a wide-brimmed hat, casts a shadow that leaves an important part of the face in the shade. Outdoors, toplight is the typical midday light in summer, beloved by beginners and many amateurs because it is "so nice and bright," but shunned by experts who know that in almost any case, a lower-angle light gives incomparably better results.

pp.204-207
pp.220-221

Light from below is virtually unknown in nature (exceptions: light from a camp fire, or sun glare on water) and almost invariably creates theatrical impressions. Also, because in nature the light source is almost always above, an illumination that strikes the subject from below automatically produces unrealistic effects, fantastic, often grotesque, and always artificial. Light from below is almost an invitation to disaster and should only be used by imaginative photographers who know precisely what they are doing.

Multi-directional light is light from several sources at once. This always means artificial light. Although in studio work it is often unavoidable that several light sources must be used, the best results will usually be achieved if the impression is created that the subject or scene was illuminated by only a single lamp. In other words, all cast shadows must seem to come from only one lamp and run in the same direction; they must never crisscross one another, nor must there be shadows within shadows—for example, a primary shadow (cast by the main light) containing within its confines a secondary shadow cast by a fill-in lamp.

p. 205
Simultaneous use of two or more main lamps (or key lights) is always risky, difficult, and should be avoided if at all possible. More often than not, this can be accomplished by replacing several relatively weak lamps with a single stronger one used at a greater distance from the subject and, instead of photolamps, using reflecting boards for shadow fill-in. And when working on location (interior and factory photography), experienced photographers know that the on-site illumination can rarely be surpassed if the purpose of the photograph is to capture the particular "atmosphere" of the scene. Consequently, they may fill-in a shadow here and a shadow there but will always be careful not to destroy the overall character of the original light. And they will never rush in with powerful photolamps (as was customary not too long ago), nor will they fire away with flash in the manner of so many over-eager amateurs. Because they know that the particular "atmosphere" that gives a place distinction is largely due to its particular kind of light.

p. 108

p. 30

98

CONTRAST

As far as a photographer is concerned, contrast is the span between extremes of light and dark—the lightest and the darkest parts of the picture. If we look at the three gray scales reproduced below and analyze the differences in effect, we find that the high-contrast rendition evokes feelings of hardness, cleanliness, clarity, strength, and power, while the low-contrast rendition appears soft, soothing, and weak. This realization should provide any sensitive photographer with food for thought, particularly since both pictures are reproductions of the same original; in other words, the difference in their appearance is due to the control the photographer was able to exercise over the contrast range of his subject. But these differences in emotional appeal represent only *one* aspect of the role that contrast plays in regard to the outcome of the picture.

The other results from the fact that the contrast range of films, and especially color films, is much more limited than that of some of the subjects we may want to photograph. As a result, satisfactory rendition of both the lightest and the darkest areas of a high-contrast subject in the same picture is often

impossible, at least as far as an uncontrolled rendition is concerned. As a matter of fact, the effect of such an uncontrolled rendition can be so bad that the picture becomes worthless because the lightest subject areas blend in an undifferentiated mass of white while detail in the darkest drowns in unrelieved black.

On the other hand, particularly in black-and-white photography, the opposite situation is not uncommon either: Subject contrast is so low that an uncontrolled rendition would be ineffective and even useless. As an example, I want to point to the accompanying photographs of a piece of coral, which actually is pure white, representing a subject of the lowest possible contrast.

White coral photographed in frontlight (above) and backlight (opposite page). When subject contrast is low, backlight may be the only type of light to yield a good picture.

Realizations like these should make it obvious that a real need for contrast control exists in photography: Sometimes, the photographer may want to show his subject in picture form more contrasty than it actually is; other times, he may want to lower in the reproduction the contrast of an excessively contrasty scene. In either case, the necessity for a modification of contrast may be the consequence of either aesthetic considerations, technical considerations, or both.

Fortunately, quite a few means for contrast control are at the disposal of any photographer who cares to avail himself of them, because the degree of contrast in a photograph is the combined result of the following factors: the

100

contrast range of the subject; the character of the illumination; the type of film; the film exposure; the color filter; the type of film developer; the temperature of the film developer; the duration of film development; the contrast grade of the enlarging paper; the exposure of the print; and the duration of the print development. Any change in either one of these factors affects the contrast range of the print, but the potentially greatest influence is that exerted by the subject illumination—the only factor with which we are here concerned (readers who wish to know more about the other means of contrast control are referred to the author's book *The Complete Photographer*, where they are fully discussed).

Harsh or mellow light?

In regard to contrast, photographers distinguish between two extreme forms of light: harsh (or high-contrast) and soft (or low-contrast) illumination. Harsh light is bright to glaring and casts sharply defined deep-black shadows; soft light is mellow and easy on the eyes and casts shadows that are never very dark and characterized by more or less diffused outlines. Whether a light source produces harsh or mellow light depends on two factors:

<div align="center">

apparent size, and
brightness (intensity)

</div>

and of the two, size is more influential than brightness.

Only a bright light source can produce true high-contrast illumination, *but only if its size is relatively small*—the smaller, the higher the contrast. Smallness, here, is relative—"apparent size." The sun, for example, although actually enormous, is, as far as the photographer is concerned, only a light source of relatively small size and, consequently, a producer of high-contrast illumination. Carbon-arc lamps and spotlights are also light sources of relatively small sizes and, consequently, produce high-contrast light. But if we would place large-diameter diffusers in front of them, we would increase their effective diameters while at the same time decreasing their intensity, the result of which is that their light would then be less contrasty and the shadows they cast would be fuzzy instead of hard-edged. Bounce light (flash directed at the ceiling) and light in the open shade or on an ovecast day are so soft— and shadows so weak and ill-defined—because the effective light source is relatively enormous, being, in the first case, *not* the flashlamp, but the entire ceiling of the room; and in the second, *not* the sun, but the entire area of the sky that is visible from the subject position. Consequently, we are now ready to draw some important conclusions:

The degree of contrast of an illumination is inversely proportional to the *effective* size of the light source (the *effective* size of, for example, the sun is very small although, actually, it has a diameter of some 864,000 miles): the smaller the effective size (or the more nearly parallel the beam of light), the higher the contrast of the illumination and the more sharp-edged and darker the shadows, and vice versa.

If a high-contrast illumination is required, a bright light source with a small effective diameter must be used.

If a low-contrast illumination is required, a light source that is not particularly bright but has a large effective diameter must be used.

To convert a high-contrast light source into one that produces a less contrasty illumination, its effective diameter must be increased by means of a diffuser.

Of the light sources listed below, the first is so contrasty that if it were used in an enlarger, razor-sharp prints could be made *without* benefit of a lens; the last—illumination inside a light-tent—is completely shadowless. A light-tent, incidentally, consists of "walls" of semitransparent white paper (usually stapled to frames) that surround the subject on all sides, including top and bottom, with only a single opening just large enough to shoot through. A number of photolamps are then arranged *on the outside*, roughly in the form

p. 134

of a circle or a square, and pointed toward the center of the tent. This method illuminates the subject within with light that penetrates the paper walls, is totally diffused, and completely envelopes the subject.

Here is a list of light sources producing light of varying degrees of contrast, arranged in descending order, with the most contrasty light source at the top:

Zirconium-arc lamps
End-on ribbon filament lamps
Carbon-arc lamps
The sun on a bright, clear day
Spotlights
Small flashbulbs
Speedlights
Photoflood lamps without reflectors
Photoflood lamps in narrow, deep reflectors
Photoflood lamps in small, shallow reflectors
Photoflood lamps in medium-size reflectors
Photoflood lamps in large, shallow reflectors
Photoflood lamps in large, shallow reflectors with a still larger, spun-glass diffuser 6 to 10 inches in front of the reflector
Photoflood lamps in large, shallow reflectors 2 feet behind a diffuser consisting of a sheet of mat acetate stapled to a 3' × 3' frame
Banks of from 16 to 25 photolamps or 6 to 10 fluorescent tubes mounted in a frame 5' × 5' or 6' × 6'
Daylight from an evenly overcast sky or in the open shade
Bounce light
Light inside a light-tent

Shadow fill-in illumination

Contrast control by means of a light source that produces the required kind of light is one way; another is with the aid of auxiliary shadow fill-in illumination. This involves the use of a second photolamp, auxiliary (daylight) flash, or a reflector that throws light into the shadows cast by the main source of illumination and, by lightening them to a greater or lesser degree, reduces the contrast range of the subject. This method, of course, is applicable only if subject-to-camera distance is relatively short (maximum approximately 20 feet), as excessive distance would make the auxiliary fill-in illumination ineffective. The degree to which the shadows should be "filled-in" depends on the

intentions of the photographer and the contrast latitude of the film. To do a successful job, a photographer must know the following:

Subject contrast is the product of two factors: *lighting ratio*, and *reflectance ratio*. Here is an explanation of the meaning of these terms:

Lighting ratio is the difference between the amounts of light received by the most brilliantly illuminated subject areas and those in the deepest shade.

p. 56

Let's assume we have to make a reproduction of a painting, a flat object without depth. Prerequisite for a good job is that the illumination is perfectly even. To assure this, we take two *identical* photolamps and place them at *equal* distances from the painting, one to the right, the other one to the left, at an angle of approximately 45 degrees to the subject-camera axis. To check the evenness of the illumination, we use the Kodak Neutral Test Card already mentioned, hold it flat against the painting in different places (center and four corners), and take brightness readings with a reflected-light meter. If all readings are identical, the illumination is uniform; if not, we adjust the positions of our lamps until we get identical readings. In such a case, where all parts of the subject receive identical amounts of light, there is no difference between "fully illuminated" and "shadow" areas, as a result of which we have a lighting ratio of 1:1.

Now, let's consider a different case, one involving depth and thereby shadows, perhaps the arrangement of a portrait illumination consisting again of two *identical* photolamps, but this time, one serving as the main light, the other as the shadow fill-in light. Again, we place both lamps *at equal distances* from the subject (this is important), but one (the main light) at an angle of 45 degrees to the subject-camera axis, the other (the fill-in light) as close to the subject-camera axis as we can without the lamp getting in the way of the picture. Under these conditions, those parts of the subject which receive light from *both* lamps will be *twice* as brightly illuminated as the areas lying in the shadows cast by the main light, which are illuminated by only one lamp—the fill-in light. In such a case, the lighting ratio would be 2:1.

p. 16

However, if the fill-in light were at *twice* the distance from the subject as the main light, it would, in accordance with the inverse-square law discussed before, throw only *one-quarter* as much light on the model as the main light; or, which is the same, the main light would throw 4 times as much light on the subject as the fill-in light. In such a case, the subject areas illuminated by both lamps would receive five units of light and the shadow areas one. Consequently, the lighting ratio would be 5:1.

104

Reflectance ratio is the *difference in brightness between the lightest and the darkest colors* of the *uniformly* (lighting ratio 1:1) illuminated subject. Black and white don't count and must be disregarded when taking brightness measurements. To establish the reflectance ratio of a subject, uniformly illuminate it with shadowless frontlight. Make sure that the illumination is really even by taking check readings with the aid of a Kodak Neutral Test Card held at different positions within the picture area. If all yield identical readings, the light is uniform; otherwise, rearrange the illumination accordingly. Then, disregarding areas of black and white, which are not required to show detail in the picture, measure the reflectance of the lightest and the darkest colors by taking close-up readings with a reflected-light exposure meter. If the lightest color is, say, four times as bright as the darkest, the reflectance ratio of this particular subject would be 4:1.

Subject contrast, as I said before, is the product of lighting ratio and reflectance ratio. To go back to our example: If the lighting ratio of our portrait setup is, say, 2:1, and the reflectance ratio 4:1, subject contrast would be $2 \times 4 = 8{:}1$.

Reversal (positive) color films will yield excellent color rendition if subject contrast is average and lighting contrast does not exceed a ratio of 3:1 (ultra fussy photographers prefer 2:1). However, if the reflectance ratio is lower than average, that is, if *all* the colors of the subject are either relatively light or dark (and therefore light and dark colors don't occur in the same setup), the lighting ratio can be increased to 6:1 without the subject contrast exceeding the contrast latitude of the color film.

For black-and-white films, the maximum lighting-contrast ratios permissible for satisfactory rendition are 5:1 (conservative: 4:1) and, for subjects of lower than average contrast, up to 10:1.

The f/stop substitution method

In the field of near-distance photography (portraiture, commercial product photography, close-ups, and the like), provided that two *identical* photolamps in *identical* reflectors are used to provide main and shadow fill-in illumination, lighting-contrast ratio can be established quickly and easily by thinking of lamp-to-subject distances in terms of f/stop numbers. This system works because the inverse-square law applies equally to f/stop numbers and subject-to-lamp distances. For example, if an f/stop number is doubled, say, from f/4 to f/8, any photographer worth his salt knows that the exposure must be quadrupled if the result in terms of negative density is to remain the same. Similarly, if the subject-to-lamp distance is doubled, say, from 4 feet to 8 feet,

p. 16

the exposure must be quadrupled if the result is to remain the same since the light intensity at the subject plane is inversely proportional to the square of the distance between subject and light source. Consequently, it is possible to arrive at specific lighting-contrast ratios by thinking of the lamp-to-subject distances of the main light and the fill-in light in terms of *f*/stop numbers and comparing the differences. Accordingly, we can set up the following equations:

$$
\begin{aligned}
\text{Equality of } f/\text{stop numbers} &= \text{lighting-contrast ratio 2:1} \\
1 \text{ stop difference} &= \text{lighting-contrast ratio 3:1} \\
1\tfrac{1}{2} \text{ stop difference} &= \text{lighting-contrast ratio 4:1} \\
2 \text{ stop difference} &= \text{lighting-contrast ratio 5:1} \\
2\tfrac{1}{2} \text{ stop difference} &= \text{lighting-contrast ratio 7:1}
\end{aligned}
$$

To check the validity of this system, let's once more consider our portrait lighting scheme in which the two lamps providing the main and fill-in illumination, respectively, were placed at equal distances from the subject, say, 8 feet. Translated into terms of *f*/stops, we would then have *f*/8 for the main light and *f*/8 for the fill-in light—that is, equality of *f*/stop numbers which, according to both our first calculation and the table above, corresponds to a lighting-contrast ratio of 2:1.

For a further check and confirmation, let's go through the same routine once more, this time taking as an example our second portrait lighting scheme according to which the fill-in light is twice as far away from the subject as the main light, say, 8 feet and 4 feet, respectively. In terms of *f*/stop numbers, this would correspond to *f*/8 and *f*/4, a difference of 2 stops. According to our original calculation, the lighting-contrast ratio of this particular lamp arrangement was 5:1, and if we look up a 2 stop difference in the table above, we also find that this corresponds to a lighting-contrast ratio of 5:1. As we can see, our *f*/stop substitution method works.

We would, of course, have gotten the same result if the main light had been placed at, say, 5.6 feet and the fill-in light at 11 feet, or 8 feet and 16 feet, respectively, or X and 2X feet, because in all these cases, the difference in terms of *f*/stops would have amounted to 2 full stops; and as we know now, a 2 stop difference is equivalent to a lighting-contrast ratio of 5:1.

Working backward, we can just as easily calculate the factors by which the main-light distance must be multiplied to give us the distance at which the fill-in lamp must be placed to produce a predetermined lighting-contrast ratio; see the following table:

106

Desired lighting- contrast ratio:	2:1	3:1	4:1	5:1	6:1
Fill-in lamp distance factor:	1	1.4	1.7	2	2.2

For example: A photographer wants to make a portrait study in black-and-white with a lighting-contrast ratio of 4:1. He begins in the customary way by placing his main light first. The position of this lamp established to his satisfaction, he then measures its distance from the model and finds it to be, say, 7 feet. He consults the table above and finds, under the desired lighting-contrast ratio of 4:1, that the fill-in lamp distance factor for this contrast ratio is 1.7. Consequently, all he has to do is to multiply 7 feet by 1.7, get as a result 11 feet 9 inches, and place his fill-in lamp at this distance from the model, as close as possible to the subject-camera axis, secure in the knowledge that the lighting-contrast ratio of this setup will be exactly 4:1.

p. 205

Please note, however, that as I pointed out before, *these tables and calculations apply only if the two lamps are identical in every respect*—model type, wattage, reflector, and the like. Apart from this condition, it does not matter whether they are photofloods, flashbulbs, or speedlights. In other words, the moment one (the fill-in lamp) is equipped with a diffuser while the other one (the main light) is not, the resulting lighting-contrast ratio is no longer predictable on the basis of our calculations. In such cases, lighting-contrast ratio must be established by taking gray-card readings of the lightest and darkest subject areas, with the aid of a reflected-light meter. However, the *f*/stop substitution method does not preclude the use of, say, accent or background lamps (their functions will be explained later) since neither one affects the lighting-contrast ratio between main and fill-in light.

p. 56

p. 206

Outdoor contrast control

On clear and sunny days, subject contrast, particularly in near-distance shots and close-ups, often exceeds the contrast latitude of the film, especially in color photography. To avoid pictures in which the lightest areas are "burned out" and the darkest areas an unrelieved black, photographers have a choice of three methods of contrast control:

Frontlight. As we learned before, frontlight is "flat" light; that is to say, it casts less shadow visible from the camera position than light from any other direction, and this characteristic is the more pronounced the closer to the 6 o'clock position the direction of the light. As a result, the impression created by frontlighted pictures is generally one of lower contrast than that produced

p. 91

p. 89

by side- or backlighted subjects. (This, incidentally, is the reason why manufacturers of color films generally recommend frontlight as the type of illumination most likely to produce satisfactory color slides.) Although this low-contrast appearance is often illusory—actually, contrast between illuminated and shaded subject areas can be just as high as in sidelighted views, and sometimes even higher—the actual shadow areas, which determine the contrast range, are so small relative to the well-illuminated areas that it is the latter which dominate the impression. Because most of the picture area is evenly illuminated, contrast seems lower than it actually is, since the shadows are ineffective because they are so small. Consequently, unless other considerations take precedence—for example, perspective, the need to create depth illusions through the interplay of light and shadow; the requirements for graphically effective texture rendition; or simply the fact that circumstances preclude the possibility of using frontlight—photographing by frontlight instead of light from another direction is often the simplest way to good pictures in situations where the reflectance ratio of the subject is abnormally high.

p. 242

p. 105

Reflecting panels, which reflect light emitted by the main source of illumination into the shadow areas of the subject, provide an excellent means for accurate contrast control at subject distances of up to 10 feet. In comparison to fill-in illumination by flash (see below), they have the great practical advantage that the photographer can see what he is doing while he does it instead of being forced to wait for the finished picture before he can find out whether he did something wrong (when it is too late to take corrective measures). Panels with different reflecting surfaces provide different effects: In bright sunlight, for example, a mirrorlike surface (an actual mirror or a sheet of polished metal, such as a chrome-plated ferrotype tin) reflects virtually parallel light of nearly the same intensity as that of the sun, covering an area in the size of the mirror. However, if the light source emits nonparallel light, like a photolamp or flash, the intensity of the reflected light diminishes with distance more or less in accordance with the inverse-square law. For example, if the mirror is placed in such a way that the distance from photolamp to mirror to subject is about 1½ times as great as the lamp-to-subject distance, the light reflected by the mirror would have only about ½ the intensity of that emitted by the lamp. Matte, white reflecting surfaces reflect about 90 per cent of the incident light but disperse it over an angle of nearly 180 degrees. The efficiency of such reflectors diminishes rapidly with both distance and panel size. Normally, they should be not smaller than approximately 20″ × 30″, but for maximum efficiency, their dimensions must roughly equal the subject distance at which they will be used.

p. 108

p. 16

Other suitable reflectors are thin plywood panels covered with finely crinkled aluminum foil, pieces of cardboard, bed sheets, towels, handkerchiefs—

108

anything, as long as it can be placed at the required angle relative to the light source and the subject and is *white* (a colored surface is less effective, would reflect its own color on the subject and, if the picture is taken in color, would produce a color cast in the slide). Some excellent *fixed* reflecting surfaces are whitewashed walls, snow, and light beach sand. Although the latter is usually slightly tinted, the warm, yellowish tone it adds to the light can only enhance the glow of suntanned skin and normally provides excellent shadow fill-in for pictures of people sunning themselves on the beach.

Daylight flash. In cases in which the use of reflecting panels is inconvenient, impractical, or impossible (after all, they are bulky and normally require the services of an assistant), a good but somewhat difficult means of contrast control is flash. The difficulties stem from the fact that the effect of the flash is not easy to predict and can be checked only in the finished picture, when it is too late to correct possible errors of judgment. As long as flash provides the sole illumination, correctness of exposure (light intensity at the subject plane) can easily be calculated on the basis of guide numbers provided by the flash manufacturer (this will be discussed later). But in daylight-flash (some- p. 188 times called "synchro-sunlight") photography, where flash does not provide the only illumination of the subject, but is merely used to reduce its contrast range, the flash intensity must be related to the brightness of the primary light source, the sun. The problem here is to lighten the shadows just enough to show detail without destroying the sunlight effect. This requires judgment, a sensitive eye, and experience; too much fill-in light is even worse than too little. Shadows that are too black still appear "natural," although the effect of the picture will be harsh, but shadows that are too light create a totally false and artificial impression. Fill-in illumination that is too strong, by virtually eliminating all shadows, causes the subject to appear as "flat" as it would look in 6 o'clock frontlight and, since the range of flash is governed by the inverse- p. 16 square law of light falloff, often presents it as unnaturally light against an unnaturally dark background.

Calculating daylight-flash exposures presents a problem insofar as the light of the flash is added to that of the primary source of illumination, the sun, but, and this is the rub, added not only to the shaded areas (where it is needed), but also to the illuminated areas within the range of the flash (where it would cause overexposure unless the exposure is decreased accordingly). However, if we "decrease exposure accordingly," we decrease the exposure of *everything* within the area encompassed by the lens, including the background and the sky upon which the flash, of course, has no effect. These, therefore, would receive too little light and appear darker in the picture than desirable for a "natural-appearing" impression. So much for the problem. But what about a solution?

Unfortunately, there is none, at least none that is entirely satisfactory. The best anybody can do is to compromise between overexposing the foreground (where the flash is effective) and underexposing the background (where the flash is too weak to count). Now, since an accurate formula for daylight-flash calculation does not exist, just about everybody who uses daylight flash for shadow fill-in illumination has his own ideas. Here is one that seems to work reasonably well:

p. 89

Let's assume you want to take a group shot of your wife and children outdoors on a sunny day in direct 8 o'clock 60-degree sunlight. You use Kodachrome 25 with an ASA speed of 25, and for shadow fill-in, a speedlight that, in conjunction with this particular film, has a guide number of 40.

Start by taking a light-meter reading of the subject. Since the light is bright, you might get 1/125 sec. at f/8. Unfortunately, since the focal-plane shutter of your SLR does not X-synchronize at shutter speeds faster than 1/30 sec., you now have to convert your data accordingly and arrive at an exposure of 1/30 sec. at f/16.

Next, calculate the flash exposure. Let's assume that the subject-to-flash (at the camera) distance is 5 feet. Then, according to the formula *guide number divided by flash distance equals f/stop number*, you get 40 ÷ 5 = 8 as the f/stop that would yield a correctly exposed flash picture *if flash had been the only light source*. However, you don't want a *fully* flash-exposed picture since your primary light source is the sun and flash serves only as auxiliary fill-in illumination. Consequently, the "correct" flash exposure must now be decreased to approximately ¼ of its full strength, which can be accomplished most easily by stopping down the lens by 2 stops, from f/8 to f/16. This, however, is precisely the f/stop which would be correct for an exposure in sunlight, so is all well? No, not quite, because the (weakened) flash will still superimpose itself upon the area illuminated by sunlight and the effect would be one of overexposure. To avoid this, stop down the lens a little bit more. This is the moment when things get somewhat empirical, for how much is "a little bit more"? That depends on how light or dark you like your pictures. Some photographers say stopping down ¼ f/stop is enough, others go as far as ½ stop or farther. Only a test can decide once and for all what *you* like best.

But what happens if things don't work out so smoothly—for example, if you use a Rolleiflex and Kodak Ektachrome-X film with an ASA speed of 64? Let's say you want to photograph your children at play in bright sunlight, and to "freeze" motion, you must expose 1/250 sec. at f/8. In this case, high shutter speed is no problem, since Compur shutters X-synchronize at all speeds. The speedlight should be the same, with a Kodachrome 25 guide number of 40 which, in conjunction with Kodak Ektachrome-X, ASA 64, comes out to about 100. Accordingly, since the subject-to-flash (at the camera) distance is, say, 8 feet, the correct f/stop for a *fully* flash-exposed shot would be 100 ÷ 8 = f/12.

110

Now comes the problem: You don't want a *full* flash exposure; all you want is to fill-in the shadows, and this requires only ⅓ to ¼ of the full strength of the flash. This necessitates decreasing the diaphragm by 1½ to 2 stops, from *f*/12 to *f*/18 or *f*/24, depending on how much or how little you want to lighten the shadows. To allow for the increase in light intensity due to the flash, you also must decrease the diaphragm aperture required for a correct exposure in sunlight by approximately ½ stop, from *f*/8 to, say, halfway between *f*/8 and *f*/11. But how do you reconcile the difference between halfway between *f*/8 and *f*/11 on one side, and somewhere between *f*/18 and *f*/24 on the other—a difference of approximately 2 stops? You do this by reducing the effective light output of the speedlight with the aid of a translucent flash-shield attached in front of the reflector.

Since such shields are not available commercially, you have to make them yourself. You begin by collecting samples of different translucent material, like matte acetate, heavy tracing paper, imitation parchment, translucent plastic. Then, you establish their light transmittance: First, take a reflected-light meter reading of an ordinary white window-roller shade transluminated by the sun and make a note of the brightness value. Then, without changing the position of the light meter in regard to the window shade, hold each sample of potential shield material in front of the meter cell and note the resulting drop in light transmission. The trick is to find a material that will reduce brightness by exactly ½ stop, and a second one that reduces intensity by 1 full stop. Once you have found this material, cut yourself a few shields in the size of the speedlight reflector and fix them up so they can be attached in front of the flashtube either with tape or clips.

Now, all you have to do to bridge the gap of 2 *f*/stops between a correct sunlight exposure and a correct shadow fill-in exposure is to attach two layers of the 1-stop shield material in front of the speedlight reflector and presto, exposure by flash is reduced by 2 *f*/stops without affecting the sunlight exposure. To be on the safe side, and to make sure that all your calculations are correct (the figures you must work with will doubtlessly be different from the ones I used here), before you take your first "serious" picture, run a few tests under different light conditions and at different subject distances, using the shields that, according to your calculations, are correct. If you like the results, you are in business. Otherwise, modifying your formula on the basis of the here given instructions should be simple, and once adjusted to your satisfaction, it will work forever.

In case you think all this is too complicated, relax; it is not. Read this chapter once again more slowly so you understand the principle, prepare your flash shields, run a few tests, and before you know it, the whole procedure will seem routine.

111

The photo-journalist. Contrast and shadow combine to create a memorable picture.

A note of caution. Control implies mastery, mastery a master, and a master is someone who knows how to do something right. But doing something right does not necessarily mean standardization, because what is right in one situation may be wrong in another. What I want to say is this: Reducing the subject contrast to fit the contrast latitude of the film, while a necessity for successful rendition in one case, may be a mistake in another. For most effective presentation, many subjects demand a graphically powerful treatment where the presence of snowy whites and juicy blacks is more important than differentiation in highlights and shadows. In other words, "chalky" highlights and "detailless" shadows don't have to spell photographic disaster. On the contrary, they often are prerequisites for an effective subject presentation. Therefore, don't stereotype; don't misuse your newly acquired mastery over the contrast range of your pictures by automatically reducing the contrast range of *all* your photographs to the same denominator: normalcy. The picture on the opposite page illustrates what I mean.

SHADOW

The words *shadow* and *shade* are often used interchangeably, but to a photographer, their meanings are different: *Shadow is form*—the silhouetted image of an object, parts of an object, or a person projected onto a surface by rays of light. When, in the following, I speak of "shadow," I always mean a *cast* shadow—a shadow that has more or less sharply defined outlines and, like a caricature, represents in more or less distorted form the object to which it owes its existence.

Shade, on the other hand, *is comparative darkness* caused by an opaque and usually large object, such as a building or a mountain, cutting off the rays of direct light emitted by the sun or an artificial light source. Shade, in the photographic sense, has no particular outline; rather, it is a type of reflected, highly diffused light of very low contrast and relatively low intensity. We do not photograph "shade"; we photograph "in the shade." But we can very well photograph a shadow.

Shade

As far as the photographer is concerned, shade has three important characteristics:

> It always is relatively dark
> It is a form of highly diffused, virtually shadowless light
> It usually is colored light

113

Photographing in the shade requires longer exposures than photographing outside the shaded area in direct light—an obvious disadvantage. This, however, is more than offset by the advantage that usually within the space of a few feet, a photographer has a choice of two very different types of light:

p. 131
p. 132
direct light (which is relatively contrasty and casts well-defined shadows) and diffused light (which is a low-contrast form of illumination casting only weak shadows or none at all). In portraiture, for example, diffused light is normally preferable to direct light, and a portrait taken in the open shade will almost always turn out better than one made in the sun, especially if black-and-white film is used. For here, we run up against a peculiarity of shade, which can, but does not have to be, a disadvantage: the fact that light in the shade is nearly always colored. Outdoors on a sunny day, for example, objects in the shade are illuminated only by skylight. If the sky is blue, light in the shade is blue, too, and color pictures taken under such conditions naturally have a

p. 69
bluish cast—that is, unless the photographer exerts control by "bringing the light back to standard" with the aid of the appropriate light-balancing filter, as
p. 79
we discussed before. On the other hand, if utilized with skill and imagination, a bluish cast can become an advantage that turns an otherwise insipid snapshot into an unusual and perhaps even outstanding photograph.

p. 113
As I said before, and repeat here for emphasis, standardization (in this case, of light in regard to color) does not necessarily guarantee effective pictures. As long as a photographer knows the problems he is up against, and knows how to deal with them, he can do anything he likes, even if it is contrary to "the rules." For only he who combines knowledge with imagination and daring can hope to make great photographs.

Shadow

Shadows are such ordinary occurences that nobody pays attention to them. This is alright for "ordinary" people in the ordinary course of life, but not for photographers. Why? Because in reality, shadows change with every move we make. With every step we take, we see them from different angles, in a different perspective, in different relationships to their surrounding, and it doesn't matter whether they are ugly or significant, because in any event, the next moment they look different again or are gone. Not so in photographs. There, an ugly shadow is an ugly shadow, and no wishing, waiting, or wailing on our part can make it disappear. And an ugly shadow, like, for example, a
p. 220
badly placed nose shadow in a portrait, can irreparably ruin a picture. On the other hand, the right kind of shadow in the right place—interesting, beautiful, significant—can turn a "nothing" subject into a fascinating photograph. It is for reasons like these that experienced photographers pay attention to the shadows that appear in their pictures, because they are aware of the importance of shadows, which manifest themselves in three respects:

114

Shadows are indispensable to create illusions of space
Shadows are graphically important because of their darkness
Shadows have form and can become subjects in their own rights

Shadow as space symbol

Shadows are *ipso facto* graphic proof of depth, because only objects in three-dimensional space can cast shadows. For example: No matter how we illuminate a perfectly flat, smooth surface, we cannot raise a shadow on it, because it is two-dimensional. But the moment we bend, corrugate, or otherwise distort the surface and thereby elevate it into the third dimension, light skimming along its face will produce shadows, miniature hills and valleys will appear, and the surface will not only be three-dimensional, but will also appear as such in picture form.

Even an obviously three-dimensional object like a cube, if photographed p. 195 in shadowless light, must appear dimensionless and "flat." But if we illuminate it in such a way that it casts a shadow, and each of the three sides visible from the camera position appears in a different tone, it acquires volume and seems three-dimensional in the picture. In other words, whether the subjects we photograph appear three-dimensional or flat is largely a matter of how we handle the shadows.

More specifically, shadows are graphic space symbols that, in photography, play a multiple role: They provide the most important clues in regard to the true three-dimensional nature of the subject and are indispensable when it comes to defining shapes and forms. (Remember what I said before: p. 24 Shading creates illusions of three-dimensionality and depth.) They are essential for indicating surface texture. They help to create the contrast between p. 242 light and dark without which our pictures would be flat and dull. They promote differentiation between the various parts of a subject and clarify detail. And last, but not least, they indicate in the picture the position of the light source or sources that illuminated the subject.

Shadows differ in two respects: in regard to sharpness of outline, and in regard to depth of tone. Usually, but not necessarily, these two qualities are related insofar as a sharply delineated shadow also has a deeper and more even tone than a shadow with a more indistinct outline, which, as a rule, consists of a dark center surrounded by a somewhat lighter area called the penumbra, a kind of half-shade. But then again, the razor-sharp black shadow cast by a spotlight or the sun can be lightened to any extent with the aid of fill-in illumination. Normally, however, the more pointlike the light source, the sharper, darker, and, in regard to tone, more uniform the shadow, and vice versa. But it pays to remember that even a shadow that is hard-edged in reality can appear fuzzy in the picture if it is rendered out of focus—for

Rock carving. Depending on whether the picture is seen right side up or upside-down,

example, a shadow on a wall, which is too far behind the subject to be in focus. Shadows that appear too harsh and sharp can usually be softened with the aid of diffusers, as will be shown later.

p. 216

The size of a shadow depends upon two factors: The shorter the distance between light source and object, the larger the shadow, and vice versa. And the greater the distance between the object that casts the shadow and the surface on which the shadow falls, the larger the shadow, and vice versa. However, there are exceptions: If the light source is infinitely far away, like the sun or the moon, the size of the shadow is always the same, regardless of the distance between the object that casts the shadow and the surface on which the shadow falls. Furthermore, if the light source emits more or less parallel light (for example, a spotlight), changing the distance between subject and lamp has relatively little effect on the size of the shadows.

The direction of shadows. That shadows always point away from the light source to which they owe their existence is, of course, well known to all; less well known are the photographic implications. In this respect, most important to photographers is the fact that the direction of the shadows in a photograph reveals the location of the light source, which can be found by drawing an imaginary line between some characteristic part of the subject and its shadow counterpart. The light source lies, then, on the extension of this line, beyond the subject. Visualizing this line needs a little bit of imagination and a feeling for three-dimensionality since the connecting line in the picture is only a projection of the real line, which lies in space—in front of the print if the illumination is essentially frontlight (3 to 9 o'clock light on our direction clock), behind the print if it is a form of backlight (9 to 3 o'clock light). This

p. 89

possibility of establishing the position of a light source should be of interest particularly to the student photographer who wishes to work out the lighting scheme of a picture that interested him in the hope of gaining some useful information for his own work.

Since the subject always lies in a direct line between the light source and its own shadow, it acts, figuratively speaking, as a fulcrum in regard to possible movements of the light source. In other words, if the light source moves

the carving appears in low or high relief. See also text and pictures on pp. 24-25.

(the sun) or is moved by the photographer (a photolamp), the shadow always pivots around the subject in the opposite direction. Outdoors, since the sun always moves from left to right, shadows always move from right to left, a useful bit of information for any photographer who would like to know where the shadows of a building, a tree, a monument, and the like would fall some time later in the day. And indoors, if we move a lamp toward the right relative to the subject, the shadow it casts will move to the left, and vice versa. Likewise, if we raise a photolamp (or the sun climbs higher in the sky), the subject's shadow on the ground will get shorter or, if it falls upon a wall, will appear at a correspondingly lower level, and vice versa.

All shadows cast by the sun belong to the same set, are parallel, and point in the same direction. In photographs taken in daylight, the apparent convergence of actually parallel shadows is an optical illusion caused by perspective. Because the most "natural" of all light sources, the sun, casts only a single set of shadows, photographers working with artificial light involving the use of several lamps can expect "natural-appearing" lighting effects only if all the shadows in their pictures seem to be cast by the same light source. In other words, shadows that run in different directions, cross each other, or are superimposed one upon another, being contrary to nature, create unnatural and normally unpleasant effects.

Because the sun is the standard by which we judge all light, and sunlight always comes from above, we naturally expect to see the shadows always fall below the level of the subject. If the situation is reversed (as is easily done with photolamps), the effect will invariably be unnatural and often also confusing. For example, if a bas-relief or similar subject is illuminated by raking sidelight to emphasize its eminences and depressions, and if the photograph is viewed in such a position that the light seems to come from the upper edge p. 25 of the picture, the effect will be natural and the subject will appear as we expect to see it. However, if we turn the picture upside down so that the light seems to come from below, we will still get the bas-relief effect, but this time in reverse: Areas that actually were elevations will now appear as depressions, and actual "valleys" now seem to be "heights."

117

Shadow as darkness

Independent of their importance as symbols of three-dimensionality, shadows are valuable means of graphic expression because of their depth of tone. Again and again, we find that shadows are the catalyst which enhances other picture elements simply by being there. White, for example, never looks brighter than next to black, and it is often shadow that provides the blackness. Likewise, the luminosity of any color is automatically enhanced by juxtaposition with black—a fact well known to any aesthetically aware photographer. To prove this to yourself, place a color photograph or high-quality color reproduction from a magazine on a large sheet of black cardboard (or other black surface), which, broadly showing on all four sides, creates the impression of a frame, then repeat this with a white cardboard (or background) and analyze the differences in effect: The black frame will seem to make the picture brighter and the color more luminous; the white frame, darker and duller. The conclusion that can be drawn from this experiment is obvious: By partly or entirely surrounding the subject proper of a color photograph with dark auxiliary subject matter, the picture can be made to appear more colorful than it would without this kind of "frame." Suitable dark picture components are, among others, tree trunks, branches, and foliage; a passage, window-frame, or doorway; iron grill work; silhouetted figures in the foreground rendered dark by keeping them in the shade.

Darkness—shadow—in combination with lighter picture elements creates the graphic contrast necessary to evoke sensations of strength and power. (The opposite, lack of graphic contrast, calls forth softer, weaker moods.) Occasionally, this strength inherent in darkness, or shadow, can even be used as the theme for a rendition—for example, when a silhouette forms the subject proper of a photograph, a powerful form which, by sheer weight of darkness, dominates the entire picture. In addition to strength and power, darkness symbolizes other intangible qualities like masculinity, drama, old age, poverty, suffering, hopelessness, and death (lightness, on the other hand, symbolized by light—the opposite of shadow—is suggestive of femininity, youth, happiness, joy, and life). Darkness is also the most effective means for creating serious, somber, or mysterious moods. The epitome of darkness is shadow.

Shadow as form

A shadow is the projection of the outline of a (usually) opaque body onto a surface. If the surface is flat and both object and surface are at right angles to the axis of the beam of light, the shadow, apart from possible changes in size, will be undistorted. In all other cases, it will appear more or less distorted—a caricature of the object to which it owes its existence. But similar

118

Shadow as form. On an overcast (shadowless) day, there would have been no picture.

to a caricature, which often is more expressive than a "true" representation of the depicted subject, so a distorted shadow can often create particularly expressive and otherwise unachievable effects.

Outdoors, the most expressive shadows occur very early or late in the day. Unlike dilettantes and beginners who like to photograph around noon "when the light is nice and bright" and shadows are short, experienced photographers are most active when the sun is low in the sky and long, slanting shadows abound. Examples of the expressive power of such shadows can be found in bird's-eye views (taken from a window or an overpass) of people in the street rushing home after work in which weirdly distorted shadows, grotesquely elongated by a low-riding sun, express with almost surrealistic intensity the hectic pace of city life. And one of the most memorable photographs I've ever seen owed its impact to shadows. This was a low-level aerial shot of a fire-bombed German city made during World War II by Margaret Bourke-White. It was taken straight down in the late afternoon in such a way that the still standing walls of the roofless buildings, seen on edge, were all but invisible. What "made" the picture was the shadows of these shattered empty-windowed walls which, forming a black-and-white pattern of hollow squares, created the vision of a macabre "city of shadows" that in an unforgettable way summed up all the senseless destruction, brutality, and horror of war.

Shadow, darkness, outline, and silhouette—graphically power-
ful picture elements based on light—combine to symbolize the
powerful effect of the sculpture of Alexander Calder and lead to

120

a good rendition of the master himself. Without the interesting shadow, the left photograph would have been ordinary; without the silhouette effect, the right one would have been insignificant.

121

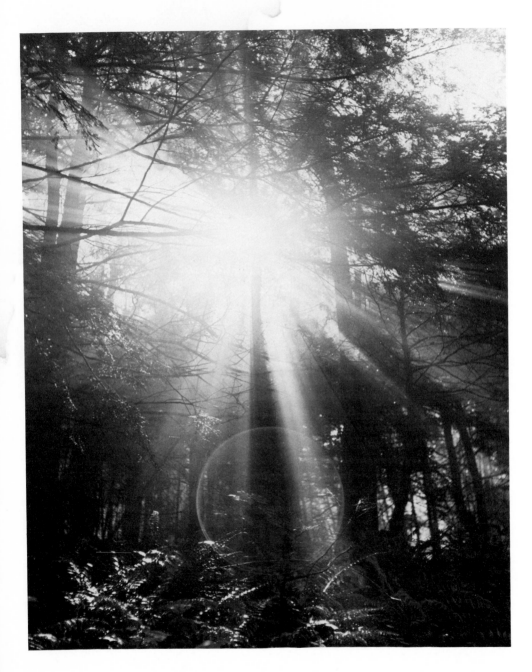

Flare and halation, creatively used, symbolize the glory of radiant light.

IV. The Forms of Light

Without in any way wanting to belittle the importance of the quantitative approach to light—how much light, how bright?—which obviously is a prerequisite for correct exposure, and which, in turn, is the starting point for any technically perfect photograph, I now have to come back to my contention that *this approach must be complemented by a qualitative assessment of light* if the result of a photographer's endeavor is to be not merely a technically perfect photograph, but also an *effective picture.* In other words, the question "how bright is the light?" must always be preceded by the question "what kind of light?" For unless light is of the right kind—suitable to bring out specific *qualities of the subject* or implement specific *ideas of the photographer*—the shot, at least in my opinion, is not worth making because, under unsuitable lighting conditions, not even the most accurate exposure can produce a worthwhile picture. While this may be news to beginners, it is "old hat" to experienced photographers who, in this respect, distinguish between the following different forms of light:

Radiant light
Direct light
Diffused light
Shadowless light
Reflected light
Polarized light
Filtered light
Natural light
Artificial light
Continuous light
Discontinuous light
Light from pointlike sources
Light from arealike sources

RADIANT LIGHT

As a photographer, I feel it is important to distinguish between two forms of light that most people lump together: radiant light, and direct light. Radiant light is the kind of light we see when we look directly into a light source;

direct light is a form of illumination. Outdoors on a sunny day, for example, we would experience *radiant light* if we looked directly at the sun (which, incidentally, can seriously damage the eyes and is mentioned here only as an example; don't actually do it). But everything else we see—the landscape, the buildings, the people, the trees—unless they are in the shade, would be illuminated by *direct light*.

The reason why I feel it necessary to make this distinction is this: In a photograph, the brightest tone we can produce is white. As a result, in picture form, there would be no difference in regard to tone of rendition between, say, a street lamp at night and a white building, irrespective of the fact that the first gives off *radiant light* while the second is illuminated by *direct light*. In both cases, the images of the street lamp and the building would appear in the identical tone: ordinary white. This, of course, in no way corresponds to the actual experience which, in the case of the street lamp, was one of dazzling light, and in the case of the building, of the "color" white.

Photographers who, in the interest of greater efficacy of their pictures, wish to be specific and let the viewer know whether radiant or direct light was involved in the depicted scene can do so by using different forms of rendition for these two different forms of light. And since they cannot render radiant light in a brighter *tone* (because they cannot produce anything that is brighter than white), they must render it in a different *form*. This requires the use of symbols.

Traditionally, the symbols of radiance have always been the halo and the star. Centuries ago, artists wishing to express in their paintings the feeling evoked by radiant light invented the multi-pointed star—a figment of the imagination that has no counterpart in reality because real stars appear to the eye as tiny dots of light. They also surrounded the heads of holy personages and the wicks of burning candles with halos—disks of glowing luminosity that effectively symbolize a softer form of radiant light. Such halos do not exist in nature but are the product of an artist's fantasy.

Photographers who wish to express in their pictures the radiance of light in a form that is more significant than a mere blob of white, are daring enough to leave the beaten path and, regardless of criticism by traditionalists, go their own way have a choice of several techniques by means of which to symbolize the brilliance of radiant light:

Flare and halation
Small diaphragm apertures
Wire screens
Diffusion devices
Out-of-focus rendition
Old-fashioned glass plates

Skiers, by Ronny Jaques. Lens flare effectively suggests the almost unbearable brilliance of the sun. Imaginatively used, a fault can become an asset.

Flare and halation

Traditionally, it is against the rules of good photography to permit rays of direct light to enter the lens because this may cause undesirable effects on the film in the form of flare and halation. Flare manifests itself in photographs in the form of more or less sharply defined, circular, pie-, or crescent-shaped and

125

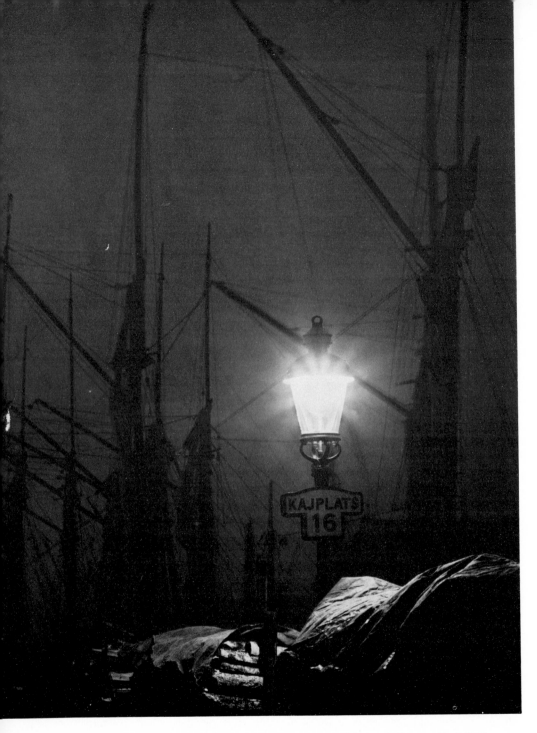

Quay in Stockholm. Diaphragm star (p. 234) symbolizes radiant light.

126

occasionally polygonal light spots; halation manifests itself by laying a veil of light over parts or all of the image, causing loss of contrast or color saturation in the picture. Though normally these are rightfully considered faults, if used in the appropriate place, these faults can become expressive means for graphically symbolizing the brilliance of radiant light. Although they have no substance in reality (and the form in which they will appear in the picture is therefore unpredictable), these light phenomena correspond closely to the sensations we experience when confronted with a source of dazzling light: We get temporarily blinded, we see nonexisting spots and shapes in front of our eyes, things get blurred and hazy; in short, the image seems dissolved in light.

Photographers wishing to produce equivalent effects in their pictures must not hesitate to shoot straight into the light, must include in their views sources of direct light, no matter how bright, and be prepared for surprises. For results, as I said, are unpredictable and depend on a variety of factors, among them, the construction and coating of the lens; the size and shape of the diaphragm aperture; the brightness of the light source; the position of the light source within the picture; the duration of the exposure; and the antihalation protection of the film. And where some photographers get the strangest (and most fascinating) light effects, others, under apparently (but not really) identical conditions, get very little or nothing at all. This technique is a challenge to any creative photographer who is willing to gamble the loss of a piece of film against the chance of making a terrific picture.

Small diaphragm apertures

In photographs that include bright, pointlike light sources, such as distant street lamps at night, an interesting phenomenon can often be observed: Each lamp is rendered in the form of a many-pointed star. The rays of these stars are caused by reflection of radiant light from the edges of the diaphragm blades and occur only if apertures as small as f/16 or smaller are used, but are also affected by the duration of the exposure: the longer, the larger the stars. Although not precisely predictable, this method of light-symbolization has the following advantage over the one involving wire screens: except for small, bright sources of light, the rest of the picture is unaffected. Diaphragm-created stars can be particularly effective in photographs of sun-glittering water, distant street lamps at night, and pictures that include the sun.

Wire screens

A piece of bright, bronze, or copper flyscreen placed in front of the lens while taking photographs of pointlike light sources will cause them to be

Star patterns produced by crossed flyscreens. See also pp. 234-235.

rendered in the form of four-pointed stars. To produce eight-pointed stars, two such screens in close contact, one rotated against the other by 45 degrees, must be used. The size of the resulting stars increases with exposure time. Although wire screens have the advantage in that results are rather predictable, a potential disadvantage is the fact that they act as diffusers with the result that the image is never really sharp. However, considering the type of photograph for which this device is normally used—glamorizing shots of merchandise in advertising, idealized portraits of women, and city scenes at night in which documentation is less important than mood—the resulting slight degree of blur and halation is usually inconsequential and may even enhance the picture.

Diffusion devices

A photographer has two ways in which he can surround bright areas in his photographs with more or less pronounced halos or seams of light suitable to symbolize the radiance of light: diffusion disks and soft-focus lenses. Characteristic of both is that they affect bright picture areas more than darker ones, which only appear slightly softened but otherwise normal.

128

The Rodenstock Imagon lens turns bright lights into flowerlike patterns.

Diffusion disks are flat, filterlike devices of colorless optical glass with a number of concentric impressions that disperse bright light but leave the darker areas of the image relatively unaffected. They are most suitable for photographing high-contrast and backlighted scenes with brilliant highlights, glare and reflections, sun glitter on water, and pointlike sources of radiant light; but they also give good results in conjunction with subjects such as sparkling jewelry, highlighted hair in portraits, and edge-lighted silhouettes of almost any kind.

Soft-focus lenses, which today have largely been replaced by diffusion disks, create virtually the same effects as these devices, with one exception: the Rodenstock Imagon lenses, which, however, are available only in focal lengths suitable for use with 2¼″ × 2¼″ SLR and larger cameras. These remarkable lenses are equipped with variable sievelike diaphragm stops that permit the photographer to adjust the degree of diffusion from sharp to very soft in accordance with his intentions and the requirements of the subject. Small, sharp light sources and highlights, for example, can be made to appear in flowerlike shapes—luminous centers surrounded by petals of light. Application of these lenses, which give particularly interesting results when used for making idealized portraits of women, is, of course, rather limited.

129

Photographed out of focus, a waterfront street becomes a necklace of light.

Out-of-focus rendition

By deliberately throwing the image of a distant, pointlike light source out of focus, a photographer can increase its diameter by almost any amount. Occasionally, this technique of deliberately unsharp focusing provides an effective means for graphically symbolizing the radiance of light. In shots of city scenes at night, for example, out-of-focus rendition transforms ineffective dots of light into softly glowing disks, which can convert a prosaic row of street lamps into a necklace of pearls, transforming an ordinary scene into a vision from a fairy tale. Since the rest of the picture would appear equally blurred, application of this technique is limited. But in cases in which a photographer's intention is not documentary, but the creation of an unreal, dreamlike mood, and a multitude of small but brilliant sources of radiant light are involved, out-of-focus rendition may be just the technique he needs.

Old-fashioned glass plates

These can be used only in old-fashioned plate cameras, which at one time produced the most beautiful halos of all. Today, glass plates are employed only for lantern slides, in photoengraving, and for certain scientific purposes, and, as far as the amateur is concerned, are very hard to get. However, experimentally inclined photographers with access to an old plate camera with cassettes may want to give it a try.

130

DIRECT LIGHT

Direct light is invisible. If this sounds fantastic, consider this: If we look at a light source, we see radiant light. If we contemplate an object illuminated by this light source, we see reflected light—the light reflected by the object. Therefore, to be accurate, we should hereafter only talk about reflected light, but the term "direct light" is so much in use that I'll stick to it, provided the following is understood:

Strictly speaking, direct light is light that has not been reflected, refracted, filtered, scattered, or otherwise altered since emission from its original source. It therefore is *predictable* insofar as its spectral composition is constant and identical to that of its source, an aspect which, as we have heard, is of great importance in color photography. The light emitted by the gaseous discharge tube of a speedlight, for example, is always the same in regard to its color and, if used in the form of direct light, will always give the same result as far as color rendition is concerned. But if we would direct this same speedlight against a ceiling and use it for "bounce light," its light, before striking the subject, would have been reflected and, possibly, modified in regard to its spectral composition by the ceiling. The light which then illuminates the subject is therefore no longer direct, but reflected and potentially unpredictable in regard to its spectral composition, a fact that might result in a color cast even in cases in which the color temperature of the flash is the same as that of light for which the color film is balanced.

p. 145

Similar considerations apply to many other forms of direct light. The direct light of a photolamp used at the proper voltage, for example, is constant over the greater part of its life and therefore predictable; that of the sun is not. Why? Because sunlight, in addition to always being supplemented by light reflected from the sky, the clouds, the ground, is not necessarily direct in the strict sense of the term, but often filtered or scattered by the dust particles and water droplets of the atmosphere, which we perceive as haze, smog, or overcast. As far as daylight-type color film is concerned, only a single one of the many forms of sunlight qualifies as "daylight" in the strict sense to the color photographer and guarantees natural-appearing color rendition: *standard daylight*, which is defined as *a combination of direct sunlight and light reflected from a clear blue sky with a few white clouds when the sun is more than 20 degrees above the horizon*. This kind of daylight has a color temperature of approximately 6000 K and a decamired value of 17.

p. 79

Direct light, therefore, as we understand it here, is *light that casts clearly defined shadows*, whether it is *truly* direct or filtered, for example, light from a spotlight equipped with a colored gel—a filter in the form of a sheet of

131

colored gelatin. And since the outstanding characteristic of direct light is neither brightness nor color but the fact that it casts shadows, it always is a relatively contrasty form of light.

Actually, "pure" direct light exists only on the moon or in space, because what we loosely call direct light is always a mixture of direct and reflected light. Outdoors on a clear day, for example, direct light is unobstructed sunlight. However, if this were the only kind of illumination, the shadows it casts would have to be pure black since they represent areas inaccessible to, and therefore not illuminated by, direct light. The fact that this is not the case, that shadows may be very dark in reality but are never pure black (as they can be in photographs), is proof that another type of illumination is involved: reflected light—light reflected from the blue sky, the clouds, the ground, and so on. The relatively greater the proportion of reflected light to direct light, the more transparent the shadows and the less contrasty the illumination, and vice versa.

One of the most contrasty forms of direct light is sunlight on a cloudless day. Under extreme conditions, with the sun more or less overhead, the ratio of intensity between sunlight and shade—the area illuminated only by light reflected from the clear blue sky—can be as high as 16:1, a difference of 4 f/stops. Under such conditions, shadows would be extremely dark. Standard daylight—sunlight supplemented by skylight and light reflected from white clouds—has a contrast ratio of approximately 6:1, while the contrast ratio of hazy sunlight can be as low as 2:1 and even 1½:1, a fact that makes hazy sunlight the ideal illumination for outdoor portraits.

pp. 104-105

In regard to specific subjects, the decision of whether or not direct light is the most effective form of illumination depends on the importance of shadows. Although, in the majority of cases, shadows are of minor importance, in some cases, they are indispensable for satisfactory rendition, for example, whenever texture is involved; in other cases, they interfere with the clarity of presentation and should be avoided. For shadows, obviously, can clarify as well as obfuscate. Whether they do one or the other is a decision a photographer must make every time he takes a picture—a decision that must take into account the nature of the subject, the purpose of the photograph, and the mood he wishes to create.

p. 113

p. 242

DIFFUSED LIGHT

Diffused light is direct light that has passed through a diffusing medium with the result that it is no longer more or less directional but scattered.

132

Consequently, diffused light casts only weak and ill-defined shadows or none at all, its spectral composition may differ from that of its source, and color pictures taken in it may have a color cast.

Outdoors, the light will be increasingly diffused, the more the sun is veiled by haze or clouds; light on an evenly overcast day with the cloud layer so dense that the sun is completely hidden, and light on a sunny day in the open shade, is almost totally diffused and virtually shadowless.

Similar effects can be created on sunny days by erecting between the sun and the subject a diffusing screen that is large enough to cover the entire picture area. Suitable materials for such screens are old bed sheets, cheesecloth, muslin, and sheets of colorless translucent plastic (if necessary, applied in double thickness), which can be suspended from ropes strung between poles. With little work, a terrace or balcony can thus be transformed into a near-ideal outdoor portrait studio providing a highly desirable form of well-diffused light.

Indoors, except for spotlights, any kind of photolamp can be converted into a source of diffused light by equipping it with a diffuser. Suitable diffusing materials are spun-glass cloth, tracing paper, cheesecloth, muslin, ground-glass, translucent plastic, and the like. The most perfect diffusing material is a sheet of flashed opal glass; this, however, considerably reduces the brightness of the light source.

I previously mentioned that the degree of contrast of an illumination is p. 102 determined by the effective diameter of the light source—the larger the diameter, the less contrasty (directional) and more diffused (scattered) the light. Consequently, in order to be able to reduce contrast, a diffuser must increase the effective diameter of the light source which, in the case of a photolamp in reflector, is the diameter of its reflector. From this it follows that an effective diffuser must be *larger* in diameter than the reflector; it also must be attached to the lamp in such a way that it is so *far out in front of the reflector* that the light bulb can illuminate it in its entirety. A diffuser clamped to a photolamp in contact with its reflector reduces its intensity but hardly diffuses its light.

One of the best sources of softly diffused light is a speedlight equipped with an umbrellalike reflector consisting of aluminized cloth. The flash is aimed at the inside of the umbrella and from there is reflected onto the subject. A list of photolamps producing light with different degrees of diffusion can be found on p. 103.

Low-contrast, more-or-less-diffused, light is particularly well suited to color photography because it matches the relatively limited contrast range of the film. However, as pointed out before, a diffuser may affect the color balance of the light, and only tests can reveal whether this is the case, and if so, in which direction and to what extent.

SHADOWLESS LIGHT

Shadowless light is the ultimate in diffused illumination—light that so evenly envelopes the subject from all sides that shadows can no longer exist because all hollows, nooks, and crannies have been completely "filled-in" with light. In such a case, the lighting ratio would be 1:1, with all parts of the subject receiving identical amounts of light.

Shadowless light is a rarely used form of illumination; however, when needed, it is invaluable because nothing else produces similar results. Its main application is in the field of commercial photography for satisfactory rendition of objects having a mirrorlike surface, primarily polished metalware and glazed ceramics. The idea is to replace otherwise objectionable reflections with reflections of broad areas of softly diffused light, which aid definition instead of confusing it.

The light-tent is the most perfect device for providing shadowless illumination. It is a kind of housing that either completely encloses the subject or at least surrounds it on all the sides visible from the camera position. Its walls and ceiling consist of a framework covered with a white translucent material, like tracing paper or white polyethylene sheeting; there is an aperture in one side through which to poke the lens since the camera is normally positioned on the outside. Illumination is provided by a number of photolamps placed at strategic positions around and above the structure, transluminating its walls and ceiling and illuminating the subject within with totally diffused light. Should this kind of light prove to be too monotonous, reflections more interesting than those of the transluminated walls can be introduced by attaching pieces of black paper or sheets of colored acetate or gelatin, cut into suitable shapes, in appropriate places to the insides of the tent.

If subjects too large to fit inside a light-tent must be photographed in shadowless light, another way of creating a virtually shadowless illumination is to place the subject on a large sheet of white seamless background paper, then point a number of high-intensity photolamps against the walls and ceiling and completely saturate the studio with reflected light. If color film is going to be used, the walls and ceiling must be white to avoid a color cast; if black-and-white film is used, walls painted in light pastel shades, as often found in ordinary rooms, will do almost as well. In the latter case, color photographs can still be taken if the effect of the colored walls is compensated for by using a color-compensating filter the shade of which must be determined by test.

p. 82

134

Above: Schematic sketch of one type of light-tent; see also pp. 254, 255.
Below: Lighting arrangement for shadowless illumination; see also p. 225.

20"

30"

8"

Large rectangular ventilation
opening in bottom

Schematic view of a light-box; see also pp. 225-227.

The light-box. Whenever it is desirable to present the subject in the clearest possible form, a perfectly neutral background is usually required. Normally, such a background consists of two parts: a horizontal surface or base on which the subject stands, and a vertical surface or background behind it. In the interest of effective presentation, neither one should be marred by the shadow cast by the subject. Now, a background shadow can usually be p. 224 avoided by keeping a sufficient distance between subject and background, but elimination of a base shadow presents a problem, which can only be solved in one of two ways: either by retouching the transparency or print, which is expensive, time-consuming, and requires an expert; or by photographing the p. 225 subject on a light-box.

In principle, a light-box is a wooden frame housing a number of lamps covered on top with a diffuser, which provides the base for the subject. In practice, a few refinements are usually added. The lamps, for example, are not ordinary household bulbs, which are relatively ineffective, but fluorescent tubes, which have the following advantage over incandescent lamps: They produce virtually no heat. Nevertheless, it is always advisable, and in case incandescent lamps are used, absolutely necessary, to cut a few large openings in the sides of the box frame to provide for ventilation; for the same reason, the frame of the box should be open at its base, be equipped with short furniture legs, and must not be made too low or too tight for the

number of lamps it must accommodate. Photographers who worry about un-suitable color temperatures can relax; this problem is irrelevant here because the luminous surface of the light-box will always appear "burned out" in transparencies and pure white in prints. The accompanying sketch shows the dimensions of a light-box the author built for his own use.

Although commercial light-boxes usually come equipped with a sheet of groundglass, I strongly recommend instead a sheet of flashed opal glass. The latter makes a much better diffuser, completely eliminating any "hot spots," which, unfortunately, are only too prominent in the case of groundglass. The only disadvantage of flashed opal glass relative to groundglass is its shiny surface, which, occasionally, may reflect those parts of the subject which are illuminated from below. The simplest way to avoid this possibility is to place a separate sheet of groundglass, matte side up, on top of the flashed opal glass. The thickness of the flashed opal glass depends on the size of the box. For light-boxes up to 2′ × 3′, glass ⅛- or 3/16-inch thick is sufficient; larger boxes require ¼-inch glass. Most suitable for light-boxes is what is known as *double-flashed* opal glass, which has a translucent coating of white glass on both sides. Before buying a sheet of flashed opal glass, hold it up to a strong light and examine it for defects; streaks in the coating would show up later in the picture and make it useless. Flashed opal glass made especially for photo-graphic purposes is manufactured by Kodak and can be ordered through photo stores.

Outdoors, virtually shadowless light is provided by an evenly overcast sky when the cloud cover is so thick that it completely obscures the sun. Such days, which most amateurs consider a total loss, photographically speaking, are treasured by experts who have to shoot very complex subjects, because in such cases, shadows would only compound the complexity of an already diffi-cult situation. The photographs on the following spread of a medieval church portal and a New York street scene should prove my point.

REFLECTED LIGHT

As photographers, we must distinguish between three forms of reflected light: the kind that produces sensations of color; the kind that is responsible for mirror images, reflections, and glare; and the kind we use for shadow fill-in and shadowless illumination in the form of indirect light.

Although, in all three cases, the underlying principle is the same, there are important differences in effect caused partly by differences in the composi-

Above: Portal of a medieval church on Gotland, Sweden. Right: New York street scene. Typical for both subjects is a wealth of small detail. Consequently, I deliberately photographed them on a cloudy day in totally diffused light in order to avoid cast shadows which, in such cases, would only be confusing.

138

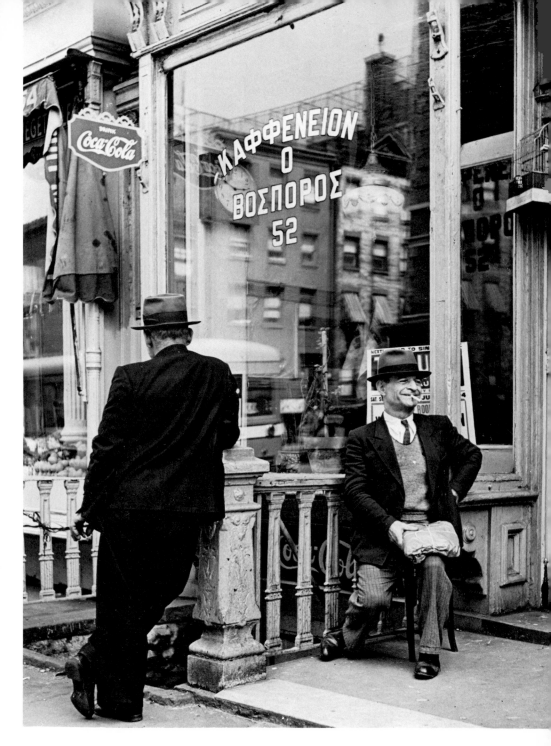

tion and surface structure of the reflecting matter and partly by the way in which we make use of the reflected light in the interest of better pictures. In this respect, photographers should know the following:

Reflection as producer of color

p. 73
p. 83

Light emitted by the sun or a photolamp falls upon an object and penetrates the surface deep enough to lose part of its spectrum through absorption by the material. The nonabsorbed spectral component of the light is reflected. This process, which I described in detail earlier, is called *diffuse reflection* and is responsible for giving most nonmetallic substances their color. Color rendition, as I explained before, can be controlled with the aid of color filters.

Metals, as we all know, have colors that have a different quality than body or pigment colors—they look "metallic." This difference is caused by a characteristic called *selective reflection,* which is peculiar to all metals. Light reflected by metals in the form of *specular reflection* (see below) has, on contact with the molecules of the surface, undergone certain changes that altered its spectral composition relative to that of the incident light, thereby giving the metal its typical color. For example, white light reflected in the form of glare from a piece of polished gold is no longer white (as it would have been if the substance had been, say, glossy yellow paint), but yellow; reflected from polished copper it is no longer white, but red; and so on.

Reflection as producer of mirror images and glare

A ray of light falling on a glossy or polished surface is reflected in such a way that the angle of reflection is identical to the angle of incidence (see the accompanying sketch).

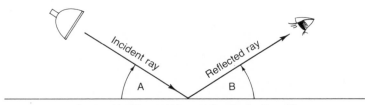

Angle of incidence (A) = angle of reflection (B)

Under these conditions, the spectral composition of the incident light is not affected by the reflecting material (metals, of course, excepted) with the result that it retains its original composition and color. For example, if the incident light is white, the reflection (or glare, which is the same) will also

140

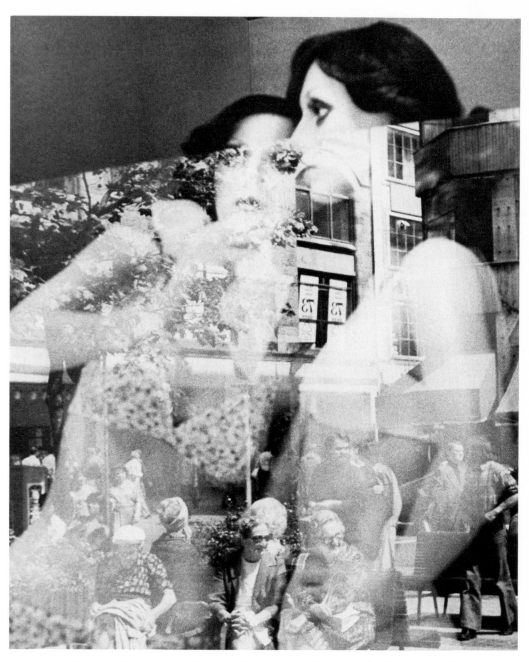

Reflections in a shop windowpane, Copenhagen. The effect is almost surrealistic, as if the two mannequins were discussing the elderly ladies sitting on the mall.

appear white even though the reflecting surface itself may have been colored or even black. This type of reflection is called *specular reflection* (from the Latin word for mirror: *speculum*).

It is specular reflection which, in the form of glare, makes transparent substances like glass, colorless plastic, cellophane, and water visible and thereby photographable. A clean windowpane, for example, would be completely invisible if it did not reflect light (the sky, automobile headlights, street lamps at night) that is, light brighter than the light reflected by the objects we see through it, which is transmitted unchanged. Likewise, water—a puddle, a lake, a river, the sea—would be invisible were it not for reflections of the sky, of bordering trees, a nearby mountain, or the sun in the form of glitter. Highlights, too, are a form of specular reflection and, as any photographer should know, indispensable for satisfactory rendition of shiny objects. For example, without "catchlights" in the eyes, a portrait looks lifeless and dull; without highlights (which could easily be removed with the aid of a dulling spray), a polished bronze statuette loses its metallic character and might just as well be made of yellow painted wood.

p. 258

Other reflections important to a photographer are, for example, the reflection of a face in a mirror, because it enables him to show in one picture two different views of a head, thereby making the picture more informative; reflections of passersby and street scenes in a shop window, which, through superimposition, can create almost surrealistic effects; distorted images of people and buildings in curved, shiny surfaces, such as the bodies and hubcaps of automobiles, convex and concave mirrors, curved store windows, mirrored ornamental spheres. Such images, analogous to caricatures, which often give more penetrating impressions than a faithful image, can show us aspects of our world that hadn't occurred to us before.

p. 140

The same law which dictates that the angle at which a ray of light is reflected by a flat polished surface must be identical to the angle of incidence also makes it easy to either create or avoid reflections. To create a reflection—a highlight in just the right place, a mirror image, the image of an object reflected in a pane of glass—all a photographer has to do is see to it that the camera relative to the reflecting surface is in such a position that the angle between the optical axis of the lens and the surface *is identical* to the angle between the surface and the object he wants to see reflected. Conversely, if he wants to *avoid* a reflection—usually the reflection of a flash, light from a photolamp in a window, picture under glass when taking indoor shots, or his own reflection in a shop window when taking photographs of the display—all a photographer has to do is make sure that the angle between the axis of the lens and the reflecting surface *is different* from the angle between the reflecting surface and the object (photolamp, photographer) that should *not* be reflected. The simplest way to do this is by trial and error. If an undesirable

142

reflection occurs, move the offensive object slightly to one side while keeping the camera in place. If the object is immovable, move the camera instead. And if neither one of these moves is possible, you can always try "killing" the offensive reflections with the aid of a polarizer in accordance with the instruc- p. 147 tions given in the chapter on polarized light.

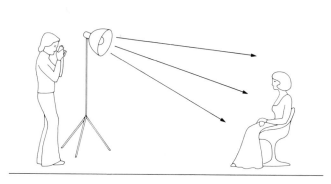

Direct light (see discussion below).

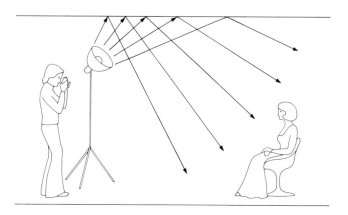

Indirect light (see discussion below), "bounce light."

Reflection as producer of indirect light

The difference between direct and indirect light is this: Direct light travels in a straight line from light source to illuminated object, which subsequently reflects it into the eye or lens; indirect light follows a broken line from light source to reflector to object before it is reflected into the eye or lens.

143

As a result of its encounter with a reflector, reflected light can differ from the incident light to which it owes its existence in three respects: brightness, direction, and color. Except in cases in which the reflector is a flat mirror, no matter how directional and parallel the original beam of light, if reflected from a nonspecular (not mirrorlike) surface it will emerge weakened in intensity and diffused; the more so, the rougher the texture of the reflecting surface. Unless the reflecting surface is pure white or consists of a material that does not affect the spectral composition of light (for example, aluminum foil), the indirect light will have acquired a color cast. The first two aspects concern all photographers, the third only those who work with color film.

Pointlike light source, mirrorlike surface, reflection is specular.

Pointlike light source, matte surface, reflection is semi-diffused.

Arealike light source, matte surface, reflection is totally diffused.

Since indirect light is always reflected light, it is subject to the laws of reflection. Specifically, if the reflector is a flat polished surface (a mirror, a ferrotype plate), the angles of incidence and reflection are identical, the reflection is specular, and the reflected light is strongly directional (which is the opposite of diffused). This type of indirect light is virtually as bright and contrasty as the light source to which it owes its existence.

On the other hand, if the reflector is a matte surface (for example, a sheet of matte white cardboard), the angles of incident and reflected light are theoretically still identical, but in practice the reflected light is no longer directional but more or less diffused around the axis of reflection. If the reflecting surface is smooth-matte, maximum reflection will occur at an angle equal to the angle of incidence, this peak being surrounded by a cone of increasingly diffused light. If the reflecting surface is rough-matte, the reflected light will be totally diffused and scattered over an angle of 180 degrees.

In photography, indirect light can be used in two ways: as the main and even only source of illumination, and as supplementary light for shadow fill-in.

144

A typical example of indirect light furnishing the only source of illumination is bounce light—flash beamed at the ceiling or light reflected from the p. 143 walls and ceiling of a room. Another example is light in the open shade—sunlight reflected by the sky providing the only source of light. For use in the studio, an excellent producer of indirect illumination is the flash umbrella p. 133 already mentioned; another is a skylight facing north.

Sources of indirect light for shadow fill-in purposes are: reflecting panels with surfaces that range from mirrorlike to semi-matte to rough; from aluminum foil to cardboard to white painted plywood sheets; from seamless background paper to bedsheets and handkerchiefs—just about anything flat will do as long as the reflecting surface is either white or, if photographs are to be taken in color, such that it will reflect light unchanged in regard to its spectral composition—for example, aluminum foil. Which one of this welter of different reflecting panels will give the best result in a specific case should always be determined on the basis that the rougher the surface and the larger the panel, the more diffused and softer the light and the larger the area covered, and vice versa.

Black-and-white photographers working with indirect light have to consider only its brightness and degree of diffusion; color photographers, in addition, must watch out for its color. In this respect, "natural" reflectors are much more likely to cause trouble in the form of unexpected color casts than reflector panels, which usually have been selected with care; natural reflectors often go unnoticed and take the photographer by surprise—when he sees his transparencies. Such potentially troublesome natural reflectors are the blue sky, which gives pictures taken in the open shade an unexpected blue color cast; foliage, which is likely to cause a greenish color cast in photographs made under trees or in the forest; a red brick wall against which a person is posed; and strongly colored apparel, which might reflect its color on the face of the wearer.

POLARIZED LIGHT

Visually, polarized light is indistinguishable from unpolarized light, and no photographer would give a hoot whether the light in which he photographs is polarized or not if, photographically, polarized light did not have two very useful qualities: It enables a photographer to exert almost complete control over glare, reflections, and highlights; and in color photography, it makes it possible to darken a pale blue sky in the picture without affecting any of the other colors of the scene.

145

Glare control is practiced mainly for one of two reasons: (1) to tone down or eliminate glare and reflections that otherwise would interfere with the efficacy of the picture—for example, broad highlights on polished wood, which would obscure the beauty of the grain; (2) in color photography, to increase color saturation by eliminating surface gloss, which washes out a subject's natural colors and makes the subject appear desaturated and too pale.

In contrast to ordinary light, which vibrates freely in all directions at right angles to its axis of propagation, polarized light vibrates only in a single plane. And whereas ordinary light could be compared to a tightly stretched string that can vibrate sideways in every direction, polarized light is comparable to a string passed through a narrow slot in a piece of cardboard, which restricts its vibrations to a single plane—the plane of the slot. It is this peculiarity of polarized light which makes it possible to control it with the aid of a special filter called a polarizer. What happens is this:

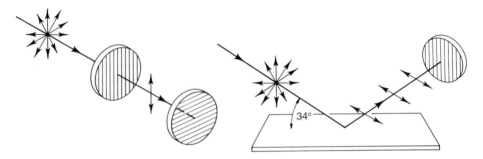

Left: Light source, "crossed" polarizers. Right: Reflected light is polarized.

In regard to its molecular structure, a polarizer is analogous to a grille consisting of millions of microscopically small, parallel bars set tightly together. Placed in the path of a beam of ordinary light, it transmits it but in the process of transmission also imposes its own finely sliced pattern on the light. As a result, after passage, the light no longer vibrates freely but only in one plane—the plane parallel to the slots of the grille; in other words, it emerges polarized.

Now, if we place such a grillelike filter in the path of an already polarized beam of light, it will permit this beam to pass, but only if its plane of vibration coincides with the plane of the "slots." If this is not the case, for example, if the polarizer is being gradually rotated relative to the plane of vibration, passage of light will be progressively restricted and stopped entirely the moment the "slots" are at right angles to the plane of vibration of the beam of

polarized light. In this position, the polarizer is said to "cross" the light and the result at the other end is darkness. This can be observed visually: Take two polarizers, hold them up against the light and look through them; then, rotate one against the other and watch the field darken. When the two polarizers are "crossed," the field appears black.

Naturally polarized light occurs in two photographically important forms: as glare reflected from nonmetallic surfaces, and in the form of a broad band stretched across the sky at right angles to an imaginary line connecting the camera and the sun.

Glare control by means of a polarizer

All light reflected in the form of specular reflection from nonmetallic p. 142 surfaces is more or less polarized. Polarization reaches its maximum at an angle of incidence of about 34 degrees and decreases steadily as the angle approaches 0 or 90 degrees, when polarization stops. Now, glare on backlighted blacktop or shiny leaves, highlights on polished wood or glossy paint, mirror images in water, reflections in glass and innumerable similar occurrences are, optically speaking, only different manifestations of the same phenomenon—glare—and in a photograph can be controlled by the same device—a polarizer placed in front of the lens. Adjustment is always done visually: If used in conjunction with a single-lens reflex or groundglass-equipped view camera, place the polarizer on the lens; if a rangefinder or simple roll-film camera is used, hold the polarizer up to one eye and look through it at the subject. Then, slowly rotate the polarizer while observing the image either in the viewfinder (or groundglass) or directly and watch how the brightness of glare and reflections varies between maximum and minimum strength. At the desired degree of extinction, stop rotating the polarizer. If the filter is already on the lens, take the picture; if not, without changing its angle of rotation, transfer the polarizer to the lens, then take the picture. In either event, don't forget to increase the exposure by the polarizer factor, which normally (but not necessarily) is 2½, equivalent to slightly more than 1 f/stop.

The degree to which glare and reflections can be eliminated with the aid of a polarizer depends on the angle of incidence of the glare-producing light relative to the reflecting surface. At an angle of about 34 degrees, glare can be eliminated completely; glare control will be progressively less effective as the angle approaches 90 degrees or 0, and ceases completely at an angle of 90 degrees. As mentioned before, light reflected by metallic surfaces does not become polarized, and under ordinary circumstances, glare on metal cannot be controlled with a polarizer.

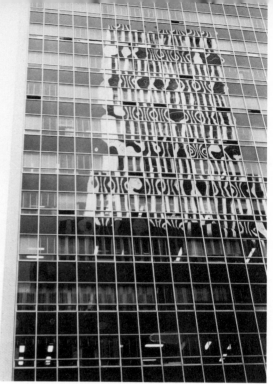

Shot made through a polarizer. Shot made without a polarizer.

In the studio, however, *total* glare control (including control of glare on metal) is possible if screens of polarizing material ("pola-screens") are placed in front of the photolamps and the picture is taken with a polarizer in front of the lens; the only provision here is that the lamp-screens must be oriented in such a way that their planes of polarization are parallel. In that case, the light that illuminates the subject is already polarized, specular reflections (glare) will be polarized *at all angles*, and the light reflected from the surface proper will become depolarized. Now, by applying the polarizer in front of the lens at the appropriate angle of rotation (which must be checked visually on the groundglass), a photographer can at will either tone down, or *eliminate completely*, *all* specular reflections regardless of the angle of incidence, including those on metal. Complete elimination of glare will take place if the planes of polarization of the screens at the lamps, on one hand, and that of the polarizer at the lens, on the other hand, are "crossed" at an angle of 90 degrees.

Setting up the pola-screens and orienting them in such a way that their planes of polarization are parallel to one another can be speeded up considerably if the planes of polarization are marked, perhaps with a small black dot applied with an indelible ink marker near the edge of the screen. The screens should also be mounted in frames that permit rotation through an arc of 90

148

Shot made without a polarizer. Shot made through a polarizer.

degrees. And to prevent them from being damaged by heat, they must be affixed at least 6 inches in front of the lamp reflector.

Exposure determination for shots made through a polarizing filter must take into account the color of the subject. If the subject is shiny but very dark, for example, a set of polished walnut dining-room furniture, and the shot is made facing a window, glare on the wood could be extensive and a light-meter reading comparatively high. If such data were simply multiplied by the polarizer factor, which might be 2½, the shot would probably be underexposed because after elimination of the glare the dark wood would reflect so little light that a light-meter reading taken under such conditions (which, unfortunately, is not possible), would have indicated a much longer exposure. In such cases, the best insurance is to bracket one's exposures—that is, to p. 58 take several pictures with increasingly longer exposures.

If photographs are taken with polarizing screens in front of the lamps and the lens, a factor between 8 and 16 will probably apply. The uncertainty, however, is so great that it is advisable to establish the correct exposure by test. The simplest way to do this is with the aid of Polaroid film, as described p. 60 earlier in this book. If the photograph is to be made on reversal (positive) color film, running a separate test on this film to establish the quality of the

149

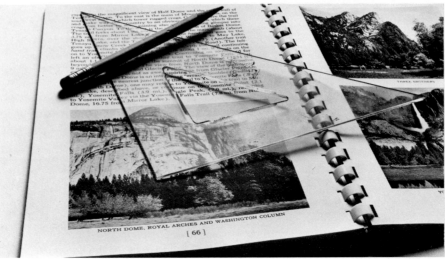

Elimination of specular reflection on shiny surfaces by means of a polarizer. The upper picture was shot without, the lower one with, the aid of a polarizer.

color rendition is strongly recommended: The polarizers, in conjunction with reciprocity failure due to the abnormally long exposure, may cause a color shift that would have to be corrected with the aid of the appropriate color-compensating filter. This, too, has been explained before. Inclusion of a gray scale in the test setup considerably facilitates judging the result of this test because its medium shades would clearly reveal even the slightest indication of a tint.

p. 82

Blue skylight control by means of a polarizer

As mentioned before, light from a blue sky along a broad band situated at 90 degrees to a line between the camera and the sun is strongly polarized. As a result, in both black-and-white and color photography, a polarizer can be used to render those areas of the sky darker in the picture than they would otherwise appear without affecting any of the other colors of the scene. The effect can be studied visually by observing the subject through the polarizer while slowly rotating it between thumb and forefinger; or, if the shot is made with a single-lens reflex or view camera, by placing the polarizer on the lens, rotating it, and watching the resulting brightness changes in the viewfinder or on the goundglass.

p. 72

In scenic color photography, use of a polarizer is often a good way to improve both the rendition and degree of saturation of color because it reduces specular surface reflections from leaves. This kind of glare usually goes unnoticed by the photographer because it manifests itself in minute but endlessly repeated quantities, each leaf having its own little highlight, but the total adds up to a considerable overall desaturation of color. And since these reflections can contain a surprisingly high amount of blue (representing the contribution of blue skylight), the overall effect is often that of a blue haze overlaying the entire landscape. If this is the case, use of a polarizer, by largely eliminating this blue form of glare, can improve both the saturation and rendition of color.

A note of caution. Once more I feel I must remind the reader that mastery—here, of glare control—implies a master, a person who knows not only how to do things, but also why to do them. Specifically, even in cases in which complete elimination of glare and reflections is possible, this is seldom advisable because a subject or scene entirely devoid of highlights appears strangely lifeless and flat. Bodies of open water without sun glitter or reflections of mountains, trees, and sky would look so unnatural as to be almost unrecognizable, and polished objects without highlights would look "dead." Although, in certain cases, elimination of glare is a prerequisite for success, in others, it is a road to disaster since all too often it is precisely the sparkle of glare that gives a subject "life." Therefore, think before you reach for your polarizer, and if you feel you have to use it, remember that in the majority of cases, partial elimination of glare—toning down rather than extinction—is most likely to give the most pleasing results.

151

FILTERED LIGHT

Filtered light is light that has passed through a filter and thereby lost some of its spectral components, with one exception: Light that has passed through a neutral density filter is merely diminished in brightness but is otherwise unchanged. But even light that has gone through an apparently colorless ultraviolet or haze filter, although unchanged as far as the eye can see, has been altered because its (invisible) ultraviolet component has been removed in transmission—and film is sensitive to ultraviolet. As a result, a photograph taken in filtered light invariably differs from one that, under otherwise identical conditions, was made in unfiltered light. And since light can be filtered in innumerable ways, a photographer who knows how to avail himself of the thereby offered opportunities can exert almost unlimited control over the contrast and color rendition of his pictures.

For practical reasons, photographers distinguish between two kinds of filtered light:

existing filtered light, and
intentionally filtered light,

and two reasons for resorting to filtration:

to make the existing light compatible with the color response of the film for the purpose of producing a "natural-appearing" rendition; and

to deliberately change the spectral composition of the existing light in order to create in the picture a specific, otherwise unattainable, effect.

Existing filtered light

Such light can be found almost anywhere. Outdoors, sunlight filtered through layers of dust, smoke, haze, or clouds is different from direct sunlight in regard to color and spectral composition, varying in accordance with the time of day and atmospheric conditions from "warm" red and yellow to "neutral" white to "cool" blue and mauve. Light under trees—filtered by foliage—is green; underwater light is blue-green or blue. Indoors, daylight in commercial buildings often has a green or yellow tint because of tinted window glass. Likewise, the glass in airplanes and automobiles is usually slightly green—a fact that is clearly noticeable when a car window is half-open and comparison between the colors of the scene as they appear through the opening and through the glass is easy. The difference in color shades is often astonishing

and comes as a surprise to the viewer who was under the impression that window glass is colorless. Taking color pictures through this kind of glass (for example, from airplanes) naturally results in slides with a greenish cast unless the shot was made through a 05R or 10R color-compensating filter.

The fact that people usually don't notice even rather large deviations from "white" in the color of the existing light is due to a characteristic of our vision called *general color adaptation*: Our eyes automatically adapt their color sensitivity to changes in the color of the prevailing illumination relative to the colors and neutral tones of our surrounding in such a way that we continue to see the scene as if it were illuminated by "white" light. And if the illumination consists of two light sources that differ in regard to color (for example, in interior shots in which bluish daylight from windows is supplemented by p. 71 yellowish incandescent light), the eye, minimizing the differences in color quality, tends to adapt itself and see the whole scene in an intermediate shade.

Furthermore, another peculiarity of our vision called *approximate color constancy*—a kind of color memory—causes us to see familiar objects in the colors in which we are accustomed to see them—as they appear in "white" daylight—even though a tinted illumination may have changed these colors substantially.

The value of these responses lies doubtlessly in the fact that they aid identification: Objects seem more familiar and are more easily recognized than if their appearance were constantly changing with every shift in the color of the incident light. But to the color photographer in pursuit of "natural-appearing" color, his color responses are a constant problem with which he must learn to deal, for the following reasons:

While the eye is rather uncritical when it comes to judging *color in reality*, it is highly critical as far as *color in picture form* is concerned because, then, the color memory of which I spoke takes over: In the absence of "the real thing" with which to compare the subject of the picture, we "remember" how it should look, and unless its colors are rendered "as expected," that is, as we remember seeing them in "white" daylight, we are likely to pronounce the transparency or slide "unnatural."

Unfortunately, while the eye is uncritical about the way it sees color in reality, the color film is not. On the contrary, it is quite sensitive to changes in the color of the illumination to which it reacts with corresponding color shifts. As a result, unless the illumination matches the standard for which the color-film emulsion is balanced, a scene that to the eye appears "normal" in reality may appear "exaggerated" in the slide in regard to color and hence "unnatural."

153

Blue filter. No filter.

Intentionally filtered light

It is in cases like those cited above that photographers resort to filtration to intentionally change the color of the existing light. Here, we are confronted with a paradox: In order to achieve a form of rendition that the eye accepts as "true," we must "falsify" the existing light through filtration.

p. 85 However, as we heard before, the need for filtration is not restricted to color photography. In black-and-white photography, too, filtration may become necessary to achieve specific results, for two apparently contradictory reasons: either because an unfiltered rendition would not correspond accurately enough to reality, or because it would be too accurate to be effective. Altogether, there are four specific reasons why a photographer may intentionally have to filter and "falsify" the existing light:

1. In black-and-white photography, filtration is required if the translation of colors into shades of gray must be monochromatically correct; that is, if all colors must be transformed into gray shades of precisely corresponding lightness (or darkness), even if this means that colors of identical brightness but different hues (for example, a medium-light red and a medium-light green) will appear in the print as identical shades of gray. The means for accomplish-
p. 85 ing this are the *correction filters* already discussed.

2. In black-and-white photography, filtration is required if two colors that are different in hue but more or less equal in brightness (for example, a medium-light red and a medium-light green), which otherwise would be ren-

154

Yellow filter. Red filter.

dered as identical (or very similar) shades of gray, must be separated graphi-
cally in the rendition in the interest of greater clarity. In other words, instead
of letting the two colors blend along their lines of juncture (which might be
rather confusing to a viewer of the picture), the photographer intentionally
makes one appear lighter than the other and thus, by creatively translating
color contrast into gray-tone contrast, increases not only the informative value
of the picture, but also its aesthetic appeal. The means for accomplishing this
are the *contrast filters* already discussed. p. 85

 3. In color photography, filtration is required if the color of the existing
light does not match the color of the light for which the film is balanced, yet
the subject must appear in the transparency as it would have appeared to the
eye in "white" daylight. The means for accomplishing this are primarily the
light-balancing filters but occasionally also the *color-compensating filters* al- p. 79
ready discussed.

 4. In color photography, filtration is required if the color of the existing
light is unsuitable to carry out the intentions of the photographer, regardless
of whether or not it corresponds to the type of light for which the film is
balanced. For example, if the photographer wishes to give a scene a rosy
glow, or show his subject in a cool blue light although the existing light is
"white" as far as the color film is concerned, he must resort to filtration. The
means for accomplishing this are the *color-compensating filters* already p. 82
discussed.

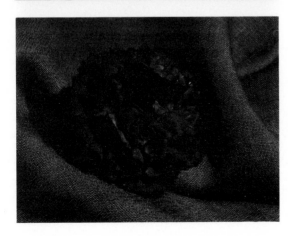

Red carnation on bright blue fabric.
Color control in terms of black-and-white is so extensive that this subject could be rendered either as white against white, white against gray, white against black; gray against white, gray against gray, gray against black; or black against white, black against gray, black against black. The principle that governs this form of color control is discussed on p. 83.

157

Above: Shot made through a blue filter; below: through a red filter. The upper front part of the locomotive was orange, the rear part of the roof dark blue, the lower half of the engine gray. Pictures taken under otherwise identical conditions.

NATURAL LIGHT

When photographers speak of *natural light*, they mean daylight, or more precisely, light that originated in the sun—the standard by which all other forms of illumination are judged. And if a subject or scene must appear "natural" in the picture, even if the illumination is furnished by artificial light, the illumination must comply with the principles established by sunlight, which are:

1. Since there is only *one* sun in the sky, the illumination must be such that it comes (or appears to come) from *only one* light source. In photographic parlance, this light source is called the *main light*, the *dominant light*, or the *key light*.

2. Since all light comes (or seems to come) from only one light source, each object can cast only one shadow, and all the shadows cast by all the objects visible in the picture must fall in the same direction. In other words, multiple shadows, shadows pointing in different directions or crossing one another, and secondary shadows within primary shadows are "unnatural," normally do not occur in nature (exception: A shadow cast by a strongly reflecting surface may cross a shadow cast by the sun), and give a photograph a dilettantish or phony look.

On the other hand, daylight on an overcast day is almost shadowless. Consequently, the presence of shadows is not a prerequisite for a natural-appearing illumination.

3. Since the sun is visible—and can cast shadows—only as long as it is above the horizon, the illumination must always seem to come from above (exception: sun glitter on water can illuminate, say, a face, with light from below). Therefore, any light seeming to come from below eye level (photo-lamps directed upward) will appear unnatural, even if deliberately arranged and admittedly expressive.

4. Because sunlight is always supplemented by skylight, which acts as a shadow fill-in light, and furthermore because the eye in scanning from light to shadow adapts automatically and rapidly to the change in brightness level, we never see outdoor shadows as black, that is, totally devoid of detail. Consequently, in a photograph, shadows that are pure black will always make an unnatural impression, no matter how graphically powerful, aesthetically justified, and pictorially expressive.

159

A note of caution. Considering the preceding list of characteristics of natural light, the reader might get the impression that these principles constitute a "law," violation of which automatically results in bad pictures. This is not true. What a violation of these principles will bring about are photographs that look unnatural, which means artificial, but not necessarily bad, although this possibility exists and is even likely. On the other hand, there are very few "rules" in photography that cannot be violated successfully, provided there is a reason and the photographer knows his business. Letting yourself be guided by the principles of natural-light illumination is never wrong; on the other hand, if you feel strongly otherwise, go ahead and do anything you want. Perhaps you'll come up with a great picture, although the chances are admittedly small.

The types of natural light

The most outstanding characteristic of natural light is its unpredictability, a consequence of its enormous variability in regard to

> brightness,
> color,
> diffusion.

The brightness span of natural light ranges all the way from the intense brilliance of direct sunlight to the gloom of dusk and the darkness of a moonless night. Its color varies from the "white" of standard daylight to the blue of light in the open shade and at dusk, the yellow of late afternoon light, and the red of light at sunset. Its degree of diffusion runs the gamut from virtually undiffused (parallel) and very contrasty to totally diffused and very soft. Photographers with a feeling for quality in regard to illumination can have a ball working with natural light. To help them make the most of it, here are some specifics:

p. 165

Sunlight on a cloudless day represents the most contrasty type of natural light. Photographically speaking, this form of illumination consists of two sources: the sun and the blue sky. The sun, as the modeling main light, provides a strongly directional and virtually parallel illumination, while the blue sky reflects totally diffused light from all directions of the hemisphere and fulfills the function of the shadow fill-in light.

It should be obvious that working under these conditions is not easy, the two main problems being high contrast and high color temperature. The first can be alleviated in near-distance and close-up photographs (where it is most pronounced) with the aid of shadow fill-in light (daylight flash or reflecting

p. 77

pp. 108, 109

160

panels), the second with the aid of a warm-up filter in case the shot is made p. 80 on color film.

On a cloudless day, with the sun at an angle of 50 degrees above the horizon, the lighting-contrast ratio between sunlight and shade can be as high as 8:1, which, as we know by now, represents about the maximum still compatible with acceptable black-and-white rendition but is far too high for good color rendition. This ratio gradually decreases as the sun approaches the horizon. At the same time, the light slowly changes color from white to yellow to red because the incoming rays must pass through increasingly thicker layers of dust-laden air. As a result, they encounter increasingly larger numbers of particles, and especially a greater number of relatively coarse particles within the lower layers of the atmosphere, which scatter a much wider range of wavelengths of light. Under such conditions, only the long red-producing wavelengths remain unaffected and are able to penetrate the atmosphere, as shown in the accompanying sketch.

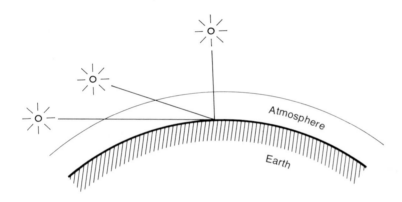

On a clear day, the shadows falling on a white or near-white surface will appear intensely blue since these areas are illuminated only by blue skylight. Although this is a perfectly natural phenomenon, the eye tends to see all shadows as gray. If a similar appearance is wanted in a color photograph, the excess blue must be toned down through filtration, the type of filter depending on the degree to which blue should be suppressed: An ultraviolet or haze filter will produce a mild and filters of the Kodak Series 81 increasingly p. 80 pronounced warm-up (yellowish) effects.

Sunlight on a hazy day. From a photographer's point of view, a hazy day is almost always preferable to a clear one for the following reason: The lighting-contrast ratio between sunlight and skylight decreases with increasing p. 104 haziness, ranging from about 4:1 to 2:1, which is ideal for color photography.

As a result, shadows are less dense, less sharply defined, and also less blue because the intervening layer of haze acts like a diffuser-cum-filter in front of the main light, the sun.

On the other hand, since haze is whitish, the hazier the day, the more toward white the color of the sky, a fact that may produce rather dull results in cases in which the sky is an important part of the scene, particularly in black-and-white photography where a yellow or red filter will have little effect as far as darkening this kind of sky in the picture is concerned. However, this disadvantage is often compensated by the effect of a phenomenon called *aerial perspective,* which is increasingly pronounced, the thicker the haze: Objects appear the lighter, the farther from the camera they are, thereby creating increasingly pronounced impressions of depth. In black-and-white photography, the degree of aerial perspective can be controlled with the aid of filters: a blue filter will increase, while a yellow and to an even stronger degree a red filter will decrease, the feeling of distance and space. The impression of depth will be strongest if the shot is made toward the sun (in backlight) and will be particularly effective if the picture contains a wide range

p. 121 of tones, preferably from black to white, with black (silhouetted) objects in the foreground, varying shades of gray in the middle distance, and white representing the sky. On the other hand, if, for some reason, a clear and contrasty picture of a distant view must be taken on a hazy day, the haze effect can be partly or totally eliminated by making the shot on haze-penetrating infrared film through a Kodak Wratten 87A, 87B, 88A, or 89B filter.

Near-distance and close-up color photographs taken on a slightly hazy day usually show excellent color rendition since the haze acts as a nonselective reflector of sunlight. As a result, unfiltered photographs taken in the open shade will not appear objectionably blue. This kind of light, however, must not be confused with light on an overcast day, which again tends to be bluish.

Light from an overcast sky. If the cloud layer is dense enough to com-
p. 172 pletely obscure the sun, the overcast takes on the nature of an area source of illumination emitting totally diffused light from all parts of the sky. As a result, contrast is extremely low and shadows all but absent. This has both advantages and disadvantages, making this kind of light particularly well suited to certain kinds of photographs, totally unsuited to others.

Overcast days are ideal for photographing any kind of very complex subject with large amounts of fine detail where shadows would be confusing rather than clarifying, for example, the accompanying view of St. Mark's Square in Venice. They are equally suitable for making pictures of subjects of intrinsically high contrast and for shooting arrangements or patterns forming strong graphic designs that would be obfuscated by shadows. Likewise, portraits taken in this kind of light usually turn out very well. And finally, if, for

162

St. Mark's Square in Venice. I deliberately shot this picture on a hazy day at noon to avoid cast shadows that would only have made this already busy scene busier.

163

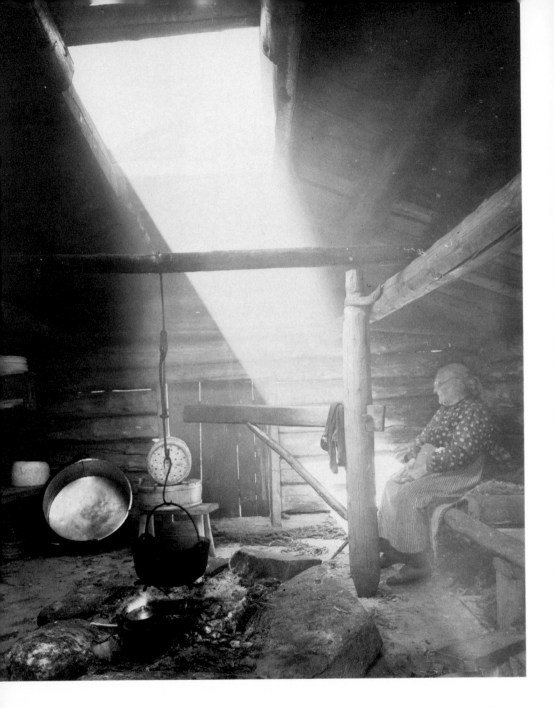

Timbered cottage in Lapland. Without the shaft of sunlight coming through the roof, this shot would have been nothing but another run-of-the-mill travel picture.

164

some reason, the feeling of depth and space should be avoided (perhaps to create a two-dimensional pattern effect), light on an overcast day will help to accomplish this.

Conversely, if impressions of three-dimensionality and depth must be created in a photograph, shooting on overcast days should be avoided since the typical low contrast and more or less shadowless light would tend to make the subject appear flat.

As far as the color photographer is concerned, light on overcast days is inclined to be bluish, making the use of a haze, ultraviolet, or moderate Kodak Series 81 filter almost mandatory. Furthermore, color is always less p. 80 saturated in diffused than in direct light, a fact that, depending on the nature of the subject, the purpose of the picture, and the intentions of the photographer, can be an advantage as well as a fault.

Sunlight and broken clouds. As far as the color photographer is concerned, this is the definition of *standard daylight,* the type of light for which all daylight color films are balanced: *a combination of direct sunlight and light reflected from a clear blue sky with a few white clouds during the hours when the sun is more than 20 degrees above the horizon.* This kind of light has an equivalent color temperature of approximately 5500 to 6000 K, a decamired p. 79 value of about 17, and is perfect for taking outdoor color photographs, giving natural-appearing color rendition without the need for filtration.

Sunlight reflected from white clouds provides an excellent source of shadow fill-in light, which, since it is more or less neutral white, tends to minimize the effect of light reflected from clear areas of blue sky. As a result, shadows are less dense and less blue than they are on cloudless days.

Daylight in the open shade, as mentioned before, is almost totally diffused and more or less blue, requiring the color photographer to resort to the appropriate Kodak Series 81 filter if a natural-appearing color rendition is p. 80 needed. Otherwise, photographically speaking, this kind of light is rather similar to light from an overcast sky.

Light on misty or foggy days is moderately to totally diffused and of correspondingly low contrast; as far as color is concerned, it is usually neutral, that is, neither yellow nor blue. To the scenic photographer and pictorialist, it offers potentially spectacular opportunities for outstanding pictures, with light itself becoming the subject of the shot. Particularly effective in this respect are backlighted scenes in the forest and large industrial installations with shafts of light making space itself visible and bursts of sunlight carving almost tangible shadows out of misty air.

But nowhere, perhaps, are the special qualities of mist and fog more appre-

Times Square, New York. Never is the city more enchanting than on a foggy night when the air itself becomes luminous, glowing with softly diffused light.

ciated than in night photography in the city, when the air itself seems to glow with the reflected color of neon advertising signs, and street lamps are surrounded by halos of softly diffused light. Then, all the grime and corruption disappear, and what we see instead is a city of light magically transformed by the night.

Light during rain and snowfall is totally diffused and neutral in color. To an even higher degree than mist and fog, it must be considered a subject for pictures rather than an illuminant. And because few photographers take pictures during a snowfall or in the rain, the chances of producing unusual and interesting photographs are great, particularly in color photography where the contrast between the total neutrality of the falling rain or snow can effectively be contrasted with a few areas of carefully selected color, each enhancing the other by contrast. This is a field in which experts sensitive to the potential of light and color should excel.

Incidentally, a type of subject that, photographically speaking, gains enormously from rain is the city at night when wet pavement reflects and literally doubles the light and colors from street lamps, automobile headlights, and advertising signs.

166

ARTIFICIAL LIGHT

In contrast to natural light, which is enormously varied, constantly changing, and therefore inherently unpredictable, artificial light is available in only a relatively small number of specific types. Each of these, however, is predictable because it is stable and uniform in regard to brightness and color, the only condition being that the respective light source is operated at the proper voltage and that this voltage is constant. As a result, correctly exposed color photographs made in suitable artificial light usually have excellent color rendition. Here is a summary of the different forms of artificial light most commonly used in photography:

The types of artificial light

Specular light is more or less parallel (undiffused) and therefore highly directional light that casts deep-black, hard-edged shadows. It is the most contrasty form of light normally used by photographers today, surpassed in this respect only by pointlike light sources such as zirconium and carbon arc lamps. Specular light is the indoor equivalent of direct sunlight on a cloudless p. 160 day, has the same advantages and drawbacks, and is used mostly for overall illumination (in which case it normally must be augmented by auxiliary fill-in illumination), in texture rendition, and to provide accentuating highlights and p. 242 sparkle. It is totally unsuitable as shadow fill-in light. Photolamps producing specular light are called *spotlights*. p. 185

Moderately diffused light generally is the most useful form of photographic light, the indoor equivalent of sunlight on a hazy or thinly overcast p. 161 day. It is moderately contrasty, crisp rather than hard, and casts well-defined shadows that, however, are not as hard-edged and deep as those cast by a spotlight. It is equally suitable for use as the main light and for shadow fill-in illumination. Lamps producing this type of light are *photofloods in reflectors,* p. 184 *reflector floods, flashbulbs in reflectors,* and *speedlights.*

Highly diffused light is the indoor equivalent of daylight on a solidly overcast day. It is soft and almost shadowless, the type of light that, used for p. 162 overall illumination, gives outstanding results in the hands of experts who know when, and especially when not, to use it. It furthermore is ideal for shadow fill-in illumination. Lamps and devices producing this kind of light are *photoflood lamps in large reflectors equipped with even larger diffusers, fluo-* pp. 184, *rescent tubes (especially if clustered in the form of "banks"), tungsten lamps* 186 or *electronic flash in conjunction with reflecting umbrellas,* and *speedlights*

and *flashbulbs aimed at the ceiling in order to illuminate a room with reflected "bounce light."*

Totally diffused, shadowless light is a type of light that has no counterpart in nature. It is a rarely used form of light that, by uniformly surrounding the subject from all sides (or at least the sides visible from the camera position), prevents the formation of shadows. It is primarily used in photographing shiny objects like porcelain, glazed ceramics, and polished metalware where it facilitates the control of reflections. Devices furnishing shadowless light are the *light-tent* and the *ringlight*.

p. 254

pp. 134, 228

The color of artificial light

Although of no concern to photographers who work in black-and-white, the color of artificial light is of the highest importance to color photographers because it determines whether their transparencies and slides will appear in "natural" colors or have a color cast. In this respect, we must distinguish between the following different types of artificial light:

p. 165

Daylight-type photolamps produce light of a color that more or less matches the color of standard daylight (5500 to 6000 K). I intentionally say "more or less" because the number of lamps that can be used in conjunction with daylight color film without the need for corrective filtration is relatively large, ranging from blue-glass photoflood lamps (4800 to 5400 K) and blue-lacquered flashbulbs (6000 to 6300 K) to electronic flash (6200 to 6800 K). Needless to say, the same subject photographed in these slightly different types of light would appear also slightly different in regard to color rendition, its colors somewhat more yellowish (warmer) if illuminated by a light source of 4800 K than by one of 6800 K, the latter producing a rendition in colder, more bluish tones.

Light of approximately 3800 K is emitted by clear press-type flashbulbs that are primarily intended for black-and-white photography. However, these bulbs can also be used with daylight-type color films if the shot is made through an 80C color-conversion filter, which requires an exposure increase of 1 *f*/stop. The decamired value of this type of light is 26.

p. 79

Light of 3400 K is emitted by amateur photoflood lamps that are intended for use with Type A color film; the decamired value of both is 29. No filter is needed.

p. 79

Light of 3200 K is emitted by professional tungsten lamps that are intended for use with Type B color film; the decamired value of both is 31. No filter is needed.

p. 79

168

Conversion of light to match a type of color film originally intended for use with another type of light is possible with the aid of color-conversion filters in accordance with the following table:

Type of color film	Light source	Kodak filter	Exposure increase
Daylight-type	3200 K	80A	2 f/stops
	3400 K	80B	1⅔ f/stops
	3800 K	80C	1 f/stop
Type B (3200 K)	Daylight	85B	⅔ f/stop
	3400 K	81A	⅓ f/stop
Type A (3400 K)	Daylight	85	⅔ f/stop
	3200 K	82A	⅓ f/stop

Fluorescent light, although very well suited to black-and-white photography in cases in which a highly diffused type of illumination is required, is basically unsuited to color photography for two reasons: (1) Because it has a line spectrum superimposed upon a continuous spectrum, is deficient in red, is not emitted by an incandescent filament, and has no color temperature in the strict sense of the term. (2) Because fluorescent tubes come in a number of different "colors" and more or less "white" light, which, however, is not white at all as far as the color film is concerned. As a result, the situation is confusing and filtration (which is an absolute necessity) is hazardous and likely to lead to successful color rendition only if educated guesses are confirmed by tests. As a service to photographers, Kodak recommends the following manner of filtration as a starting point for tests:

Fluorescent light—tentative correction-filter table

KODAK FILM TYPE	TYPE OF FLUORESCENT LIGHT					
	Warm white deluxe	Warm white	White	Cool white deluxe	Cool white	Daylight
Daylight except Kodachrome Daylight film	60C + 30M	40C + 40M	20C + 30M	30C + 20M	30M	40M + 30Y
	(+ 1⅔)	(+ 1⅓)	(+ 1)	(+ 1)	(+ ⅔)	(+ 1)
Kodachrome Daylight film	60C + 30M	30C + 30M	20C + 30M	30C + 20M	40M	50M + 30Y
	(+ 2)	(+ 1⅓)	(+ 1)	(+ 1)	(+ ⅔)	(+ 1)
Type A	None	30M + 10Y	40M + 30Y	10M + 20Y	50M + 50Y	85+30M+10Y
		(+ 1)	(+ 1)	(+ ⅔)	(+ 1⅓)	(+ 1)
Type B Type L	10Y	30M + 20Y	40M + 40Y	10M + 30Y	50M + 60Y	85B+30M+10Y
	(+ ⅓)	(+ 1)	(+ 1)	(+ ⅔)	(+ 1⅓)	(+ 1)

Note: The figures in parentheses indicate, in the form of f/stops, the amount by which the meter-calculated exposure must be increased. The filters specified above are Kodak Color-Compensating (CC) filters. Comparable filters made by other manufacturers may require different exposure increases.

If demands in regard to color accuracy are high, Kodak recommends running a filter test series up to ± CC20 from the values given above under each lighting condition.

For long exposure times, the filters necessary to correct for reciprocity failure, both in regard to time of exposure and possible color shift, must be added.

CONTINUOUS AND DISCONTINUOUS LIGHT

Photographers working with artificial light often are faced with the decision whether to use continuous or discontinuous light. Photofloods, spotlights, and fluorescent tubes emit continuous light; flashbulbs and speedlights, discontinuous light. What, precisely, are the advantages and drawbacks of each? When should one use which form of light?

Continuous light has the invaluable advantage over discontinuous light that it is steady—the photographer can see and leisurely evaluate its effect upon the subject, particularly in regard to the all-important position of the shadows. He can measure its brightness and contrast range with an ordinary exposure meter and, if necessary, rearrange the lamps to suit his purpose. He can see and eliminate obnoxious reflections (for example, photolamps reflected in windows or pictures under glass). And ordinary photolamps emitting continuous light are relatively inexpensive.

p. 184

On the other hand, there are drawbacks. In comparison to flash, continuous artificial light is relatively weak—certainly not bright enough to shoot at motion-stopping shutter speeds, especially not in conjunction with diaphragm stops small enough to insure extensive sharpness in depth. Furthermore, photolamps draw large amounts of electric current, perhaps so large as to overload ordinary home circuits. They also produce a great deal of heat. And finally, photolamps emitting continuous light are not as portable and independent as flash because they are tied to an electric outlet from which they can be placed no farther away than the length of their cord.

p. 186

Discontinuous light is produced by flashbulbs and speedlights (electronic flash). Its main advantage over continuous artificial light is its motion-stopping ability—electronic flash is fast enough to "stop" a bullet in flight, and flashbulbs can be used at the highest shutter speeds of which a camera is capable.

170

The second great advantage of flash over photolamps producing continuous light is movability—independence from a stationary power supply since all flashbulbs and amateur speedlights are powered by their own batteries and can be used anywhere at any time, indoors as well as outdoors. And finally, flashlamps are easier on the eyes in portrait photography and also produce virtually no heat (despite the fact that, for a few seconds, a freshly fired flashbulb is much too hot to touch).

The great disadvantage of discontinuous light—and a very serious one—is that lamps emitting this type of light don't permit a photographer to see what he is doing. Except for large (and very expensive) studio speedlights, which have built-in "guide lights," a flash, whether from a bulb or a gaseous discharge tube, lights up and is gone, with the photographer none the wiser where the light hit and where the shadows fell. All he can do in this respect is guess, hope, and pray.

A second and only slightly less serious disadvantage of flash in comparison to continuous light is the fact that the photographer can ordinarily not measure either its contrast range or its brightness and must base his exposures on a formula: *f/stop equals guide number divided by distance in feet between subject and flash,* with the flash manufacturer providing specific guide numbers for different types of flash. Although special strobe meters are available, they are quite expensive and normally not found in the hands of amateurs.

Conclusions. The enormous popularity of small electronic-flash units stems from the fact that they make near-distance photography, and particularly color photography, virtually foolproof. With flash at the camera, a photographer never has to worry about light. He literally doesn't have to know a thing about photography except how to load his camera with film and focus the lens, yet he can be assured of perfectly exposed, tack-sharp pictures every time he takes a snap. In comparison to this advantage, what does it matter that frontlight makes the subject look flat, or that the background is too dark because of the limited reach of the flash? That depends—on your demands as a photographer. If you are satisfied, fine. If not, you probably will agree with me who firmly believes that flash is no substitute for continuous light but a supplement: If the nature of the subject and circumstances permit the use of lamps producing continuous light, this type of light will always give better results than flash because of the advantages I discussed above. Only if photolamps producing continuous light cannot be used—because subject motion must be stopped, accidental camera shake made harmless, or because electricity is unavailable or cannot be used—only then should a photographer reach for flash.

LIGHT FROM POINTLIKE AND AREALIKE SOURCES

p. 102 Since the difference in effect between these two types of light has already been discussed, I can limit myself here to a brief summarization. Basically, the smaller the *effective* diameter of a light source (the more pointlike), the more contrasty the light and the sharper and deeper the shadows, and vice versa.

Consequently, if a photographer wishes to use a contrasty form of light, he must pick a light source with a relatively small effective diameter (an electric arc lamp, a projection lamp with a small filament, a light bulb without a reflector, the sun). Conversely, if he needs a soft and diffused form of light, he must use a light source with a relatively large effective diameter (a photoflood lamp in a large reflector preferably equipped with a still larger diffuser, a bank of photolamps or fluorescent tubes, reflecting panels, light from an overcast sky). That, literally, is all there is to choosing light with the right degree of contrast.

172

V. The Sources of Light

Again, we must distinguish between a quantitative and a qualitative approach. Some photographers are satisfied with any light source as long as it is bright enough to fit their purpose. Others, aware of the widely varying effects of different types of light, are discriminating and choose their light source on the basis of its specific quality because they know that any *effective* photograph is the result of a successful *synthesis of technique and art:* To be *technically* perfect, a negative or color slide must be correctly exposed, which means that the right *quantity* of light must be admitted to the film; but to be *pictorially* perfect, the *quality* of the illumination must fit the nature of the subject, the purpose of the picture, and the intentions of the photographer. Because if the light is wrong in regard to quality, the mood and "feeling" of the picture will also be wrong, and the most perfectly exposed negative or transparency is nothing but a wasted piece of film.

The four photographically most important qualities of any light source are:

> **Brightness**
> **Contrast**
> **Color**
> **Duration**

Since these qualities have already been discussed in a different connection p. 37 elsewhere in this book, I can here confine myself to a brief summation of their most relevant points. Other qualities, like power consumption, heat emission, portability, weight, size, and price, are of practical rather than pictorial interest and so obvious that I mention them here only for completeness.

Brightness becomes important only if high shutter speeds in conjunction with small *f*/stops are a prerequisite for success. Otherwise, even a relatively dim light source can be made to do the work of a brighter one simply by exposing the film accordingly. As a matter of fact, time exposures of city streets and passages at night, which to the eye appeared so dark that almost nothing could be seen, can be made; these show almost as much detail as

173

pictures taken in daylight as a result of the light-accumulating ability of film. And a very simple way to regulate the brightness of any artificial light source at the subject plane is choosing the lamp-to-subject distance in accordance with the inverse-square law: The closer to the subject, the brighter in effect the light, and vice versa.

p. 16

The brightest light sources are the sun, arc lamps, flashbulbs, and electronic flash, followed by large spotlights and 3400 K photofloods. Tungsten lamps, 3200 K, are slightly less bright, and ordinary household bulbs even dimmer. Basically, the higher the watt-rating of a lamp, the brighter its light, but the design of its reflector also influences its *effective* light output: A large, polished, high-efficiency reflector yields more useful light than a smaller, satin-finished one, and the presence of a Fresnel or condenser lens further increases the effective light output of the bulb by gathering the light into a more narrow-angled, more or less parallel beam instead of letting it dissipate itself over a wider angle in the form of diffused light.

p. 102

Contrast, as I have pointed out, is a function of the effective diameter of the light source: The more pointlike, the more contrasty, and the more area-like, the softer the quality of the light. In this respect, without a reflector, a clear glass bulb of the same filament size and wattage as a "frosted" bulb yields a more contrasty type of illumination than the latter light source, the effective diameter of which is the diameter of the bulb while that of the former is the much smaller diameter of the clearly visible filament. And while it is always relatively simple to convert a high-contrast light source into one producing softer light (all a photographer has to do is to equip it with a diffuser), it is virtually impossible to coax a high-contrast illumination out of a lamp designed to produce diffused light. Fitting such a lamp with a diaphragmlike device that reduces its effective diameter would do the trick but, at the same time, cut down its brightness enormously. A more effective, but not always practical, way would be to use the bulb bare instead of putting it in a reflector; in the first case, it is the diameter of the bulb that represents the "effective diameter" of the light source, and in the second case, it is that of the reflector. A list of different light sources producing more or less contrasty light was given before.

p. 103

Color, although of no interest to a photographer who works in black-and-white, is, as far as the color photographer is concerned, perhaps the most important quality of any light source because it decides whether the color rendition of his transparencies and slides will appear "natural" or "wrong." In this respect, he must distinguish between light sources with the following color temperatures:

174

Daylight (can vary between 1500 and 27,000 K)
Electronic flash (6000 to 6800 K)
Blue-lacquered flashbulbs (6000 to 6300 K)
Direct sunlight (6000 K)
Standard daylight (approximately 5500 K)
Blue-glass photoflood lamps (4800 to 5400 K)
Clear flashbulbs, zirconium (4200 K)
Clear flashbulbs, aluminum (3800 K)
Amateur photoflood lamps (3400 K)
Professional tungsten lamps (3200 K)
100-watt general-purpose lamps (2900 K)
40-watt general-purpose lamps (2750 K)

That a natural-appearing color rendition can be expected only if the color of the incident light matches the color of the light for which the film is balanced has been stressed repeatedly. Likewise, the fact that light of the "wrong" color temperature can be converted to light that is "right" by using the appropriate filter. In this respect, whether or not a color shift due to light p. 76 of incorrect color temperature will be noticed in the transparency depends partly on the colors of the subject: If strong and highly saturated colors prevail, a color shift of up to 200 K will often go unnoticed or at least not be found objectionable. On the other hand, if subtle colors and pastel shades predominate, and especially if the subject contains areas of neutral medium gray, a color shift as small as 50 K can make the difference between acceptable and unacceptable color. Under normal conditions, for example, pictures taken on Type B color film in 3400 K photoflood illumination will already appear somewhat too blue and "cool"; conversely, pictures on Type A film taken by 3200 K tungsten light will appear slightly yellow and too "warm."

While we are on the subject of color shift, it should be pointed out that any photolamp will yield light of the listed color temperature only if it is operated at the specified voltage. If the voltage is lower, the light shifts toward yellow; if the voltage is higher, toward blue. In this respect, experience has shown that each increase or decrease of 1 volt produces a color shift equivalent to 10 K. And since a drop of 5 volts is nothing unusual during peak hours in the city, the resulting color shift of 50 K can be serious. To guard against this possibility, discriminating color photographers incorporate into their electrical system a constant voltage transformer that automatically compensates for such fluctuations.

Duration. The advantages and drawbacks of continuous and discontinuous light—incandescent light and flash—have already been discussed. What I p. 170 want to emphasize here is the fact that these two forms of light are not interchangeable but complementary, each fulfilling a specific purpose: Contin-

uous light, by enabling the photographer to *see precisely* what he is doing, is unsurpassed in cases in which an AC outlet is within reach and the subject more or less static. Flash, on the other hand, is indispensable when it becomes necessary to "freeze" action and motion, when a *cool* yet relatively powerful source of light is needed (for example, in close-up photography of live insects), or when artificial light is required but no AC power outlet is at hand. However, the current craze for small speedlights at the expense of incandescent photolamps is, in my opinion, as unjustified as the fantastic popularity of the 35mm single-lens reflex camera at the expense of larger instruments. Although, theoretically, flash can expose a piece of film just as correctly as tungsten light, an incandescent lamp, provided it can be used at all, will, for reasons discussed before, always do a better job, just as a larger camera, if applicable at all, will do a better job than a 35mm SLR. Which leads me to believe that the present popularity of 35mm SLR's and speedlights is due more to laziness on the part of the photographer (both are smaller and easier to use than other types of cameras or lights) than to an intrinsic superiority.

p. 170

THE TYPES OF LIGHT SOURCES

As photographers, we have a choice of two basically different light sources:

The sun (or natural light)
Artificial light sources

The sun

pp.160-166 We have said much about the characteristics of sunlight—its versatility in regard to brightness, contrast, and color; its different forms under different atmospheric conditions; its "naturalness"; and so on. But we should point out one quality so far not discussed: Over large areas, sunlight on clear as well as on hazy or cloudy days is of an unsurpassed evenness; there is never a "hot spot" or any light falloff toward one side of the picture. In cases in which uniformity of light distribution is imperative, for example, in copying a painting, the greatest problem is to illuminate the subject evenly if artificial light is used. But take the painting (or any other subject) out into the open, and no matter where you place it (just as long as it is not partly in sunlight and partly in the shade), it will be evenly lit. You don't even have to bother making spot checks with a light meter.

Sunlight—whether on a clear, hazy, or cloudy day—is natural light *par excellence*, and this feeling of naturalness can at best be equaled, but never surpassed, by any form of artificial illumination. But whereas it is very easy to go wrong (and achieve an unconvincing effect) in trying to arrange a natural-appearing illumination with artificial light, with sunlight this is an impossibility. The lighting effect may be too harsh, or too flat, or the color may appear to be way off, but to the experienced eye, it will still be "natural," although perhaps unusual. And this, in my opinion, is the photographically most valuable quality of sunlight.

Artificial light sources

The range of different forms of artificial light by which photographs can be made is virtually unlimited, and so is the roster of light-producing or moderating devices. To mention them all is practically impossible, nor is this necessary since, for photographic purposes, they can be divided into a few groups, the members of which are basically alike. In this respect, understanding one means understanding all. Furthermore, going into detail here would be a disservice to the reader because, as elsewhere in photography, progress in the field of lamp design is so rapid that products described today may already be discontinued, if not obsolete, tomorrow. I therefore will go only into the principle of the different types of photolamps, then send the reader to the nearest photo store to see and try out different representatives of each type for himself.

Basically, any photolamp consists of three main parts:

The light source
The reflector
The support

Occasionally, this basic design is supplemented by auxiliary devices:

A light-gathering device
A light-diffusing device
A light-restricting device
A light-coloring device

These components are then assembled in the form of a photolamp that may belong to one of four types:

Floodlights
Spotlights
Fluorescent lamps
Flashlamps

The light source

Photolamps can be equipped with one of nine different light sources, each having its own specific characteristics. And while all can be used in conjunction with black-and-white film, their use with color film is always restricted to p. 76 one specific type of film unless the applicable color-conversion filter is used.

Photoflood lamps (3400 K) look like large, frosted household bulbs but produce considerably more light per watt; as a result, they only have a life span of a few hours. They come in two sizes of 250 and 500 watts, respectively, and must be used in suitable metal reflectors. They produce a semi-diffused type of light and are designed for use with Type A color film.

Reflector floods have their own reflector built right into the bulb; as a result, they do not require separate metal reflectors. They produce semi-diffused light and come in two types: 375-watt (3400 K), suitable for use with Type A color film; and 500-watt (3200 K), suitable for use with Type B color film.

Professional tungsten lamps (3200 K) come in different sizes ranging from 500 to 5000-watt and must be used in suitable metal reflectors. Since their light output per watt is slightly less than that of photoflood lamps, they have a somewhat longer life span. They are designed for use with Type B color film.

Tungsten-halogen lamps (formerly called Quartz-Iodine lamps) have a tungsten filament mounted inside a Vycor or quartz tube filled with iodine or bromine gas, which prevents the gradual darkening of the tube with age (unavoidable in ordinary tungsten lamps). As a result, the light output of these lamps remains virtually constant during their 25 to 30-hour life. They produce an intensely brilliant light and are powered either by AC house current or a battery pack; consequently, they can also be used outdoors for shadow fill-in illumination or at night. Tungsten-halogen lamps come in two types with color temperatures of 3400 K and 3200 K, suitable for use with Type A and Type B color films, respectively.

Projection bulbs are special high-intensity tungsten filament lamps designed to conform to the optical requirements of projection systems. They come in a variety of different sizes ranging from 150 to 1000 watts and usually have a color temperature of 3200 K. They are used to power spotlights.

Blue-glass photoflood lamps (4800 to 5400 K) are ordinary photoflood lamps that have a blue instead of a colorless bulb, and must be used in suitable metal reflectors. They are intended primarily to provide shadow fill-

178

in and supplementary illumination in daylight color shots of interiors in which the main light source is daylight coming through windows. They must be used with daylight-type color film, but because their light is somewhat more yellow than standard daylight, if they provide the only source of illumination, the resulting transparencies will have a warmer, more yellow overall tone than photographs taken in standard daylight—an effect that, however, can be quite pleasing.

Fluorescent tubes are, as pointed out before, basically unsuitable for color p. 169 photography. However, since this form of light is widely used, not only in offices and industrial installations, but also in homes, taking color photographs in fluorescent light is often unavoidable. If this is the case, suitable filtration is usually a necessity and should be carried out in accordance with the instructions given before. In conjunction with black-and-white film, fluorescent p. 169 tubes, particularly if gathered together in the form of banks, are eminently suited for overall illumination if a softly diffused type of light is required. Such light banks are usually assembled and built by the photographer himself in accordance with his specific needs in regard to wattage and size.

Flashbulbs, formerly available in a generous number of types and sizes specifically designed for different purposes, are more and more being replaced by electronic flash. They are used today mainly in the form of clusters —Flashcubes or FlipFlash bars suitable for use with daylight-type color film— mounted atop inexpensive snapshot cameras.

Gaseous discharge tubes provide the light source for electronic flash (speedlights). They produce a brilliant, discontinuous light of extremely short duration that is easy on the eyes of a model; as a result, this form of light is particularly popular in portraiture and for ID pictures. Gaseous discharge tubes can be powered either by batteries or AC current, and their color temperature (6000 to 6800 K) is compatible with daylight-type color film.

The reflector

We distinguish between two types of reflector: *lamp reflectors*, which are part of an illuminating system; and *reflecting panels*, used primarily to lighten shadows with *indirect*, reflected light.

Lamp reflectors. The purpose of a lamp reflector is to make the most efficient use of the light emitted by a photolamp: to direct it toward the subject that is to be illuminated; to prevent part of it from being wasted in a direction away from the subject; and to block spill light from entering the lens because this might cause flare and halation on the film.

179

Lamp reflectors are made in three basically different types: spherical, parabolic, and elliptical. Spherical reflectors produce a broadly diverging beam of light equally suitable for overall and shadow fill-in illumination. Parabolic reflectors produce a beam of more or less parallel light and are used mainly in spotlights where they form an integral part of the optical system. Elliptical reflectors produce a converging beam of light when the lamp is positioned at its focal point and are used mainly in enlargers.

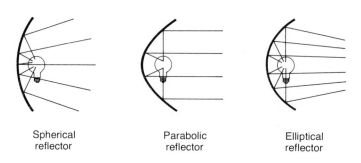

Spherical
reflector

Parabolic
reflector

Elliptical
reflector

Now, whereas the reflectors of spotlights and speedlights form part of their optical system and the photographer must take them as they come, he has quite a choice when it comes to selecting reflectors for photoflood lamps. To make the right choice, he must know the following:

The larger the reflector, the more diffused the light and the softer the shadows, and vice versa. Reflectors with pressed-in rills and ridges produce a softer, more diffused light than reflectors with an even curvature. Reflectors with a polished reflecting surface produce a more contrasty light and deeper and more sharply delineated shadows than those having a satin-finished or semi-matte surface. Spherical reflectors yield the most even light distribution while parabolic and elliptical reflectors usually have "hot spots"—relatively small areas of more intense brightness than the rest—which appear at a specific distance from the lamp, this distance depending on the focusing characteristics of the respective reflector and the distance between reflector and lamp.

p. 104
Reflecting panels are used to lighten with *indirect* (reflected) light those subject areas covered by shadows and thereby reduce the lighting-contrast ratio of the illumination to a level that is more compatible with the contrast range of the film and the intentions of the photographer.

The size of a reflecting panel should be at least as large as the area that has to be "filled-in" with indirect light. For close-ups of small objects of nature such as shells, a 5″ × 5″ piece of white cardboard stuck to the end of a stiff

180

wire (from a wire clothes hanger) may already be sufficient (and very easy to manipulate into just the right position); in portraiture, a 3' × 3' panel may be needed. And for more extensive setups, so-called *reflector flats* 4' × 8' or 8' × 8' mounted on casters will often be found invaluable, particularly if one side is painted white and the other black.

For panels up to 16" × 20", stiff white cardboard is excellent, while for larger panels, thin plywood sheets are best. To get the maximum use out of plywood panels, one side should be painted with a flat white paint, the other covered with finely crinkled aluminum foil for somewhat higher reflectance. Mirrorlike reflecting panels (mirrors, ferrotype plates) yield indirect light that is specular and unsuitable for shadow fill-in purposes because it is directional, casting the same kind of shadow as the primary light source it reflects.

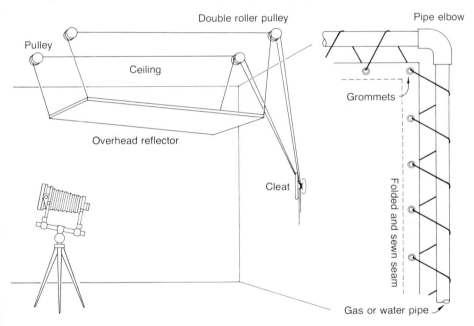

Suspension arrangement of an overhead reflector and a detail of its construction.

An overhead reflector can be a useful piece of equipment in cases in which the ceiling is unsuitable as a reflector, perhaps because it is too high, not white, or cluttered with heat and air ducts, braces, girders, rafters, or beams. Such overhead reflectors consist of an 8' × 10' or 10' × 12' frame made of galvanized gas pipe and a reflecting surface of heavy white canvas stretched and laced inside the frame in accordance with the accompanying sketch.

The frame is suspended by clotheslines attached to its four corners, which then pass through double roller pulleys fastened to the ceiling, and from there

181

to a cleat on the wall, permitting the photographer to adjust the reflector at any angle and in any desired position. When not in use, it is hoisted flat against the ceiling.

p. 133 **Umbrella reflectors,** as mentioned before, are excellent sources of highly diffused light equally suitable for main and shadow fill-in illumination. They are most often used in conjunction with electronic flash.

The support

To hold a photolamp in the required position, a suitable support is needed. In this respect, we distinguish between three types: light stands, spring clamps, and camera mounts.

Light stands come in many sizes and are rigid or collapsible. Inexpensive collapsible light stands are often so flimsy that they are all but useless. Points to consider when choosing a light stand are the weight and degree of solidity of the stand, the height to which it can be extended, and the width of its base, which is a measure of its stability. The heavier types of photolamps, and in particular spotlights, require correspondingly strong and heavy stands to support them safely. For professional studio use, noncollapsible heavy-duty light stands mounted on dollies are recommended for all but the smallest and lightest types of lamps.
An unusually practical form of light stand is one equipped with a counterbalanced boom, which converts an ordinary photolamp into a *boomlight*. Such boomlights have over lights mounted on regular light stands the priceless advantage that they enable the photographer to get the lamp into any—repeat, *any*—position without the light stand ever appearing in the picture or otherwise getting in the way. Overhead illumination, for example, is virtually impossible to achieve with a lamp mounted on an ordinary light stand, but is a cinch for a boomlight. If the boom is adjusted in a vertical position, such a boomlight can be used like any ordinary light-stand-mounted lamp.

Spring clamps permit a photographer to dispense with light stands altogether by clipping the lamp directly to any suitable support, for example, the back of a chair, the edge of a shelf or door, a table leg. Such clamps come in two types: with rubber-covered grips attached to an aluminum reflector, and as "Gator Grip" clamps with toothed jaws to the upper clamp to which the lamp is mounted. Despite the fact that such clamps can support only relatively light lamps (up to 500-watt floodlights in reflectors), they are very practical devices particularly for the traveling photographer, but also because

182

they enable him to use a photolamp in a place or position where an ordinary light stand cannot get.

Camera mounts are used only in conjunction with flash, either by flashbulb or by speedlight. They permit attachment of a small battery-powered light source directly to the camera and fire the flash in synchronization with the shutter. Since these lamps deliver only "flat" frontlight, their usefulness is very limited.

p. 91

A special type of camera-mounted photolamp is the *electronic ringlight*, a gaseous discharge tube that encircles the lens and produces a completely shadowless illumination. In cases in which this form of light is needed, a ringlight is a priceless addition to any camera.

p. 134

Auxiliary devices

Light-gathering devices are condensers and Fresnel lenses. Their purpose is to gather the light emitted by a projector-type bulb and convert it into a beam of more or less parallel light. In comparison to condensers, Fresnel lenses have the advantage of being thinner, lighter, less likely to affect color rendition, less expensive, and more heat-resistant than the much thicker condensers; the latter are more subject to internal strain often followed by cracking under the influence of heat. A Fresnel lens (less often a condenser) forms an integral part of any spotlight.

Light-diffusing devices are the diffusing screens already discussed. They can be used in conjunction with any type of photolamp and convert parallel light (from spotlights) into diffused light and semi-diffused light (from photoflood lamps) into still softer light. To be most effective, they must be larger in diameter than the lamp in conjunction with which they are used and mounted so far out in front of the reflector that they are completely illuminated by the bulb.

Light-restricting devices come in three different forms: barndoors, snoots, and gobos. The first two are attached directly to the photolamp, the last one is interposed between the camera and a lamp.

Barndoors (or gates) consist of a pair of hinged flaps that can be set at any angle to more or less restrict the spread of light and thereby prevent it from spilling into areas where it is not wanted. Commercially available barndoors are made of sheet metal and can be rotated in front of the lamp for adjustment in any direction. In an emergency, however, pieces of cardboard taped to the sides of the lamp will do almost as well. Barndoors can be used in conjunction with either spotlights or photoflood lamps in reflectors.

Snoots are black metal cylinders or cones open at both ends and mounted in front of spotlights to reduce the diameter of the light beam. They are available in different diameters and lengths, permitting the passage of wider or narrower beams of light in accordance with the demands of different situations. In an emergency, tubes fashioned of cardboard or black paper and taped to the spotlight will do just as well but are less convenient.

Gobos are pieces of stiff, flat, black material supported by stands, which can be interposed between the camera and a photolamp to prevent unwanted light from shining into the lens as this might cause flare and halation on the film. Gobos are usually home-made of black cardboard or fabric sewn around a wire frame; they can have any shape or size but are normally rectangular and approximately 10″ × 15″.

Light-coloring devices for use on photolamps consist of sheets of gelatin or acetate in various colors. Their purpose is to give a white background a specific color (which is easier and faster to accomplish by filtration and projection than by painting), but sometimes also to partly or entirely suffuse a setup with a certain color shade (for example, to give a scene a warm and rosy glow, or a cold, ice-blue tone). They are attached in front of the respective photolamp either by means of a channeled frame or with tape.

The types of photolamps

The four lamp designs described in the following are not interchangeable. Each has its own specific qualities that make it particularly well suited to certain kinds of photographic work and less suited, or not suited at all, to others.

Floodlights. The floodlight is the "work horse" of any photographer using artificial light. It produces a semi-diffused type of light that is equally well suited for main light, overall, and shadow fill-in illumination. Floodlights consist of either "frosted" or clear light bulbs in aluminum reflectors and come in a large variety of sizes and designs. The smallest practical size has a 250-watt bulb in a 10-inch reflector; the most commonly used size has a 500-watt bulb in a 12-inch reflector. To illuminate more extensive areas evenly, larger 16 or 24-inch reflectors equipped with 1000-watt mogul base bulbs are available; these, incidentally, are unsurpassed as main lights.

The quality of floodlight illumination can be softened but not made more contrasty. This is done with the aid of diffusing screens attached in front of the lamp. Alternatively, special "capped" bulbs can be used, the front of which

is shielded by a small metal cap that prevents direct light from reaching the subject. Instead, the light is turned back by the cap toward the lamp reflector, which, in turn, reflects it onto the subject; the subject, in turn, is illuminated entirely by softly diffused light.

If color photography is planned, the color temperature of the bulb with which the lamp is equipped must match that for which the film is balanced; in this respect, the choice is between 3200 K and 3400 K bulbs, as explained before. p. 168

Floodlights can be gathered together in the form of banks for uniform area illumination. Such banks can consist either of strips or "broads" of 2, 3, or more lamps arranged in a row, or, for use in larger studios, 9 or 16 lamps arranged in the form of a square and mounted together in a common frame. This frame in turn is either mounted on a heavy-duty light stand on a dolly or suspended from the ceiling in the manner of the overhead reflector described before. p. 181

Spotlights are lamp systems consisting of a high-efficiency projection-type bulb, a mirror-finish reflector behind it, and a Fresnel lens in front of it that gathers the light into a more or less parallel beam. A focusing arrangement permits the photographer to adjust the diameter and intensity of this beam at the subject plane from narrow, brilliant, and very contrasty to somewhat wider, softer, and less bright (this operation is called "flooding out").

Except for color, the quality of the light produced by a spotlight is very similar to that of direct sunlight. It is specular light, providing a high-contrast illumination with hard-edged, deep-black shadows. This type is particularly well suited to main light and overall illumination provided that the shadows are adequately lightened with diffused fill-in light. It is totally unsuited to shadow fill-in light. The color temperature of most spotlights is 3200 K, suitable for use with Type B color films. p. 160

Spotlights come in a large variety of sizes ranging from 100-watt "baby spots" suitable only to tabletop photography to 5000-watt "sun spots" for overall illumination in large studios. For general purposes, a 500 or 750-watt spotlight is most convenient. For use as an accent light, a 150 or 250-watt spotlight will do very well, particularly in portrait photography where it will be used to highlight the hair. For greater versatility, every spotlight should be equipped with barndoors and a set of snoots. p. 206

pp. 183, 184

When choosing a spotlight, a photographer should pay attention to the following points: The Fresnel lens should be as white as possible to make the lamp suitable to color photography (some Fresnel lenses are rather greenish in tone and require the use of a reddish color-compensating filter). When projected onto an even, white surface, the circle of the beam should be uniform in brightness, free from a more or less pronounced "hot spot" or p. 82

filament patterns. The front of the lamphouse should have provisions for attaching barndoors, snoots, and filters. The lamp housing should be adequately ventilated (the exterior should not become too hot to touch) yet effectively light-trapped in order to reduce spill light to an absolute minimum. Replacing a burned-out bulb must not be too difficult. And as an added convenience, focusing should be from either end of the lamp.

Fluorescent lamps, as repeatedly mentioned, are basically unsuited to color photography. To the black-and-white photographer, however, they provide an excellent source of cool, softly diffused, and very even light equally suitable to covering large areas with floodlight and for shadow fill-in. In addition, fluorescent tubes provide the best illumination for light-boxes and viewing boxes for color transparencies.

Because they will be used mainly for broad-area illumination, fluorescent tubes are usually gathered together in the form of banks. As described before, these banks are either mounted on heavy-duty light stands (for front- or sidelight) or suspended from the ceiling for general overhead illumination.

Flashlamps come in two basically different forms: as flashbulbs and as electronic flash. The first type, except for blue Flashcubes and FlipFlash bars, is virtually obsolete today and can here be disregarded.

Electronic flashlamps or speedlights come in a bewildering variety of sizes and models ranging from units small enough to be mounted on top of 35mm cameras to heavy-duty professional models costing thousands of dollars and powerful enough to illuminate entire convention halls. But despite these differences, all speedlights share the following characteristics:

1. A flash duration short enough to stop virtually any kind of motion, completely eliminating worry about image blur due to movement of either the subject or the camera.

2. Uniformity of light output. Provided the unit is given sufficient time to fully charge its capacitor, one flash will be exactly like the next; as a result, exposures can be calculated on the basis of guide numbers.

3. Light of a color comparable to that of standard daylight. Consequently, color photographs taken on daylight-type color film usually show excellent color rendition.

4. Synchronization with between-the-lens shutters is possible at any speed. But with focal-plane shutters, synchronization is possible only at relatively low speeds (maximum usually 1/60 sec.) since, at higher speeds, these shutters are not fully open during the flash with the result that only a strip of the film would be exposed.

186

5. Inability on the part of the photographer to see where the light hits and where the shadows fall, except in the case of large studio models that have small and rather inadequate incandescent guide lights built into the lamphead.

6. Impossibility of measuring the light with ordinary light meters (whether hand models or those built into the camera, whether reflected-light or incident-light meters), compelling the photographer to calculate his exposures on the basis of guide numbers (furnished by the speedlight manufacturer), which differ for each model and are not always reliable. However, special strobe-light meters (quite expensive) exist for use in the studio.

7. High initial cost but low cost of operation.

Mode of operation. Speedlights are powered either by batteries or AC current; some models can alternatively be powered by either one.

Battery-powered speedlights come in two types, one powered by high-voltage batteries, the other by low-voltage batteries. Each has advantages and drawbacks. The recycle time—the time required to get the capacitor fully charged and ready for the next flash—is much shorter for speedlights powered by high-voltage batteries than for those that rely on low-voltage batteries. This is a sometimes decisive advantage appreciated especially by news and documentary photographers for whom success may depend on how soon they can be ready to fire again. In addition, speedlights equipped with high-voltage batteries are more compact than low-voltage-operated units and simpler in regard to their circuitry and therefore more reliable. On the other hand, high-voltage batteries are quite expensive, deteriorate relatively fast even if not used and, worst of all, cannot be recharged.

Low-voltage-powered speedlight units can be equipped with one of two types of batteries of which the rechargeable nicad (nickel-cadmium) cell is the more popular one. A disadvantage is the fact that once the battery is exhausted, it must be recharged. This, of course, takes time, and unless the photographer has a spare unit ready, he is temporarily grounded. Photographers who don't like this idea usually prefer to work with ordinary flashlight batteries despite the fact that they cannot be recharged and have to be discarded when spent. But they are available everywhere, an adequate supply can easily be carried, and exchanging batteries takes almost no time.

Light output and exposure calculation. This is a field characterized by confusion because several methods for indicating the brightness of electronic flash exist, all incompatible with one another and none of them really accurate. This is particularly unfortunate in view of the fact that normally the only way of computing an exposure with electronic flash is on the basis of some guide number, whether in the form of watt-seconds, BCPS, ECPS, or K II

(K 25) numbers. The following is intended to clarify the situation as far as this is possible.

Originally, speedlights were rated in watt-seconds, 1 watt-second being equal to a light output of approximately 40 lumen-seconds. However, since the watt-second figure for a specific unit was arrived at by simple calculation based on the charge held by the capacitor, it was nothing but an estimate of raw electric power that completely disregarded the fact that this available electric power could be spent efficiently or wastefully depending on the circuitry and the reflector and flashtube design. As a result, speedlights of equal watt-second ratings often delivered flashes of different brightness.

In contrast, BCPS (beam candlepower seconds) and ECPS (effective candlepower seconds) ratings relate directly to exposure insofar as doubling the rating, say, from 800 to 1600, actually equals a difference in exposure of 1 f/stop; in other words, if an 800 BCPS-rated unit requires an exposure at f/8, a 1600 BCPS-rated unit would permit stopping down the lens to f/11 under otherwise identical conditions.

At the time of writing, the most popular system of rating speedlights is in the form of guide numbers relating to the speed of Kodachrome 25 Daylight film (formerly Kodachrome II): *Guide number divided by subject-to-flash distance equals appropriate f/stop number.* This is fine as long as a photographer works with K 25 but requires recalculation or conversion if a film with an ASA speed different from that of K 25 is used. (Both K II and K 25 have a rating of ASA 25.)

In view of all this uncertainty, this author recommends that the reader establish by test his own K 25 guide number, the one that *accurately* represents the light output of one particular speedlight. He can do this by taking a number of exposures with different f/stops on K 25 film bracketed at ½-stop intervals around a value that allegedly is correct on the basis of the "official" K 25 rating of his unit. The subject should be placed at a distance of 10 feet (this makes later calculations easier) and the photographer should take notes on the f/stop number with which each shot is made. The best way to do this is to write each f/stop number big on a white card and let the subject hold it up to the camera so that it becomes part of the photographic record. The developed slides should be examined and the best exposure picked out. Since the f/stop number that was used for this shot is known, the *accurate* K 25 guide number for this specific flash unit can then be calculated in accordance with the following formula:

Guide number = f/stop number multiplied by subject-to-flash distance in feet.

For example, if the guide number for the unit was 40 and the subject-to-flash distance 10 feet, the best exposure should have been the one made

at $f/4$. However, in this particular case, let's assume that the best exposure was the one made at $f/3.5$, not the one at $f/4$. Accordingly, the efficiency of the speedlight was overrated by the manufacturer and its *actual* K 25 guide number is *not* 40, but 35.

Calculated or automatic exposure. Each time he takes a speedlight shot at a different subject distance, a photographer has to recalculate the required f/stop. This, of course, is a nuisance, and not even a guarantee for a perfect exposure since misjudging the distance by only 2 feet, say, guessing at 5 instead of 7 feet, already makes a difference of 1 full f/stop. Furthermore, it obviously makes a difference whether a shot is made (at the same distance) in a small, white-walled room or outdoors at night. In the first instance, an abundant amount of reflected light would require a considerably shorter exposure (here: smaller f/stop) than would be needed in the second case, which is characterized by a total absence of light reflected by the surrounding. Yet, in both cases, the *calculated* exposure would have been the same.

As a way out of this predicament, speedlight designers invented the automatic-flash exposure. It is based on the principle of feedback: Light reflected from the flash-illuminated subject hits a photo-conductive cell that, via a special electronic circuit, diverts the surplus of the electric charge into a "black" (nonlight-emitting) tube as soon as the required exposure level has been reached. Other, more advanced systems simply stop the flow of power at the right moment without wasting part of the flash, as a result of which the battery lasts longer. Still more sophisticated speedlights feature detached sensing cells that permit the photographer to automate even bounce-flash exposures by pointing the cell at the subject, and the flash, via a swivel head, at the ceiling or wall. As a matter of fact, things are in such a flux and improvement follows improvement at such a rapid rate that it would be pointless to go into detail here since today's marvel may already be superseded by a still more fantastic innovation tomorrow. All I can do here is to alert the reader to the potential of automatic electronic flash—and let the photo dealer do the demonstrating.

p. 145

HOW TO CHOOSE YOUR LIGHTING EQUIPMENT

Which types of photolamps and how many of each a photographer should have depends primarily on the kind of work he wishes to do. In this respect, the requirements of an amateur who likes to do a bit of everything without specializing in anything are, of course, quite different from those of, say, a portraitist (a specialist) whose needs again are different from those of a commer-

189

cial studio operator who, in turn, requires a set of lamps that is different from those needed by a photographer who specializes in "on-location" shots of children, weddings, and pets.

It therefore should be obvious that it is impossible to compile itemized lists of lighting equipment for each and every purpose. It is, however, possible to establish guidelines that can help a photographer to choose the lighting equipment best suited to his own specific needs. The following contains the essence of what I found useful in this respect:

The three most important questions to ask yourself before you go to the photo store to buy your lighting equipment are: (1) How much can I afford to pay? (2) Do I want to photograph static or dynamic subjects, or, perhaps, both? (3) Do I intend to use my equipment always in the same place, or do I wish to travel with it?

The answer to 1: Buy only quality equipment. One high-quality light is worth any number of cheap and flimsy lamps with tinny, easily dented reflectors and sockets, switches, cords, and plugs that soon break down, making the entire "investment" valueless.

The answer to 2: If you only want to photograph static subjects within reach of an AC outlet, you need only floodlights and spotlights; if dynamic subjects, you need electronic flash; if both, you need both. In this respect, a "static" subject is one that holds still (this includes a "posed" person); a "dynamic" subject is one that is in (usually unpredictable) motion (this usually means "people").

The answer to 3: If you always photograph in the same place (your home, a studio), portability of the equipment is no problem; hence, you should buy the heaviest lamps and light stands you can afford because these are always the best. However, if you intend to carry your lighting equipment with you—because you have to photograph "on location" (in other people's homes, in factories, on your travels)—weight and size, that is, the degree of "portability," are important considerations, influential factors in your choice of photolamps and light stands. In that case, reflector floods, because they have their own reflectors built right into the bulb and need no space-consuming metal reflectors, are preferable to ordinary photolamps; clamp reflectors and "Gator Grip" clamps can often replace some light stands; and light stands that have many sections (and are correspondingly short when collapsed) are preferable to those with fewer but longer sections.

Floodlights are indispensable for photographing static subjects (provided, of course, an AC outlet is handy); spotlights are not.

Speedlights are more often bought as status symbols than because of need. They are expensive in terms of the number of floodlights that could be had for the same price. Mounted atop a camera, they produce "flat" frontlight, normally an undesirable type of light.

p. 91

190

Speedlights are *really* indispensable only in three cases: if motion must be "stopped" in the picture; if a photolamp is needed away from an AC outlet; if a high-intensity source of *cool* light is required.

It is not the number of different lamps that determines whether a photograph will be effective or not, but the way in which a photographer uses them. Impressive portraits have been made with only a single photolamp in conjunction with a simple home-made panel reflector. In other words, you probably need fewer lights than you think.

All a beginner needs for a good start is one 250-watt photoflood lamp in a 10-inch reflector, one 500-watt photoflood lamp in a 12-inch reflector, one 150-watt baby spotlight, and some home-made reflecting panels and diffusers. And not until he has mastered the use of these few pieces and is convinced that he needs more lamps should he acquire additional lights.

A counterbalanced boom atop a regular light stand converts an ordinary photolamp into a boomlight. In my opinion, it is one of the most useful p. 182 accessories a photographer can buy—a piece of equipment indispensable to anyone who wishes to create freely with light.

An umbrella reflector is the "secret weapon" of the photographer whose p. 133 work is admired for its sensitive use of softly diffused light.

Advice on the use of electric power

Residential electric wiring is dimensioned for average household needs, but in comparison to ordinary household bulbs, most photolamps require huge amounts of power. If their demand exceeds the carrying capacity of the line, the consequences can be serious, ranging from the relatively harmless blowing of a fuse to a potentially disastrous fire. It is therefore of vital interest to any photographer to know how many lamps he can safely connect to any one electric circuit. To find out, he must multiply the voltage of the power line by the number of amperes of the respective fuse. The result is the number of watts that can safely be drawn from the circuit. For example, if the line carries 120 volts and the fuse can take a load of 15 amperes (this is the most common combination), multiply 120 by 15. The result is 1800 watts, the maximum load that may be drawn from the circuit without the danger of blowing a fuse. This means that you can simultaneously use three 500-watt bulbs, or two 500-watt and three 250-watt bulbs, or one 500-watt and five 250-watt bulbs, or seven 250-watt bulbs. This still leaves 50 watts available for other purposes, like, for example, a weak table lamp for general room illumination between shots.

If more, or more powerful, lamps must be used, the electric load must be distributed over two or more circuits. To find out which outlets belong to the same circuit, connect one low-wattage lamp to every outlet, then unscrew the

fuses one at a time. All the lamps that go out when a specific fuse is removed connect to the same circuit, while those that stay lit are controlled by a different fuse. To avoid going through this rigamarole every time you wish to photograph, mark all the outlets belonging to the same circuit with the same identifying number or color code.

The fuse is the safety valve of the power line. It is a deliberately introduced "weakest link" designed to break harmlessly under overload in order to protect the line itself from destruction. Therefore, an accidentally blown fuse must *never* be replaced by a stronger one, a coin, or a wad of aluminum foil because, in that case, the next time it will be the power line that "gives," and the resulting short circuit may start a fire that can burn down the house.

The chances of blowing a fuse can be substantially reduced by adhering to the following suggestions:

Don't reconnect electrical equipment that caused a fuse to blow without first having found and eliminated the cause of its malfunction.

Don't use electrical wires with cracked, frayed, gummed, or otherwise damaged isolation or broken plugs. Discard them and replace them with new ones.

When disconnecting a plug, don't grab the wire and yank; this is a sure way to tear a wire from its contact points. Instead, take a firm hold on the plug itself and pull it out straight.

Make sure that temporarily strung electric cords are placed in such a way that people cannot trip over them. Lay them along the walls, behind furniture, or cover them temporarily with rugs.

Don't overload your connecting and extension cords. Be sure that wires are of sufficiently heavy gauge to carry the intended electrical load. When in doubt, ask the clerk at the store where you buy the wire for the proper gauge. After the equipment has been in use for a while, put your hand firmly around the cord; it may get warm but should never feel uncomfortably hot—a sure sign of an overloaded wire.

It is not only unlawful, but also dangerous, to nail or staple ordinary rubber-insulated electric wires to baseboards, door frames, walls, or ceilings. This type of wire is not meant for permanent installation. Only metal-sheathed B-X cable is safe for fixed installations, and it should be installed by a licensed electrician.

When splicing an electric wire, first solder both connections, then insulate each of the two strands separately with moisture-proof tape before you tape the entire splice. If feasible, making a plug connection is even better.

When you buy electrical equipment or wiring, try to get items that carry the UL (Underwriters Laboratories) label. It is a guarantee that they conform to certain minimum safety standards, which merchandise lacking this label may not meet.

VI. The Use of Light

This is the moment of truth—the moment when the reader is in possession of all the pieces of the puzzle. All that remains for him to do now is to fit them together, and he can see the picture that existed already latent in the jumble of previously discussed facts emerge in all its beauty.

He knows by now *what light is* (Part I) and what its *functions* are (Part II); he is familiar with the *qualities* of light (Part III) and the different *forms* it can take (Part IV); he has a working knowledge of the various *sources of light* (Part V). Now he must learn how to integrate this knowledge and transform it into performance.

To do this, he must "go practical." From here on, reading is no longer enough. Now, he must take out his camera and lights and start practicing— doing his "finger exercises" in accordance with the assignments that will follow as soon as we have established the principles that are the basis of all good lighting schemes.

The principles of good lighting

1. Keep it simple. Remember, the most natural of all lighting arrangements uses *only one* light source—the sun. In other words, don't use two lamps if one can do the job. Normally, the effect of a photograph made by artificial light is inversely proportional to the number of lamps that were employed. Too many lamps and too much light can ruin any lighting scheme.

2. Always work from darkness toward light. Before you start setting up your photolamps, reduce the room illumination to a level just light enough to enable you to see what you are doing, but not so bright as to interfere with judging the effect of your lamps.

3. Arrange your illumination step by step. Always start with the main light. Never add an additional lamp until the previous one has been placed to your satisfaction. Study the effect of each lamp by itself (with all the other lights turned off). Then, switch all the other lamps on again and leave them on while turning the newly added lamp on and off repeatedly to evaluate its effect relative to the other lights and the lighting scheme as a whole.

4. Place your shadow fill-in lamp above the level of the lens and as close as possible to the optical axis (in the horizontal plane) but on the opposite side

193

from the main light. In this way, the shadow it casts will be as small and unobtrusive as possible.

5. Keep your fill-in lamps well diffused to avoid one of the cardinal sins of photographic lighting: shadows (cast by a fill-in lamp) within or crossing shadows cast by the main light.

6. When in doubt, filling-in the shadows too little is better than lightening them too much. In other words, a fill-in lamp that is too weak is better than one that is too strong. A fill-in lamp that is too strong produces the same flat effect as flash at the camera. And flash at the camera is normally the least desirable form of light.

7. The greater the distance between subject and lamp, the weaker the light at the subject plane, the sharper-edged the shadows, and the smaller the highlights on curved, shiny surfaces.

8. No matter how many photolamps are actually used, the impression must be that of a subject illuminated by only a single light source. In other words, there must be only a single set of shadows, all shadows must fall in the same direction, and crisscrossing shadows or shadows within shadows must not occur.

9. Unless there are good reasons for proceeding otherwise, don't place your subject too close to the background; for if you do, it will cast a more or less prominent but usually objectionable shadow on the background, which might interfere with the clarity of the presentation.

10. In portraiture, the most important shadow is that cast by the nose. It should never touch or cross the lips. If it does, the effect is that of a beard—especially ugly if the subject is feminine. Make sure that the "blind spots" in a face receive sufficient fill-in light; you find them around the eyes, in the corners between nose and cheek, and underneath the chin.

How to light a three-dimensional subject

Assignment 1: Get yourself a cube (or make one out of cardboard), paint it white, and place it on a white surface; then, take a photolamp (floodlight or spotlight) and shoot three pictures in accordance with the accompanying photographs:

1. Take your boomlight and place the lamp above and in line with the lens, illuminating the cube in such a way that each of its three visible sides receives the same amount of light. Study the effect, notice the following facts, and memorize them for future use:

1–1: A three-dimensional subject, all the sides of which reflect identical amounts of light, looks flat. It seems to lose its three-dimensional character, appearing more like a two-dimensional design than an object that has depth.

pp. 24, 115

194

1–2: Frontlight—light source at 6 o'clock above the lens—casts virtually no p. 89
shadows, a fact that is the main cause of the flat appearance of frontlighted
subjects.

1–3: Light intensity decreases toward depth more or less in accordance
with the inverse-square law; notice how the white surface on which the cube p. 16
rests is rendered light in the foreground but appears increasingly darker
toward depth.

2. Place the lamp at a 6 o'clock 70-degree position and notice the follow- p. 89
ing changes relative to the preceding lighting arrangement:

2–1: The lighting is no longer pure frontlight, but a combination of front-
and overhead light. As a result, the top of the cube receives more light than
the sides, and this difference in tone leads to a difference in "feeling": An
impression of three-dimensionality begins to emerge.

2–2: Since the two vertical faces are equal in tone, they appear to lie in the
same plane, creating a feeling of uncertainty that weakens the impression of
depth.

2–3: Notice the light band at the base of the vertical cube faces; it is
caused by light reflected from the sides onto the surface on which the cube
rests.

2–4: Notice that the light falloff toward depth (on the horizontal surface) is
more abrupt than in the first picture; this is the result of the lamp's more
vertical position, the axis of the beam meeting the ground closer to the
camera.

3. Place the lamp in a 10 o'clock 60-degree position and notice the follow- p. 89
ing changes relative to lighting arrangement number 2:

3–1: Each of the cube's three visible sides appears in a different shade,
with the result that now the subject seems to have substance, volume, and
depth.

p. 95

3–2: A strongly pronounced cast shadow further strengthens this impression. It is due to the sidelight position of the lamp, and sidelight, as we learned before, is a form of light conducive to creating impressions of depth.

3–3: Since it received no direct light and virtually no light reflected from the base or the surroundings, the darkest side is almost as dark as the shadow cast by the cube. For a "perfect picture," this shaded side would have to be filled-in lightly with auxiliary illumination, which, in this case, could easily have been accomplished with the aid of indirect light reflected from a white panel positioned to the right of the cube.

3–4: Illumination of the surface on which the cube rests is more even than in any of the two other pictures as a result of the position of the lamp.

Conclusion: A *white* cube standing on a *white* surface photographed with a *single* photolamp is about as simple a setup as you can get. Nevertheless, *merely through appropriate use of light,* impressions varying from flat to spatial could be created; white surfaces could be rendered at will either as white, in any shade of gray, or as black; planes could be made to merge as identical shades or be separated graphically by contrast. And while in the first picture the cube appeared insubstantial and flat, in the last it almost seemed to leap from the page in a convincing demonstration of illusionary three-dimensionality.

All of which goes to show the degree to which light controls the appearance of the subject; specifically, that in order to create illusions of substance and depth, different planes of the subject must be illuminated in such a way as to appear in different shades of gray.

196

Assignment 2: Demonstration of subject–background relationship. Take a *white* sphere, set it up on a spike well in front of a *white* background, and photograph it four times in accordance with the accompanying pictures, using *only one* photolamp.

2–1: Illuminate both sphere and background with shadowless frontlight. Sphere and background will appear in the same tone except for *limb darkening*—the fact that, despite flat frontlight, the edges of the sphere appear darker than the center. Later, this effect becomes important in portraiture where we deal exclusively with curved surfaces.

2–2: Shift the lamp to a 10 o'clock 75-degree position. Introducing a p. 89 shadow area strengthens the feeling of three-dimensionality, but the tonal merging of sphere and background at the upper left is objectionable.

2–3: Tilt the lamp in such a way that the sphere remains illuminated as before but the background is only partly lit. Tonal separation of sphere and background is now satisfactory.

2–4: Further tilting of the lamp toward the camera leaves the background in the dark. A touch of shadow fill-in light provided by a reflecting panel lightens the shadow side of the sphere just enough to prevent it from blending with the background.

Conclusion: Proper use of light and shadow permits a photographer to separate graphically subject and background even in cases in which the tone or color of both is the same.

197

Assignment 3: From a gift shop, get yourself an inexpensive *white* alabaster statuette, place it well out in front of a *white* background and, with the aid of a *single* photolamp, photograph it five times in accordance with the accompanying pictures.

The purpose of this "finger exercise" is to learn how to control the tone of both subject and background independently from each other solely with the aid of light—brighter or dimmer, lamp pointed this way or that.

As these pictures show, merely with the aid of light, even a setup photographically as difficult as a white subject in front of a white background can at will be rendered in any desired way—white against white, gray against gray, black against black, black against white, or white against black. In addition, any intermediary tonal shades and combinations can be produced simply by making the required adjustment in the position of the lamp when taking the picture or varying the exposure when printing the film.

Merely with the aid of light, a white object against a white background can be rendered from white against white to gray against gray to black against black; and from black against white to white against black—convincing proof of the creative power of light.

Assignment 4: Photograph the same white statuette in the same position in front of the same white background in as many different ways as you can think of, using only a single photolamp.

The purpose of this assignment is to make you aware of the almost infinite potential of light that is available to any creative photographer. Not all of the resulting pictures will be equally effective or even usable. This time, pay particular attention to the distribution of light and shadow, specifically, whether they clarify or obscure the forms and outlines of the subject, and whether or not separation between subject and background is adequate.

Also, try to duplicate the lighting effects shown in the accompanying photographs after having analyzed the respective positions of the photolamp
pp. 36, 116 in accordance with the instructions given before.

200

Main light

Fill-in light

Assignment 5: Make a portrait in accordance with the instructions given on the following pages. The accompanying photographs show the effects of the four lamps separately (this page) and in combination (opposite page) in the form of the finished portrait.

Accent light

Background light

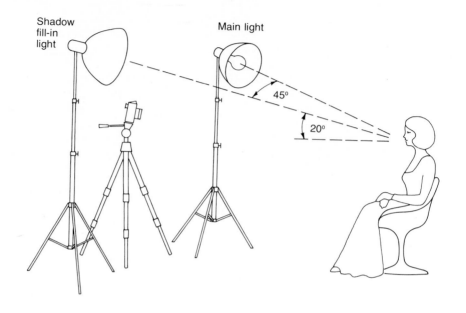

Shadow fill-in light

Main light

45°

20°

How to make a portrait

The following instructions apply to the arrangement of what might be called a standard illumination for portraits. The result, although far from original, is always pleasing and the first step on the road to mastery of the fine points not only of portrait lighting, but photographic lighting in general. Once the student knows what it is all about, he can vary the details in any way he sees fit and go on to do more original work.

5–1: Preparations. To complete this assignment, you need three identical floodlights, one small spotlight, and a live model. Seat the model comfortably 6 feet in front of a neutral background, facing the camera and looking straight into the lens (this way, the portrait will appear to look the viewer in the eyes). Extinguish the room lights but turn on a small table lamp somewhere in a corner; it should throw just enough light so you can see what you are doing, but not so much that it would interfere with the effect of your photolamps. If you can secure the services of an assistant, all the better; such a person is an invaluable asset because he or she can shift around the lamps while you remain stationary and watch the changing light effects from the camera position.

204

5–2: Place the main light, in this case an undiffused 500-watt floodlight. This is the most important of the four lamps involved in lighting a portrait, the one that through distribution of light and shadow and proportions of light and dark determines the character and mood of the picture. Its purpose is to bring out the bone structure that underlies the head and model the planes of the face. For a starter, place the main light at a 7:30 to 8 o'clock 30-degree p. 89 position relative to the head and 8 to 10 feet away. Make sure that the shadow of the nose does not touch or cross the lips (in the accompanying p. 203 photograph, the nose shadow was deliberately allowed to touch a corner of the lips to show, by actual example, the ugliness of this effect which is the result of a main light that was placed too high relative to the head). Observe, furthermore, how the light hits the eye on the side of the lamp (the other eye can lie in the shade) and its effect upon the cheek.

Placing the main light should be done with deliberation and care, because if the effect created by the main light is wrong, the portrait is bound to disappoint, no matter how correctly the other lights are placed. But if the main light is correctly placed, the basic design of the portrait will be good, and what remains to be done is mainly a matter of contrast control with the aid of fill-in light.

5–3: Place the shadow fill-in light. Its purpose is to *balance the illumination;* which means, to gently lighten the shadows cast by the main light, which otherwise would print too dark or appear black in a transparency, just enough so that they will show some detail in the picture without in any way changing the character of the illumination established by the main light.

The fill-in lamp should be a floodlight in a large reflector (preferably, but not necessarily, diffused). It should be placed somewhat above the lens since, in this position, it casts virtually no shadows that can be seen from the camera position, thereby avoiding the ugly possibility of having secondary shadows mar the rendition. Distance between fill-in lamp and subject should be more pp. 104-107 or less the same as that between subject and main light. If this is the case, and if both lamps are identical, subject areas illuminated by both main light and fill-in light would receive 2 units of light, while those that lie in the shadow cast by the main light would receive only 1 unit of light (from the fill-in lamp), resulting in a lighting-contrast ratio of 2:1, which is most suitable for the average kind of portrait.

Later, when he has acquired more experience, a photographer can work with other contrast ratios for softer (up to almost shadowless) or harder (graphically more powerful) effects. The only thing he must never do is to arrange his lamps in such a way that shadows within shadows or shadows that cross each other occur—a common fault of the beginner, which ruins any portrait.

5–4: Place the accent light. Its function is to brighten the picture by adding sparkle to the model's hair and, perhaps, edge-lighting to the contour of a cheek. Most suitable for this purpose is a small spotlight used in a 10 to 11 o'clock 25-degree position and directed toward the back of the model's head. Since this lamp must be placed somewhat behind the model, it cannot cast secondary shadows that are visible from the camera position but could shine into the lens and cause flare, a possibility that can be avoided by placing a gobo between camera and lamp.

p. 89

p. 184

Placing the accent light is a rather critical operation and, unless an assistant is available to shift the lamps around while the photographer observes the effect from the camera position, can be a time-consuming affair that may involve numerous trips between camera and lamp. This can be avoided by making use of the optical law governing reflections (because reflections are what we want from an accent light), which says that the angle of reflection is identical to the angle of incidence of the light. Accordingly, the photographer should proceed as follows:

p. 140

First, he should obtain a string about 8 feet long with a small weight at one end. Then, he must place his accent lamp—a small spotlight—directly in front of the lens and in line with its axis (the camera, of course, must be mounted on a tripod) and shine its light on the subject while all the other lamps are turned off. Now, by slowly circling the model and observing her from all sides and angles, both high and low, he can easily pick out desirable highlights in her hair. At the moment of observation, his eye is at the exact position that the spotlight must subsequently occupy if this same highlight is to be visible to the lens. This is where the weighted string comes in. It is used in the manner of a mason's plumb bob: By lowering it from the position of the eye until it touches the floor, the exact spotlight position in both horizontal and vertical directions can be found. Then, all that remains to be done is to place the accent light at the proper height above this spot, focus it on the model's hair (or "flood it out," as the case may be), check once more from the camera position, and make the shot.

p. 185

5–5: Place the background light. Depending on the intentions of the photographer, this lamp can be either a floodlight or a spotlight. Its purpose is twofold:

1. To illuminate the background sufficiently for good color or black-and-white rendition. Normally, both subject and background should receive identical amounts of light. To make sure that this will be the case, make spot checks with a reflected-light meter in conjunction with a Kodak Neutral Test Card at both the subject and the background plane; how this is done has been explained before.

p. 56

2. To create the tonal difference necessary to separate graphically subject and background: If the subject is dark, the background should normally be light, and vice versa. If one side of the subject is light and the other dark, the background can either be illuminated in such a way that it will have an intermediary tone in the picture; or it can be lit unevenly in such a way that it appears light in the picture where the subject is dark, and dark where the subject is light. This is easily done with a floodlight placed toward one side, its beam meeting the background at an angle. Other times it can be advantageous to place a floodlight immediately behind the subject (and therefore hidden from the camera) with its beam directed toward the background where it will create a "hot spot" with gradually darkening edges.

The brightness of the background illumination and the form of intentional light falloff can be controlled in several ways: by selecting a light bulb of appropriate wattage; by adjusting the distance between lamp and background accordingly; by placing the lamp at the proper angle relative to the background; by controlling the light with the aid of barndoors or gobos; by focusing a spotlight or "flooding it out." pp.183,184 p. 185

The red-eye effect. If a portrait in which a model looks straight at the lens is taken with flash at the camera, an electronic ringlight, or a photolamp that was placed very close to the axis of the lens in both vertical and horizontal respects, a curious effect occurs: instead of black, the pupil of the eye appears red in the picture if the shot is made on color film, whitish-gray if made in black-and-white. The cause of this rather startling phenomenon (which in medicine is referred to as the "red reflex") is reflection of light from the blood in the choroid, or vascular tunic, of the eye, which lies beneath the transparent retina. To avoid the red-eye effect, either instruct the model not to look at the lens (in which case the portrait will not seem to look the viewer in the eye), or make sure that no photolamp or flash is placed too close to the axis of the lens. That the red-eye effect is usually more apparent in photographs taken with flash at the camera than in portraits made by floodlight illumination is due to the fact that the first type of picture is usually taken under dimmer light conditions (when the pupil is more dilated) than the second kind, which always is made in a relatively bright surrounding in which the pupil contracts.

A standard illumination

The four-lamp lighting scheme described above represents a *standard illumination* that is never wrong, regardless of whether the subject is a gadget, a geranium, or a girl. Main light, shadow fill-in light, accent light, background light—these are the basic elements that can be infinitely varied in

regard to wattage, subject-to-lamp distance, direction, angle of incidence, contrast, and degree of diffusion. It is a lighting scheme that can be simplified as well as elaborated. In its simplest form, which, incidentally, is normally unsurpassed for photographing small objects of any kind, it consists of only a main light and a reflecting panel that acts as a source of indirect shadow fill-in light. Such an arrangement eliminates all worries about secondary shadows, which, under these conditions, simply cannot occur.

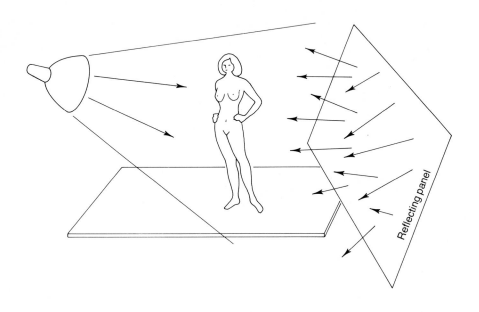

Illumination with a single lamp avoids the danger of sha-
dows pointing in different directions or crossing one
another. A reflecting panel provides shadow fill-in light.

A somewhat more elaborate arrangement would consist of main, fill-in, and background light. As far as sophistication is concerned, there is virtually no limit, although even the most complex lighting arrangements in big studios are basically only variations of the principles discussed above, the only difference being that instead of 1 there are perhaps 3 separate main lamps working together as a unit, 10 shadow fill-in lights, and several accent and background lamps. In such cases, the main problem is integration—arranging all these lamps in such a way that in the picture the illumination seems to come from only a single light source. Guidelines for arranging such lighting schemes have already been given.

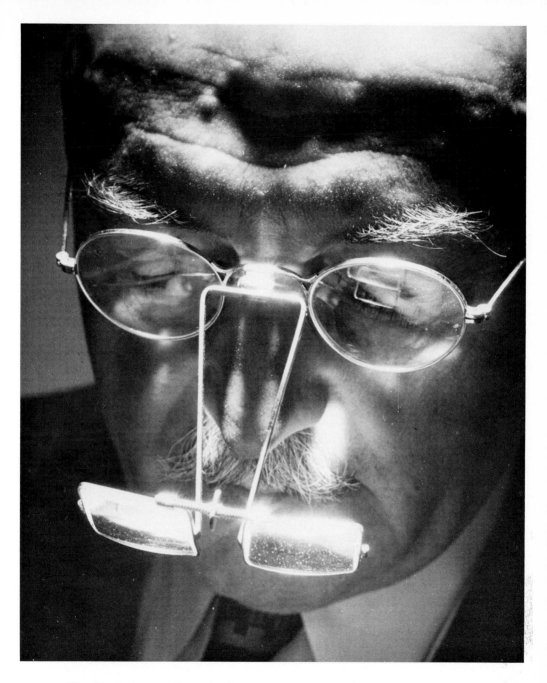

The diamond cutter. Example of a nonstandard portrait illumination based on the sharp overhead light used by this man in his profession. Highlights and reflections, complemented by extensive shadows, suggest the sparkle of precious stones.

210

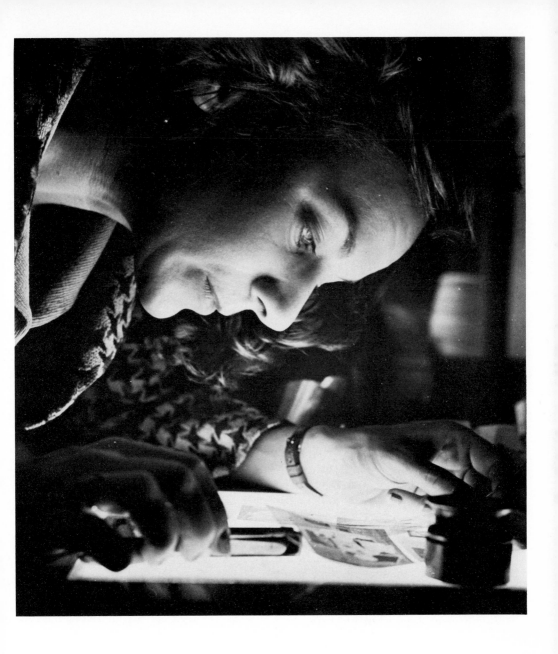

Left: Portrait of a British nobleman. Above: A photographer editing her negatives. Both portraits were made in nonstandard light, the first with two spotlights, one of which also served as an accent light, while in the second case, the sole illumination came from the viewing box. No shadow fill-in lamps were used.

"Finger exercises" with light and shadow

The following assignments are analogous to the scales a budding musician must play in order to become a master, the only difference being that here, instead of working with sound, we work with light.

p. 58 **Assignments 6 and 7:** Learn all you have to know about *bracketing*—the need for which we discussed earlier—by making a complete exposure series of each of two extreme types of subject, one very dark, the other very bright.

Assignment 6. Find a dark street, alley, or backyard view in the city at night where subject contrast is low; that is, bright street lamps or other glaring lights must not be part of the scene because they would ruin the experiment by obscuring large areas of the negative with light spill, halation, and flare. In accordance with the accompanying photographs, take a series of shots ranging from underexposure to overexposure, noting the technical data for each shot. You should learn the following:

An underexposed negative contains less subject matter and detail than was apparent to the eye in reality. Conversely, an overexposed negative contains more, particularly as far as the darkest parts of the scene are concerned. This is due to a quality common to all photographic emulsions—the ability to accumulate light impressions and thereby gradually build up an increasingly denser image. Thanks to this ability, photographs can be taken of stars and galaxies that are much too faint to be seen even through the largest telescopes, and pictures can be made at night that show detail even in areas which to the eye appeared jet-black, no matter how long and hard we stared. As a matter of fact, if only we expose long enough, the impression of such photographs will be almost indistinguishable from that of the same scene shot in daylight—completely lacking the mood and mystery of the night.

Of the accompanying photographs, the first one was exposed for 1 second, the last one for 10 minutes. In this particular case, such data as *f*/stop and film speed are immaterial; what counts is the exposure range—the ratio between the darkest and the lightest picture, which was 1:600. It shows the enormous degree of control that, under certain conditions, a photographer can have over the outcome of his black-and-white pictures merely by "playing with light."

I said "certain conditions" because, if subject contrast is higher than in this particular case, exposure latitude decreases proportionally since, with prolonged exposure, the brightest parts of the scene would become hopelessly overexposed and unprintable, and in extreme cases (as the following assignment will show), may even *solarize*, that is, appear in positive (instead of negative) form in the negative. Therefore, remember: The more contrasty the

212

subject (or the more limited the exposure latitude of the film as in color photography), the more accurate the exposure if the result is to be a picture that precisely reflects your intentions.

Incidentally, in the preceding illustration, the six steps of the "bracket" were gang-printed on the same sheet of paper. As a result, the individual pictures may not appear at their potential best. The lighter (longer exposed) ones, for example, which appear too gray and flat, would show more contrast and a fuller range of tones if printed on more contrasty paper—illustrating another form of photographic control that is at the disposal of anyone who cares enough to avail himself of it.

Assignment 7. Find an extremely contrasty subject, for example, the clear-glass light bulb used in the accompanying set of photographs, and take a series of bracketed shots. Of the pictures shown here, the first one was exposed 1/1000 sec. and the last one 10 seconds, spanning a ratio of 1:10,000. They can teach you the following:

Basically, the shorter the exposure, the higher the contrast of the negative, and vice versa. This is a fact worth remembering in cases in which subject contrast is either abnormally low or high and should be increased or decreased, respectively, in the picture. Appropriate adjustment of the exposure (in conjunction with appropriate changes in the time of development) will usually accomplish this.

With prolonged exposure, more and more detail is revealed in the darker areas of the subject. This is an often invaluable advantage which, however, can be exploited only to a point—the point where further increases in exposure would result in unacceptable overexposure of the subject's brighter parts. Consequently, the lower its contrast, the more the exposure of a dark subject (or a subject containing important dark areas) can be prolonged without the photographer running into trouble.

Overexposure of the order of several thousand times above normal results in a positive instead of a negative image on the film. This phenomenon, which is called *solarization*, normally occurs only in cases where bright sources of direct light (like the sun or a street lamp) are part of the scene. In our experimental series here, it makes the first and last pictures look like positive and negative although both show positive prints.

214

Exposure 1/1000 sec.

Exposure 1/250 sec.

Exposure 1/100 sec.

Exposure 1/10 sec.

Exposure 1 second.

Exposure 10 seconds.

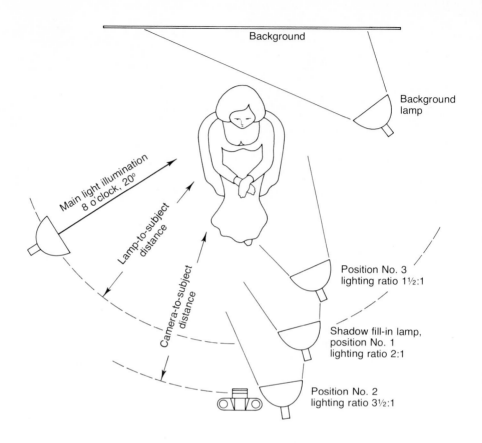

Background

Background
lamp

Main light illumination
8 o'clock, 20°

Lamp-to-subject
distance

Camera-to-subject
distance

Position No. 3
lighting ratio 1½:1

Shadow fill-in lamp,
position No. 1
lighting ratio 2:1

Position No. 2
lighting ratio 3½:1

Assignment 8: Contrast control with the aid of shadow fill-in light. To complete this assignment, you need a live model and three identical flood-lights in reflectors. In accordance with the accompanying photographs, place the model well in front of a light background. Use the first of your three photolamps as a main light, the second one as a shadow fill-in light, and the third one as a background light. Then, take a series of four or more photographs, leaving the main light and the background light in the same place but gradually moving the shadow fill-in light closer to the girl except for the first shot, for which you use no shadow fill-in illumination at all.

Draw a diagram of your setup and make notes of all the data pertaining to each shot—distances, lamp positions in terms of our direction clock, brightness in terms of light-meter readings, f/stop numbers, shutter speeds, and ASA speed of the film. In this way, the next time you want to make a portrait, all you have to do is consult your notes, confident that the groundwork for a successful picture has already been laid.

p. 89

216

Assignment 9: Experienced photographers know that one of the most difficult jobs is to make effective pictures of all-white subjects. However, I believe that the reader is now ready to attempt this exacting task. Accordingly, he should get himself an interesting, all-white subject, perhaps something like the sea urchin shell used in the accompanying photographs, which was uniformly white. This object should then be photographed in such a way that it shows every last detail without losing its all-white character.

The first one of the pair of photographs of a white sea urchin shell represents the attempt of a beginner who, within one picture, succeeded in making all the mistakes in the book: The side of the shell that faces the lamp is overlit and "burned out" while the other one is underlit and too black; the result is that, paradoxically as this may sound, overexposure and underexposure occur within the same negative. Detail is lacking in both the illuminated and the shaded parts of the shell. Half its outline is lost in jet-black shadow and blends with the surface on which the sea urchin rests. Overall contrast is too high while contrast within the illuminated and the shaded areas, respectively, is too low.

The second rendition presents quite a different picture. Contrast is pleasingly high, yet the side of the subject that faces the lamp is not "burned out" nor is the other one lost in darkness. Detail is fully preserved in every part of the shell. Its outline is well delineated all around. The effect is that of a subject which is uniformly white.

How was this accomplished? First of all, the photolamp (a baby spotlight, the same that was used to light the previous picture) was placed somewhat lower and at about five times the distance as in the unsuccessful attempt. Then, a piece of white cardboard was used as a reflector to fill-in the shadow side with indirect light, making use of the spillover from the spotlight. And to keep the background uniformly black, a gobo was inserted in the path of the light to prevent it from striking the surface on which the shell was placed.

To make an all-white subject look white in the picture despite the fact that in order to show detail its tonal range must include many shades of gray, three requirements must be fulfilled:

1. Contrast must be high (illumination by spotlight and printing on paper of hard gradation).
2. At least some picture areas must be pure white, that is, completely devoid of detail; keeping such white areas small will make the loss of detail less noticeable. Yet, without pure white in the picture, a subject can never look really "white."
3. The photograph must contain areas of pure, detailless black, because only in contrast to black can white ever appear truly "white."

218

Assignment 10: Photographers always speak of "working with light." Perhaps it would be more accurate to speak instead of working with shadow, because in a photograph, an ugly or misplaced shadow is usually more objectionable, not to say disastrous, than a wrongly placed area of light. Unfortunately, ugly shadows don't seem to be half as noticeable—and objectionable—in reality as in picture form, when it is too late to do anything about them. I therefore suggest here that the reader reenact—as a "preventive exercise"—some of the most common mistakes in regard to the placement of shadows. For it has been my experience that a mistake, provided it was recognized as such and its cause established, can be a blessing in disguise because, once made, a photographer never has to make the same mistake again.

To execute the following exercises, the reader needs two floodlights, a live model, and a few suitable objects like the stone, shell, and alabaster figurine used in the following illustration. Let's talk first about the model.

p. 204 The four photographs above illustrate the most common types of "ugly" shadows in portraiture. The effect illustrated in the picture at the left was caused by a main light that was placed too much overhead, leaving the eyes in deepest shade and causing the nose to cast a shadow that extends beyond the lips. The remedy, of course, is to lower the lamp so that the light hits the model at a lower angle.

220

In the second picture, the main light is still placed a little bit too high. Although the eyes are somewhat (but not much) better lit than in the previous shot, the shadow cast by the nose is still too long. To correct this fault, the main light must be lowered accordingly.

The third picture shows an unsuccessful attempt at lightening the area around the eyes, which were too much in the shade; notice that in this case the nose shadow is more or less acceptable although still a little bit too long for perfection. The attempt failed because of faulty placement of the fill-in light, which acted as a second main light, casting a shadow as strong as that cast by the main light proper which it crosses beneath the chin, creating a particularly ugly effect. The remedy: Instead of placing the fill-in lamp toward one side, place it in line with the camera, above, but close to, the optical axis of the lens.

The appearance of the fourth picture is marred by the heavy background shadow that causes the outline of the head to be lost. The best way to avoid this fault is to increase the distance between model and background until the shadow falls outside the picture area. If insufficient space prevents this solution, a floodlight placed behind the model (where it is hidden from the camera) and facing the wall can be used to "burn out" this kind of shadow.

221

A rather common mistake of the beginner is accidentally to include his own shadow in the picture—the predictable result of photographing in straight frontlight ("because it is so nice and bright, there are no nasty shadows, and colors turn out so beautiful") when the sun is low in the sky. Notwithstanding the fact that it is difficult to quarrel with this reasoning, the effect of the photographer's own shadow usually ranges from the comical to the pictorially disastrous. This can be avoided either by placing the subject at a different angle relative to the sun, or by crouching low and shooting slightly upward.

A constantly recurring problem, particularly perplexing to beginners, is how to eliminate the shadow cast by a small object. Here are two solutions:

Two photographs of a shell. In the first picture, the side of the shell that faces the lamp is overlit and melts into the background, while the side away from the light is underlit and blends with the shadow, which is too deep. In addition, the outline of the shell is lost and rendition of detail is unsatisfactory —the picture is unacceptable from the pictorial as well as the documentary viewpoint.

In the second photograph, the shell appears to float in space, detail rendition is satisfactory, and separation between subject and background excellent with the outline preserved in its entirety. To achieve this result, the shell was placed on a sheet of clear glass suspended above a sheet of white paper. Two lamps were used for the illumination: a spotlight trained on the shell in such a way that the cast shadow fell outside the picture area on the background 12 inches below the shell; and a floodlight that illuminated the background at an angle so the area below the light side of the shell appeared dark in the picture, and the one below the dark side, light.

222

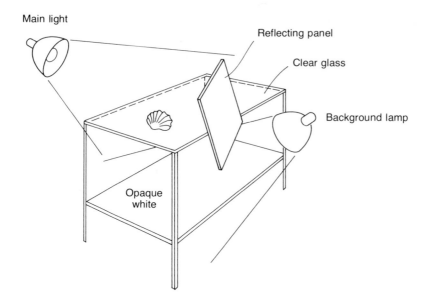

Main light

Reflecting panel

Clear glass

Background lamp

Opaque
white

223

Three photographs of a statuette. In photographs of small objects, a uniform background free from cast shadows is often a necessity to preserve the clarity of the presentation. This series shows how to accomplish this.

1. Any object placed close to a wall is likely to cast its shadow on it.

2. Attempts at "burning out" the shadow with the aid of a second lamp are futile and result only in adding a second shadow to the first.

3. The only way to avoid the appearance of a shadow on a wall is to place the object so far out in front of the background that its shadow falls outside the view or on the ground. Notice how in the third picture the shadow cast by the statuette angles off toward the right to "climb the wall" outside the picture area.

"Finger exercises" with shadowless light

Assignment 11: As photographers, we have four ways of producing a more or less shadowless illumination with artificial light. To become familiar with the respective proceedings, I suggest that the reader perform the following experiments.

11–1: The light-box. Study the accompanying pictures of a stone and a shell. Each is shown in two versions, "right" and "wrong." Both subjects are characterized by significant outlines: The stone, a 3-inch pebble ground and polished by the surf, has an outline which, in its elliptical precision and proportions of length to width, is the embodiment of a mathematical formula. The shell, a Venus comb murex, fragile and elegant, is one of the marvels of nature. To graphically ruin these outlines with clumsy shadows is inexcusable and unnecessary since better ways of rendering exist: photography on a light-box.

The shadow-ridden renditions of the stone and the shell are the work of a beginner in photography. Unfortunately, they represent a type of picture seen only too often these days, the product of a combination of incompetence, carelessness, and lack of vision and thought. The main fault of the picture of the stone are the crossing shadows, the result of two lamps of more or less equal brightness placed symmetrically at more or less equal distances from the subject. This fault could easily have been avoided if only one photolamp had been used and the shadow side of the stone filled-in with indirect light

p. 108 coming from a reflecting panel that, in turn, received its light from the primary light source.

And the picture of the shell could have been improved considerably if the lamp had been placed at a much greater distance from the subject. As it is, at the short distance involved, light falloff is so abrupt that it results in unmanageably high contrast between the near and far sides of the shell relative to the lamp.

The beginner who is more interested in maximum brightness at the sub-
p. 11 ject plane (the quantitative approach to light!) than evenness of illumination in the picture (the qualitative approach!) often winds up with an unevenly illuminated subject because he allows insufficient distance between subject and lamp, resulting in excessive light falloff. The consequences of this mistake become the more serious, the shorter the distance between subject and lamp, and are most obvious in close-up photography. Experience gathered during the photography of shells for his book *Shells* (Viking, 1972) has taught the author that in lighting a 3-inch shell, the lamp must be no closer than 3 feet from the subject (4 feet is even better) if the depicted area (measuring perhaps 5 or 6 inches in width) should appear to be evenly illuminated.

226

The author's home-made light-box. The board at the left is a protective cover; see also p. 136.

Inside view of the light-box that contains five fluorescent tubes. Note the ventilation holes.

To come back to our subject: Complete elimination of the shadow cast by an object is possible by photographing it resting on a light-box instead of an opaque support. Its surface is bright enough to "burn out" any shadow that might be cast by the subject which, in all other respects, should be illuminated exactly as if it were resting on an ordinary opaque surface. Exposure is determined exactly as in "ordinary" photography except that in this special case the light-box itself must be turned off while the brightness reading is taken. The accompanying pictures demonstrate the clarity, precision, and beauty of rendition that can be achieved by this method of shadowless photography. How anyone can construct his own light-box has been explained.

p. 136

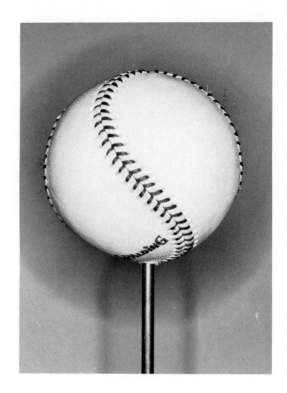

Shadowless ringlight illumination

11–2: The ringlight. Study the two accompanying photographs of an alabaster statuette and a baseball. They were made with the aid of a ringlight, in this case, an electronic flashtube that encircles the lens and produces what amounts to virtually shadowless light. Note, however, the faint shadow band cast upon the background, which follows the outline of the subject and, in the case of the baseball photograph, produced a double shadow of its support. This is a characteristic of all electronic ringlights, which can be nullified by increasing the distance between subject and background, and if necessary, illuminating the background with a separate background light to "burn out" any trace of a shadow.

Notice furthermore the light distribution in the subject—the way in which receding surfaces appear increasingly darker (the so-called limb darkening of the astronomer), which makes it possible to achieve a three-dimensional effect despite the absence of cast shadows (which fall behind the subject and are not visible from the camera position except for the "ringlight effect").

11–3: Indirect (reflected) light. A virtually shadowless illumination can be arranged by turning one or several photolamps against one or several white reflecting surfaces that, in turn, illuminate the subject with indirect reflected light. In practice, this principle can take several forms:

Reflecting panels. Study the accompanying photograph of a girl. Her face was illuminated with shadowless light reflected from two large, white panels placed on either side of the camera, which, in turn, received their light from two 500-watt floodlamps.

GOBO GOBO

11-4: Bounce light. If larger objects or entire sets have to be illuminated with shadowless light, turn several powerful floodlights against the walls and ceiling and flood the entire room with totally diffused, indirect, reflected light. If black-and-white film is used, it doesn't matter whether the walls and ceiling are white or colored as long as they are light. If color film is used, a colored wall or ceiling would, of course, result in a color cast in the transparency. This color cast, however, could be prevented with the aid of a color-compensating filter the color and density of which would have to be determined by test.

p. 82

Bounce light from electronic flash. By aiming your electronic flash at a white ceiling at a point some 6 to 10 feet ahead of you, you can create an indirect, virtually shadowless illumination that will cover a large area without the penalty of a disastrous falloff in brightness toward depth, which is unavoidable if direct flash at the camera is used. But while this sounds (and is) quite simple, calculating the *f*/stop necessary to insure a correct exposure is tricky, for the following reason:

Normally, exposure with flash at the camera is calculated on the basis of guide numbers: *Guide number divided by distance in feet between subject and flash equals f/stop number.* However, with bounce flash, the light does

230

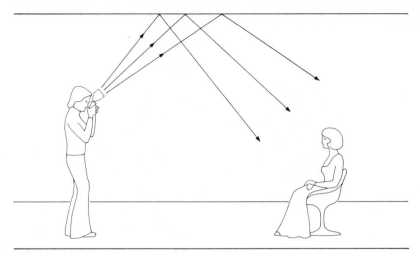

Bounce light with flash

not travel in a straight line between speedlight and subject, but follows a broken path—from flash unit to ceiling to subject. Now, if the subject is, say, 10 feet from the flash, and the room has a 10-foot ceiling, the path traveled by the light would not be 10, but some 17 feet, since you fire the flash standing at a height of some 5 feet above the floor and your model is sitting in a chair some 2 feet above the ground, as illustrated in the accompanying sketch.

However, this is only part of the story, for instead of being illuminated by direct light, the model now receives only indirect light reflected from the ceiling, which, in the process, absorbs a considerable amount of light. To figure bounce-flash exposures, experienced photographers therefore calculate (or guess) first the length of the path the light must travel, from camera via ceiling to subject. Then, on the basis of this figure and the guide number that applies to their flash unit in conjunction with film of the appropriate ASA speed, they calculate the *f*/stop number in accordance with the formula given above. But instead of using the so determined *f*/stop number, they open the diaphragm an additional 2 stops to compensate for the light loss due to absorption by the ceiling—that is, if the ceiling is smooth and pure white, because if the ceiling is rough or cream-colored, it probably absorbs another *f*/stop worth of light.

Of course, if you use one of the latest sophisticated speedlights that has a swivel head to make bounce flash a cinch and a sensor that can be aimed at the subject, you have nothing to worry about because (at least, so goes the theory) your unit will quench the flow of current as soon as the flash has delivered the required amount of light.

p. 189

231

Template. Slightly out of focus. Strongly out of focus.

The symbols of radiant light

p. 124 I have already written about the difference in emotional response to direct and radiant light and the need for expressing this difference in photographic form by means of symbols. Should the reader be interested in this subject, I urge him to perform the following "finger exercises." They are designed to familiarize him with the devices and techniques by means of which these symbols are produced and the degree to which they can be varied and controlled.

Assignment 12: Copying the design of the first of the accompanying photographs, cut a template out of thin, black cardboard approximately 5″ × 7″ with three openings: a narrow slot, a hole with the diameter of a small nail, and a 1-inch square. Since it is important that the sides and corners of these openings are perfectly smooth, use a single-edged razor blade to cut the slot and the square, then punch the hole with a nail, the tip of which has been filed off at right angles to its axis. With Scotch Tape, fasten a piece of tracing paper (which will act as a diffuser) behind the slot and the square but leave the hole uncovered. Place a lamp behind this template and make sure that no light can

232

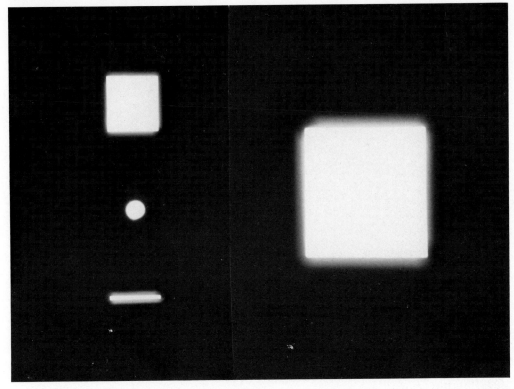

The transluminated template photographed through a diffusion screen.

escape around its edges and strike the lens. Then, photograph it in accordance with the following instructions.

12–1: Out-of-focus rendition. Focus sharply on the backlit template (which should fill the entire frame of the viewfinder or groundglass) and take a shot. Later, this photograph will serve as a comparison picture and point of reference for all the following shots. Then, take a series of pictures with the lens increasingly defocused. The more out of focus the lens, the larger the luminous forms and the more rounded their corners, producing a softly radiant effect.

12–2: Diffusion screen. Photograph the backlit template through a diffusion screen placed in front of the lens. Now, the luminous windows will be surrounded by softly glowing halos, the effect being much more subtle than that of the previous, defocused renditions. It seems as if two images were involved: a primary, sharp and central one; and a secondary, diffused one superimposed upon the first. Since this effect is very delicate, it doesn't show up too well in a small-scale reproduction of the slot and the dot, so here I show only the square.

Diaphragm star. Wire-screen-produced star.

12–3: Diaphragm stars. Stop down the lens to its smallest aperture, then take a series of pictures with increasingly longer exposures. You will notice that the longer the exposure, the more pronounced the effect: The slot and the square will appear more and more luminous, while the dot will expand into a magnificent, many-pointed star the rays of which will grow longer, the longer you expose.

12–4: Wire-screen-produced stars. Placing a piece of shiny brass or copper flyscreen in front of the lens transforms bright points of light into radiant, four-pointed stars; two such screens, crossed at 45 degrees to one another, produce eight-pointed stars. To see how exposure affects the size of these stars, take a series of shots with different exposure times: The longer you expose, the bigger and more luminous-appearing the stars.

234

Stars produced by crossed wire screens, short and longer exposures.

12–5: The Rodenstock Imagon lens. Unusual star patterns can be produced by photographing a light source with a Rodenstock Imagon lens. Since this lens is equipped with an adjustable, sievelike diaphragm, the appearance of the resulting images can be varied from dotlike and rayless to starlike and bizarre. At their best, such images resemble glowing flowers, luminous centers surrounded by twin rows of petals of light, an effect that, more than any other form of light symbolism, suggests the festive glitter of city lights at night.

235

Time exposures of moving lights

Unlike the camera, the eye is inherently incapable of retaining a visual impression for any length of time. As a result, we see a moving dot of light as a light dot in motion, whereas the camera can show us the same dot in two different forms: either as the "frozen" image of a dot in motion—a moment in time arrested on film—or, through time exposure, in the form of a line that represents the path of the moving light. This latter form of rendition, because it shows us something we otherwise could not see, is often the more interesting one because it can give us a new visual experience, expand our knowledge, and stimulate our mind.

Successful completion of time exposures of moving lights requires that three conditions are fulfilled:

1. The moving light source must be bright yet small relative to the area shown in the picture.
2. The background against which it is seen must be dark.
3. The camera must be rigidly supported for the duration of the time exposure.

Assignment 13: Study, and if you are interested, duplicate in one form or another, the essence of the accompanying photographs of a young dancer, which the author made to illustrate the fact that skeletal motion is always circular. To make the different movements photographable, flashlight bulbs powered by small batteries concealed behind the back of the model were fastened to her fingertips and feet. She then was posed on a large sheet of black seamless paper that ran up the studio wall to provide the dark background necessary to make the light track stand out sharp and clear. Two speedlights, one on each side of the girl, were set up to edge-light her figure and wired to be tripped by hand. Then, all the lights in the studio were turned off, the shutter of the camera was opened, the dancer went through her motions in darkness, the speedlights were fired, and the shutter closed.

The principle of making subject motion visible with the aid of time exposures of moving lights can be infinitely varied. While working for *Life*, for example, I once had to photograph a helicopter taking off at night, the rotor tips of which had been equipped with light bulbs. The resulting picture showed the ascent of the aircraft in the form of a delicate spiral winding its way up into the sky. Other examples based on the same principle are photographs of the wheeling stars on a clear and moonless night, traffic at night with the headlights of the cars tracing their graphs of motion and time, and photographs of fireworks, and light-studded merry-go-rounds revolving in the night.

236

Multiple exposures with repetitive light

While moving light sources automatically record their paths on film if they are sufficiently long exposed, ordinary objects in motion, as a rule, do not. Instead, they blur to such a degree that normally the picture would be useless. However, there is a way of photographing nonluminous objects in motion that results neither in frozen "stills" devoid of the feeling of movement nor in smudges and blurs, but in pictures that show the subject clear and sharp while at the same time evoking staccato impressions of motion. The means by which this can be accomplished is repetitive light.

Study the accompanying two photographs. Their subject is a mobile that was inspired by the solar system. The first picture shows the mobile at rest, with its components, representing the sun, the earth, and the moon, held together by the long arm of gravity, clearly visible below the constellation of the Big Dipper, shown at the upper left.

However, having made this record shot, the author felt dissatisfied. After having watched the mobile in motion, with the moon slowly circling the earth and both in turn revolving around the sun, the picture seemed dull and static. The subject's most important quality—motion—was missing.

To remedy this deficiency, a second shot was made: The mobile was set in motion, illuminated with repetitive stroboscopic light, and given a time exposure lasting for slightly less than one complete revolution. The result is a picture that, despite the fact that rendition is sharp down to the last detail, evokes a strong impression of motion.

Widely publicized photographs that derive their effect from the motion-suggesting characteristics of stroboscopic light are Gjon Mili's famous shot of a nude girl descending a flight of steps, and Dr. Harold Edgerton's staccato impression of a golfer swinging a club. Readers interested in this kind of photography but lacking access to stroboscopic lighting equipment can, within limits, achieve similar effects with ordinary floodlight illumination, provided they select their subjects accordingly. Consider, for example, the accompanying photograph of a human elbow joint, illustrating the movement of the bones around a common hinge. This picture was not made with stroboscopic light, but represents a multiple exposure on the same sheet of film with the subject illuminated with ordinary floodlights and the bones moved between exposures by hand.

p. 240

Assignment 14 calls for the reader to execute motion studies of suitable subjects with the aid of repetitive light. As in the case of time exposures of moving lights, prerequisite for success are a background that is very dark or black, a subject that is light in color or white, and a camera that is firmly supported during the entire exposure cycle.

238

Above: Mobile representing the sun, earth, and moon photographed in motion with stroboscopic light.
Right: The same mobile at rest.

Above: Multiple exposure of a human elbow joint (see p. 238) illustrates the fact that skeletal articulation is essentially circular. At the right, a time exposure (see p. 62) captures the splendor of a fireworks display. Both pictures owe their special character to a particular way in which light was used: in the form of a multiple- and a time-exposure, respectively.

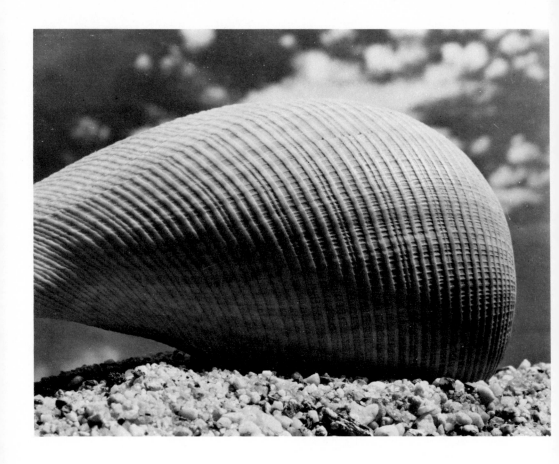

Texture rendition with the aid of light

Texture not only gives a surface its character, but also defines it in terms of the material of which it consists—indicating whether it is, say, stone, sand, wood, snow, fabric, hair, human skin. Obviously, defining texture in picture form is an important aspect of photography, and acquainting the reader with the elements of good texture rendition is the purpose of the following exercise.

Assignment 15: Make photographic studies of different surfaces with the aim of visually defining their material. To be able to do this, you must know the following:

Texture is surface structure—an aggregate of usually minute elevations and depressions. Accordingly, to photographically define texture, two requirements must be fulfilled:

1. Rendition must be critically sharp in order to clearly show the details of the surface.

2. The illumination must be such that it brings out this minute detail with the aid of light and shadow. This means a raking form of either side- or backlight which skims along the textured surface and thereby casts relatively long shadows of its tiny forms.

The accompanying sequence of photographs shows different aspects of arranging a texture illumination. *Left:* Illumination by flat frontlight—light striking the textured surface at an angle of 90 degrees—reveals the design of the fabric but gives no indication of its three-dimensional quality. *Center:* Raking spotlight illumination emphasizes three-dimensionality at the cost of design. *Right:* Combination of raking spotlight illumination and shadow fill-in with the aid of a diffused floodlight creates an impression that most accurately reflects the character of this weave.

Special lighting arrangements

The following pages contain information that may seldom be used but which, if needed, is invaluable. Also included are practical hints normally not found in textbooks since most photographers are reluctant to divulge their little tricks and secrets.

Copying

Copying means making photographic reproductions of flat subject matter such as photographs, line drawings, oil paintings, sketches, printed pages. This involves four main considerations:

1. The subject matter to be copied (the "original," in photographic parlance, also—confusingly—called "the copy") must be held perfectly flat in front of the camera.

2. The camera must be aligned in such a way that the optical axis of the lens is at right angles to the plane of the copy.

3. The light distribution must be perfectly even over the entire area of the copy.

4. Reflections in the reproduction must be avoided.

1. Holding the copy in place. Placing the copy flat on the floor and shooting straight down with the tripod-mounted camera may seem (and often is) the simplest solution but presents a problem unless the copy is relatively small: The tripod gets in the way of the light; the copy itself may be too large to fit inside the triangle formed by the tripod legs; or the camera must be raised so high above the floor that focusing becomes all but impossible. In such cases, the copy must be photographed in vertical position fastened to a wall.

Fastening the copy to the wall can be done in several ways. An excellent one, because it involves no risk of damaging the copy, is to use a copyboard consisting of a thin sheet of iron or steel and holding the copy in place with magnets. Other means of fastening the copy to the wall are pushpins (which leave holes in the copy and may therefore have to be ruled out), masking tape (which may damage the surface of the copy when it subsequently is stripped off), or a special arrangement consisting of a hinged sheet of plate glass (which has the disadvantage that it is subject to annoying reflections). The best method of holding flat copy in place is by means of a vacuum; unfortunately, such vacuum copyboards are very expensive.

244

2. Aligning the camera. To assure distortion-free reproduction, the film must be parallel to the copy. If the copy installation is permanent, a simple way to accomplish this is to draw with a permanent ink marker a large cross on the wall, its horizontal line at eye or camera level. Both the horizontal and the vertical lines must be longer than the width and height of the largest copy; they are the means by which the copy will be centered in front of the camera and must therefore be visible while the copy is being put in place. The vertical line must touch the ground and be extended on the floor at right angles to the wall somewhat beyond the camera position. With the copy in place, centered on the cross (a tape measure may have to be used to verify this), all the photographer then has to do is to place the camera directly above the line drawn on the floor (a tiny plumb bob suspended by a thread from the lens will assure this) with the lens at the same height as the horizontal line of the cross, center the image of the copy in the finder, and film and copy will be parallel.

A second, somewhat slower but very accurate way of aligning camera and copy involves the use of a mirror. After the copy has been fastened to the wall and the camera placed roughly in the appropriate position, proceed as follows: Get a small pocket mirror (or a mirror from a compact) and let an assistant hold it flat against *the center* of the copy (this is important). Then, by trial and error, find the camera position in which the front of the lens is reflected in the mirror and this mirror image of the lens appears *centered* in the viewfinder or groundglass. The moment this is achieved, film and copy are parallel.

A third way of aligning camera and copy is most practical if the copy is very large. Start by roughly aligning the camera perpendicular to the center of the copy. Then, using a tape, measure the distance from the lens to each of the four corners of the copy, shift the camera around until you find the position in which these four distances are equal, and film and copy will be parallel.

3. Illuminating the copy. If the copy is relatively small (not much larger than the diameter of the reflector of the photolamp), a single lamp is sufficient to assure an even illumination, provided the lamp is placed at an angle of approximately 45 degrees to the plane of the copy at 2½ to 3 times the distance between copy and lens (assuming that a lens of standard focal length is used). This method, because it makes use of a form of sidelight, has the advantage that it permits the photographer to indicate the surface texture of the original should this be desirable.

p. 246

Normally, however, at least two floodlights of equal wattage and design are required, one on either side of the copy equidistant from its center, the axes of their light beams inclined to the plane of the copy at an angle that may vary between 30 and 40 degrees, with each beam aimed at the more distant

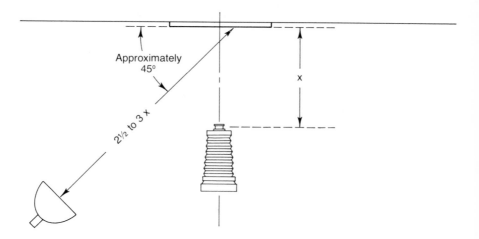

One-lamp lighting arrangement for copying relatively small originals (p. 245).

half of the area that is to be photographed, as shown in the accompanying diagram.

To assure evenness of light distribution, the distance between the lamps and the center of the copy should be not less than twice the width of the area to be photographed. If the original is rather large, four lamps instead of only two may be required, two on either side of the copy, placed one above the other on the same light stand (attach the lower lamp with the aid of a clamp reflector or a "Gator Grip"). That the color temperature of the lamps must be compatible with the film if the shot is to be made in color goes without saying.

For best results, framed originals should be taken out of their frames before copying. If this is impossible (as often in the case of valuable paintings), a shadow cast by the frame upon the original can be avoided if the lamps are placed in accordance with the accompanying diagram.

As can be seen, the trick is to have the right lamp illuminate the left side of the copy, and the left lamp the right side, with light baffles (barndoors or gobos) preventing each lamp from causing the frame to cast a shadow. In this case, to insure evenness of light distribution, it is necessary to make spot

p. 78

pp. 183, 184

246

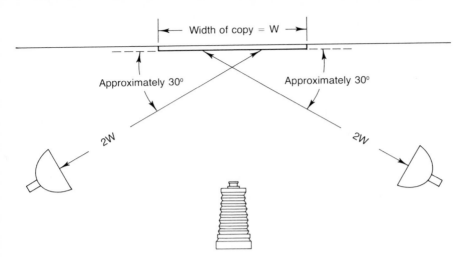

Two-lamp arrangement for making reproductions of flat originals.

checks at the center and each of the four corners of the original with a
reflected-light meter in conjunction with a Kodak Neutral Test Card in accor- p. 56
dance with instructions given before.

Lighting arrangement for "shadowless" copying of framed originals (p. 246).

4. Avoiding reflections. If the copy is framed under glass and cannot be
removed for photography, or if a sheet of plate glass is used to hold the copy
in place, bright objects in the vicinity, including shiny parts of the camera or

247

tripod, may reflect in the glass and spoil the picture. This possibility can be avoided by erecting a large doorwaylike frame consisting of two uprights and a horizontal bar (which should be at least twice as long as the widest copy) over the camera, which supports a piece of dead-black fabric. This reflection shield hangs immediately in front of the camera like a wide black curtain. To be able to photograph through it, the photographer must cut a small, U-shaped hole in the form of a hinged flap directly in front of the lens, just large enough to poke the lens through. Afterward, if desirable, the flap can be sewn back in place and the fabric used again for the same or another purpose, for example, as a background.

p. 142

p. 148

Copying oil paintings with varnished impasto surfaces presents a special problem since, no matter how we place the lamps, some specular reflections are bound to remain if ordinary lighting techniques are used. However, all specular reflections can be eliminated if the photograph is taken through "crossed polarizers"—polarizing screens in front of all the photolamps and another polarizer in front of the lens—as described before. Should such a rendition appear too lifeless, a carefully controlled amount of reflection can be retained in the reproduction by orienting the polarizing screen in front of one of the lamps in such a way that its axis of polarization is no longer parallel to that of the screen in front of the other lamp. The degree of this deviation, which results in the appearance of more or less pronounced reflections, must be determined visually on the groundglass.

High-key illumination

A high-key photograph is a study that makes use of only the upper ranges of the tonal scale—white, off-white, and light gray. These delicate shades are then contrasted with one or a few carefully placed and always relatively small areas of pure black that serve as reference points and, by contrast, make the rest of the picture appear even lighter.

High-key renditions have a festive, youthful, and joyous mood all their own. They can be very effective if used in conjunction with the right kind of subject by a photographer who knows what he is after and how to get it. This involves four prerequisites:

1. The subject must be suitable in regard to both type and tonal range. Low subject contrast is essential, high subject contrast spells pictorial disaster.

2. The illumination must be completely diffused, enveloping the subject from all sides. Cast shadows, which would ruin the high-key effect, are not permissible.

248

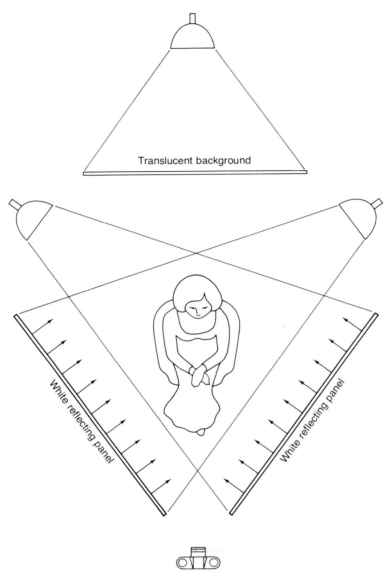

Translucent background

White reflecting panel

White reflecting panel

Lighting scheme for "shadowless" illumination with totally diffused light.

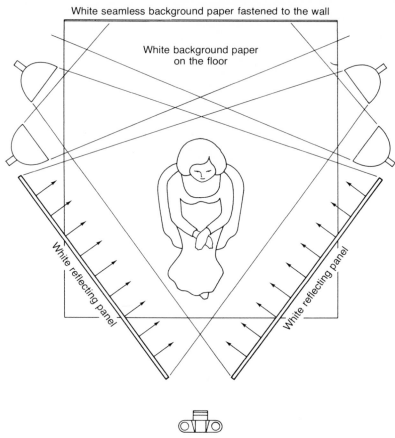

White seamless background paper fastened to the wall

White background paper
on the floor

White reflecting panel

White reflecting panel

Lighting scheme for "shadowless" illumination with totally diffused light.

3. The subject must include at least one small jet-black area, which must not be a shadow. Without such a "point of reference," even an otherwise fault-less high-key photograph would only look gray and "muddy."

4. Film exposure must be on the side of under- rather than overexposure. Overexposure blocks up the delicate nuances in the lightest shades, which are essential to effective high-key rendition. A thin negative is preferable to a denser one.

The accompanying diagrams show the relative positions of camera, subject (a person), photolamps (diffused floodlights), reflecting panels (for indirect illumination), and background. The latter can be either solid or translucent but must always be light. In high-key photography, a blending of subject and background is more often desirable than a fault because it makes the picture more ethereal and the subject appear to float in space.

Lighting the invisible

Photographing objects made of clear glass involves—literally—depicting the invisible. That this is possible at all is due to three characteristics of glass: It transmits light; it refracts light; and it reflects light.

By making use of the first two qualities—transmission and refraction—we can effectively photograph *curved* glass objects like wineglasses, flasks, clear-glass sculptures and ornaments, or old-fashioned wavy windowglass. We do this by placing the glass object in front of a suitable background the image of which, in the process of transmission through the glass, will be more or less modified. This modification manifests itself in two photographically important forms: as distortion of the background image the lines and shapes of which appear displaced, wavy, or curved; and as changes in brightness due to the refractive power of the curved glass (which acts like a lens) as a result of which the edges, stem, and base of, say, a wineglass seen against an evenly illuminated background appear darker than the center of its cup. In essence, we depict the "invisible" glass by showing its outline plus the visible effect its curvature has upon the image of whatever we see through it.

The third quality—reflection manifesting itself in the form of highlights and mirrored images—is indispensable in photographing glass *in flat form* (windows, mirrors, glass-topped tables, and so on) since flat sheets of glass transmit the image of the background against which they are seen without affecting it and therefore remain "invisible" as far as the photographer is concerned. However, when it comes to photographing *curved* glass objects, reflections, as a rule, are a nuisance that confuses rather than helps the picture.

Normally, the most effective way of photographing curved glass objects is to show them silhouetted against a white, evenly illuminated background. And since training photolamps on "invisible" glass produces nothing but a jumble of confusing highlights, paradoxically as it may sound, it is the background that must be illuminated while the glass objects themselves have to remain in the shade. This can be done in two different ways:

1. By placing the object against a white opaque background illuminated from in front.
2. By placing the object against a white translucent background illuminated from behind.

The accompanying diagrams show the relative positions of glassware, background, camera, and lights.

251

White opaque background

Lighting arrangement for photographing glassware against an opaque background.

If glassware is photographed against a front-illuminated white background, distance between subject and background must be sufficiently large to allow for proper placement of the photolamps (see diagram). The best material for such a background is white seamless background paper that comes in rolls, is fastened to the wall near the ceiling, and then rolled down and forward in a sweeping curve to form both background and base for the objects to be photographed. Great care must be taken so that no direct light strikes the glass as this would cause undesirable reflections. For the same reason, except for the photolamps, all room or studio lights must be turned off during the exposure; otherwise, light-colored or shiny objects behind the camera might reflect in the glass, marring the purity of its design.

If a transluminated background is used, the glassware can be placed almost in contact with the background, which should consist of a sheet of white matte acetate. This material is usually sold in rolls 40 inches wide and 50 feet long and comes in different thicknesses of which the heavier gauges are more suitable to our purpose. Such a background is illuminated from behind, either with floodlights or a spotlight, depending on the desired effect: even illumination or a "hot spot" in the center of the background tapering off toward darker edges and corners. To make the transition from light to dark less abrupt, the p. 185 spotlight must be somewhat "flooded out" and placed at a sufficient distance from the background.

A potential weakness of "pure" background illumination is that the base of the glassware may be rendered too dark. Should this be the case, placing the subject on a transparent shelf in front of the otherwise unchanged background and illuminating it also from below with a spotlight will remedy this fault. Such a shelf is easily constructed by placing a strip of the same acetate that was used for the background on a glass shelf of suitable dimensions, whereby the glass shelf plays the role of the support and the acetate that of the diffuser. Without such a diffuser, objectionable highlights would appear in the glass and spoil the "clean" look of the picture.

252

Lighting arrangement for photographing glassware against a translucent background.

Occasionally, however, one or two carefully placed highlights can lend sparkle to the rendition and thereby improve the photograph. The best way to add such highlights is with the aid of a small fluorescent tube placed in vertical position fairly close to the camera at a height that must be determined visually by the effect of the reflections it creates. Lacking such a strip light, a similar effect can be produced by taping a long strip of stiff white paper to a light stand (or other vertical support) and lighting it with a spotlight placed near its base; the spotlight, shining upward, illuminates the strip with sharp, raking light. Care must be taken so that the spotlight itself cannot reflect in the glassware; should this be the case, a gobo placed between subject and lamp will prevent it.

Whereas undecorated glassware usually appears most effective if photographed in front of a plain white background, cut glass and etched glass objects, as a rule, look better if photographed in front of a black background, which more effectively brings out their ornamental design. In that case, both background and support must be black, and the only light should come from a spotlight placed below the support that, through a narrow slot beneath the base of the glass object, illuminates it from below. If it is not feasible to place the spotlight in the proper position below the shelf on which the glass object stands, it can be mounted on a low support in horizontal position and its beam directed upward and through the slot below the glass via a 45 degree mirror.

Still another way of showing clear glassware effectively is by placing *a liquid-filled glass* in front of an interesting background that, distorted and miniaturized, appears reflected upside down in the glass. A widely publicized example of this technique is Bert Stern's world-famous advertising photograph showing a martini glass in the desert, with the structure of the Great Pyramid looming in the background and its image reflected upside down in the glass. This principle, of course, can be varied in an almost endless degree limited only by the photographer's persistence and imagination.

253

Lighting shiny objects

Most difficult to photograph of all possible objects are those which have a shiny or highly polished surface. Why? For two reasons:

1. Because their mirrorlike outsides reflect all the objects of their surrounding, the more or less distorted images of which are likely to create a thoroughly confusing effect.

2. Because any attempt at illuminating a shiny object with direct light would only result in the production of glaring specular highlights, which, of course, are nothing but mirror images of the photolamps. To deal with these problems, a photographer has two techniques at his disposal: "tenting" and the use of a dulling spray.

p. 134 **Tenting** involves the use of a light-tent, which is essentially a housing of white translucent material that partly or completely surrounds the shiny object in such a way that it forms a reflection barrier between the object and its surroundings. The only thing that can reflect in its shiny surfaces are the white walls of the tent. Illumination is normally provided by photolamps stationed outside the tent, their light directed against its translucent walls, penetrating them, and enveloping the object within with totally diffused light. The photograph is then taken through a small opening cut into one of the walls of the tent.

The walls of a light-tent can consist of almost any material that is white and translucent: white polyester sheeting, finely woven white cloth, and white tracing paper for larger tents; sheets of white acetate, tracing paper, or thin white stationery for smaller ones. The size of a light-tent can vary from a roomlike enclosure large enough to accommodate live models to small cylinders and cones of white acetate dimensioned to photograph small objects like jewelry and gems.

The construction of a light-tent depends on its size: the walls of room-sized tents must be supported by sturdy frames of two-by-fours, those of smaller tents by thin strips of wood or frames constructed of wire. Still smaller tents of white plastic sheeting or acetate in the form of cylinders and cones are self-supporting and require no frames. The last type is particularly suitable for use in conjunction with a light-box in order to provide a completely luminous environment, with the larger opening of the cone resting on the light-box surface while the picture is taken through the smaller hole from above.

However, a light-tent does not always have to surround the subject completely. As a matter of fact, a partial light-tent that covers only those parts of the subject which are visible from the camera position has certain characteris-

254

Shadowless illumination based on a translucent cone and a light-box; see also p. 134.

tics that are advantageous in two cases: if a more three-dimensional impression of the subject should be created than illumination with totally diffused light would permit; and if a background other than that provided by the walls of a light-tent is desirable. Such a partial light-tent, which is open toward the back, permits a photographer to create an overall illumination consisting of *diffused* (indirect) light while, at the same time, bringing into play one or several spotlights to emphasize with three-quarter backlight the subject's

three-dimensionality by means of *direct* light. Such a partial or *reflecting tent* usually consists of a semicircle of seamless background paper *inside* of which floodlights are positioned to throw light upon its walls, which, in turn, reflect it and thereby illuminate the subject with indirect, totally diffused light. Additional spotlights can then be stationed outside and behind the tent, and a separate background can be constructed and illuminated by special background lamps.

p. 140 When it comes to photographing shiny objects, we must distinguish between two types: on one hand, polished metal objects; and on the other, nonmetallic objects like porcelain, glazed ceramics, and objects made of shiny plastic and polished or varnished wood. The difference between these two groups is the result of their way of reflecting light: metals, as I mentioned before, are characterized by selective reflection, that is, highlights take on the color of the metal—"white" for silver, aluminum, and chrome; yellow for gold; red for copper; and so on—even when the color of the illuminating light is "white." Nonmetallic surfaces, on the other hand, reflect light nonselectively, which means that regardless of the object's surface color, highlights created by "white" light are always "white." As far as the photographer is concerned, the practical consequences are these:

Photographed inside a light-tent and illuminated by "white" diffused light, a shiny *metallic* object will always retain its color (that is, gold will still appear yellow, and copper red) even though the illuminating light is "white." But *nonmetallic* shiny objects, unless they are already white like white porcelain, will change their color due to the fact that inside the "tent" their own colors will be overlaid by a uniform layer of broad areas of white reflections; as a result, in the photograph, their surface colors would appear strongly diluted by white, creating a "washed-out" impression.

p. 242 Accordingly, tenting is a technique that is eminently suited to the photography of shiny *metallic* objects, particularly if imaginative inclusion of a few carefully controlled reflections, created by means of strips or cutouts of black or colored material attached to the inside of the tent, adds contrast and color to what otherwise might be a bland form of rendition. A problem, however, arises if the object (perhaps a trophy) contains an engraved inscription. Such an inscription is essentially a form of surface texture, and surface texture, as we heard before, is best rendered by strongly directional, skimming sidelight or backlight but virtually eliminated by indirect, diffused light. Fortunately, there is a perhaps crude, but highly effective way of rescuing an engraved inscription from visual extinction: Rub black shoe polish wax into its incised lines.

256

White seamless background paper

Support rod

Reflecting panel

Side view

White reflecting panel

White seamless paper

View from above

White reflecting panel

Lighting arrangement for shadowless illumination of shiny objects; see also p. 254.

257

Nonmetallic objects can be tented successfully only if their surface colors are deep and saturated like those of certain ceramics. If their surface colors are delicate and light, veiling them with broad areas of white highlights would dilute them to the point of extinction with the result that, at least in the form of color photographs, the picture would be useless. In such cases, it is better p. 148 to work with polarized light and partly or completely "crossed" polarizers, as already discussed. Alternatively, especially if the necessary pola-screens are not available, the photographer can resort to using a dulling spray.

A dulling spray temporarily turns a glossy surface into a matte one; afterward, the deposit in the form of microscopically small droplets can be wiped off with a soft cloth without leaving a trace. Dulling sprays come in aerosol cans available in better photo stores and are safe to use on glass, ceramics, porcelain, metal, wood, and the like, but may have a deleterious effect on certain types of plastic. In that case, a dull surface can still be produced by giving it a coating with Elizabeth Arden's *Screen and Stage Makeup Number 12*, which is applied with a wide, soft camel's hair brush and subsequently smoothed out with a piece of tissue paper or Kleenex.

Lighting for close-ups

In extreme close-up photography, arranging a satisfactory illumination can be a problem, for two reasons:

1. Distance between subject and lens can become so short that it is virtually impossible to light the subject satisfactorily with conventional means.
2. Exposure times can become so long that the subject may warp, shrivel, wilt, die (if alive, for example, insects and flowers), or otherwise change its form during the exposure with obviously catastrophic results, not to men- p. 53 tion the likelihood of reciprocity failure with its possible consequences of underexposure and color shift.

To avoid these calamities, a photographer has at his disposal two means: illumination by electronic flash, and mirrors.

Electronic flash provides a high-intensity source of light of a duration so short that the subject cannot possibly change its form during the exposure as a result of any of the influences listed above. Its light is bright enough to permit correct exposures with small *f*/stops even at subject distances where the exposure factor is as high as 50 (rendition in 6 times natural size) and higher. And, if necessary, it can be directed to the place where it is needed with the aid of a mirror.

258

p. 171

I pointed out before that the main disadvantage of flash is the difficulty in predicting precisely where the light will hit and where the shadows will fall. In the case of extreme close-up photography, this difficulty can be overcome by making permanent the position of the speedlight relative to the subject. This is something a photographer has to do himself. I myself have designed and built close-up equipment on the basis of an optical bench: camera and subject stage slide on the same (wooden) track; the speedlight unit is rigidly attached to the front end of the camera (or front end of the extension bellows); and a pivoting mirror on the side of the lens opposite to the flash is calibrated in regard to its position for specific degrees of subject magnification in conjunction with close-up lenses of specific focal lengths. This, of course, makes it easy to set the mirror at such an angle that the subject will receive the full force of light from the flash. With this kind of equipment, home-made from scrap wood and available parts, I have made tack-sharp close-up shots of the eyes of live insects at up to 20 times life-size on the film. Here, too, as almost anywhere in photography, it is not so much the make of the camera or the amount of money invested in equipment that counts, but the resourcefulness and imagination of the photographer, supplemented by dedication and skill.

The following pages contain photographs that owe their special character to light. As a matter of fact, if the light had been different, I wouldn't have photographed any of these subjects because, at least in my opinion, they would then not have presented themselves to best advantage.

Let me repeat for emphasis: The "wrong" light destroys a subject's character, mood, and special "atmosphere," and what's left in a picture made under such unfavorable conditions is nothing but a superficial likeness, soulless and dead. Studying the following images is part of the curriculum presented in this book and should pay off in improving the quality of the reader's photographic work.

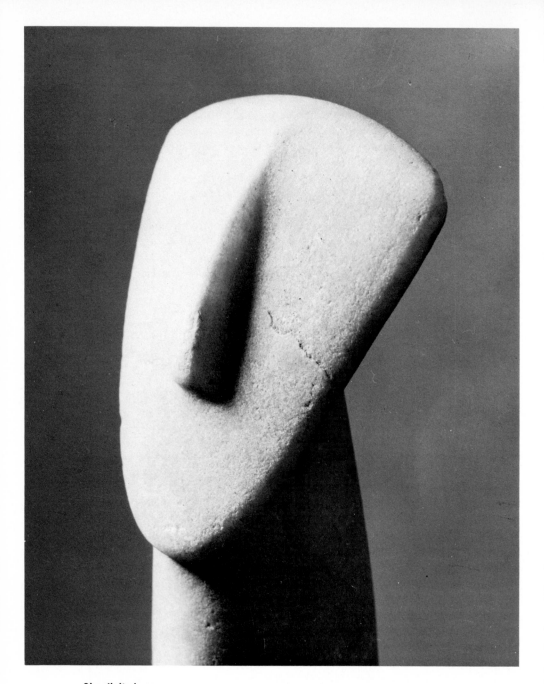

Simplicity is never wrong

I can imagine no better objects for studying the effects of light than sculptures. Here, I used light to work out the forms and planes of the prehistoric (about 3000 B.C.) marble head from the Cyclades at the left and the nineteenth century African (Senufo)

fetish at the right, paying particular attention to the positions of highlights and shadows. Both pictures were made with only a single photoflood lamp in accordance with my conviction that, in photography, less is more, and that the simplest solution is usually the best. Accordingly, I limited my renditions to only three main tones and kept the background neutral, making sure it nowhere merges with the heads.

Model with light and shadow

Left: Bronze statue of Parvati, India, fifteenth century. Right: "Ellipse" by Doris Caesar. Although, in comparison to the previous sculptures, these two works are infinitely more complex, the principle of lighting them is the same: Use light as a tool, model with highlights and shadows, accentuate, outline, and clarify the different forms of your subject, create illusions of volume and depth. Here, by accordingly arranging my lights, I particularly made sure to bring out the perfect circles of the stylized breasts of the Parvati figure, and to graphically separate the breasts and thighs of Doris Caesar's work. In each case, only two photofloods were used, and again, the background was kept neutral.

263

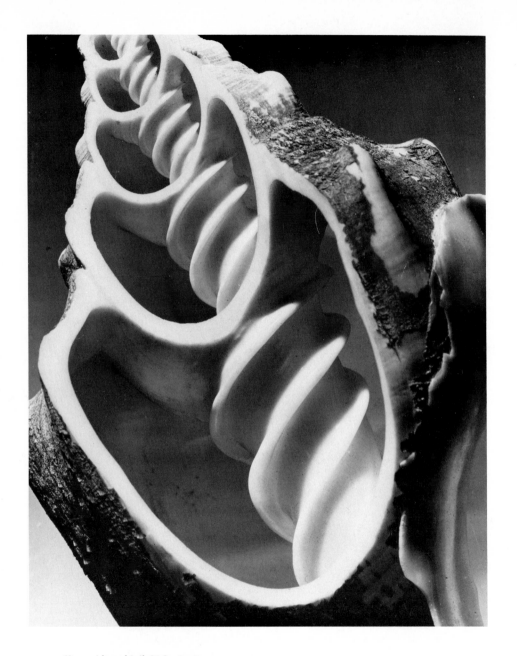

Use raking sidelight for texture

Left: Sectioned shell. Right: Detail from a medieval "seat of honor" from the village church in Suntaks, Västergötland, Sweden. In both cases, I used raking sidelight to emphasize the internal structure of the shell and bring out the textured surface of the wood.

264

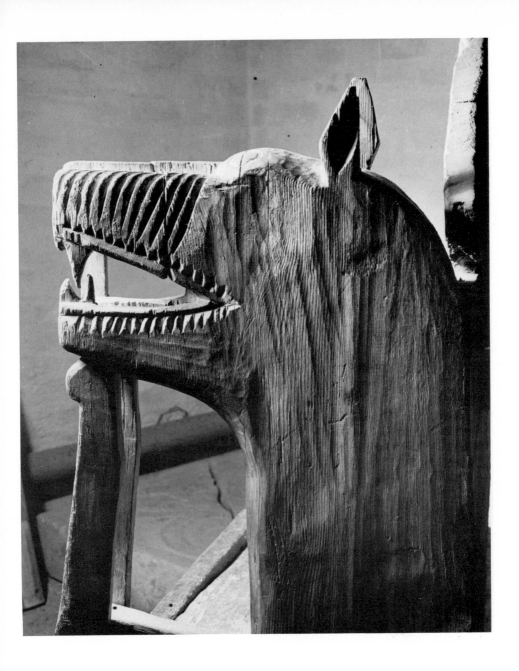

Illumination was by photoflood without a reflector in order to produce a relatively contrasty light (see p. 102). As always when raking texture light (p. 242) is involved, positioning the lamps was critical since a few inches more to one side or the other would already have produced shadows that were either too extensive or inadequate.

Sidelight for "roundness" and depth

Left: The Leaning Tower of Pisa. Right: A Roman amphitheater near
Florence. In both cases, I waited for a sunny day because I wanted

266

sharp shadows, then took the pictures at a time when sidelight (p. 95) modeled these ancient structures in bold relief. Any other kind of illumination would, in my opinion, have been less appropriate.

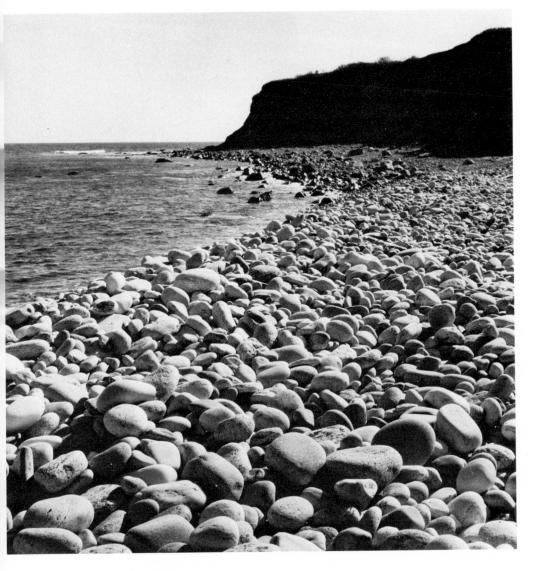

The incomparable backlight

Backlight (p. 95), because of its matchless ability to create illusions of depth, is my favorite form of light. At the left: Sunrise over Tucson, Arizona. The sun, behind the towering Saguaro, makes the trees in the valley cast shadows that radiate like the spokes of a wheel and outlines the thorny cacti with golden seams of light, thereby producing by means of perspective and graphic contrast a powerful depth effect. Above: A beach near Montauk Point, Long Island, N.Y. Backlight enabled me to show each pebble separately, define the texture of the beach, and indirectly, through diminution and perspective, create an almost tangible sensation of depth.

269

Backlight for graphically powerful effects

Backlight is the graphically most powerful form of light. Left: A geyser in Yellowstone National Park. Right: An office building in Chicago. Two photographs which prove that, when creatively used, pure, unrelieved black and white (as most easily produced by backlight) are not "faults," but expressive means of photographic design.

270

271

Backlight for sparkle and luminosity

Left: Medieval stone pavement in Florence. Right: A fallen column in the
Forum of Rome. In both instances, it is backlight that through highlights

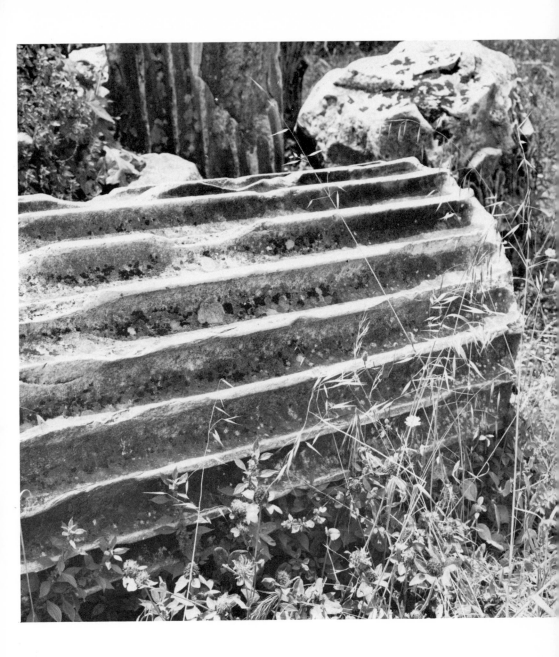

and shadows models the surface of the stone, giving it luster, texture, and depth. No other form of light can accomplish similarly expressive effects.

274

The subtle light of haze and fog

Unusual forms of light (p. 19) almost always make interesting photographs simply because of their "strangeness"—the strange is always more eye-catching than the common. In these cases, however, it was the mood of the depicted scenes rather than their unusualness which compelled me to make these shots—the smog hanging low over a Pittsburgh steel mill, and the white fog out of which a Hudson River ferry appeared suddenly as it approached its Hoboken slip. The latter photograph also illustrates the high-key effect that I discussed on p. 248. To me, it proves that large areas of almost unrelieved white can be very effective, and that not every picture needs to contain a certain amount of black in order to be considered "good."

275

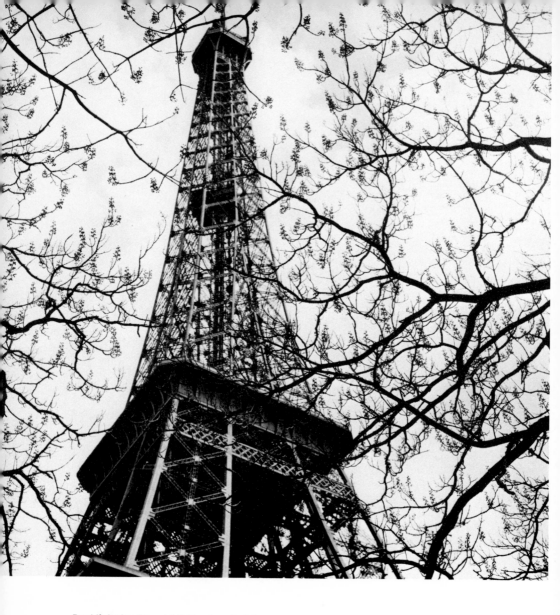

Backlight for "graphic" black and white

A shot of the Eiffel Tower in Paris and some of Alexander Calder's tools. In both instances, it is backlight that creates the special effect of these pictures: the pure, lacelike black-and-white design above, and the strong, "metallic" impression of the tin snips on the opposite page. By their special light, these photographs prove (1) that, depending on the nature of the subject, a white sky can be preferable to a blue sky with "picturesque" clouds; and (2) that white looks never "whiter" than when contrasted with black, lessons which, I should think, any ambitious student of photography would be anxious to test in practice.

276

Backlight for order and beauty

Above: Industrial pattern shot. Right: A chemical reaction. In both cases, it is back-light that "makes" the picture—separates the individual forms from one another in the pattern shot and provides the indispensable clean background for the lab-oratory scene. Let me repeat for emphasis: In photography, simplicity is never wrong, and often, the simpler the picture, the stronger the effect. And because of its pow-erful graphic character uniquely suited to the production of pure black and white, it is backlight that more than any other form of illumination provides a knowledgeable photographer with the means of strengthening his renditions through simplification.

278

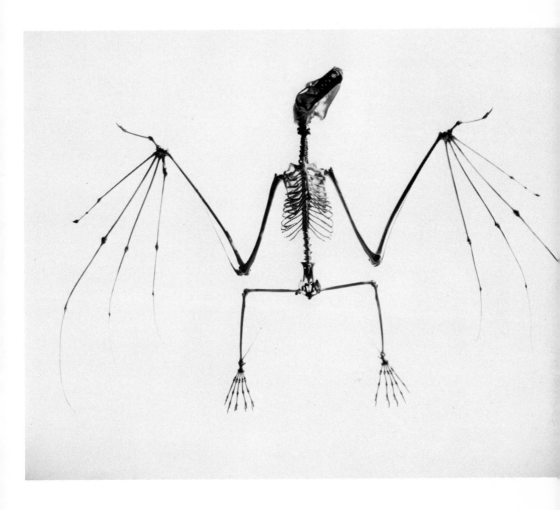

Shadowless illumination for clarity

A pure white background free from cast shadows is often indispensable in cases in which a complex, delicate, or highly detailed subject must be shown with utmost clarity. This can be accomplished in two ways: (1) by means of indirect light; and (2) with the aid of a light-box. The photograph on the opposite page was taken inside a light-tent (p. 134) in completely shadowless light, while the one of the bat skeleton was made on a light-box (pp. 136, 225). In each case, the result was the ultimate in clarity and precision of rendition.

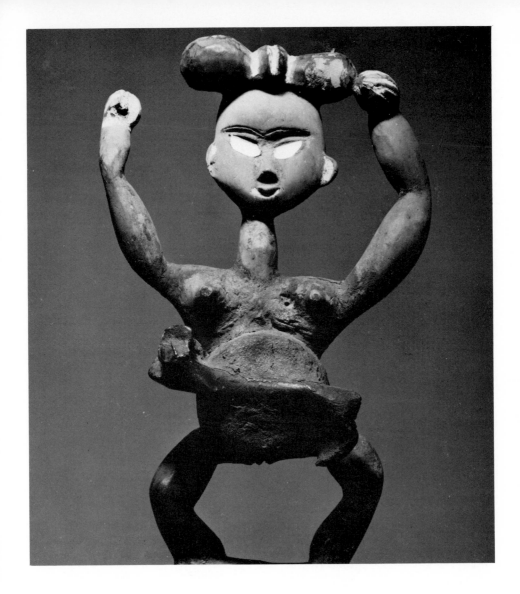

Glare for impact, darkness for power

Left: The sculptor David Smith at work. Above: African fetish. In both cases, I directed the light in such a way that it emphasized the eyes—the flame of the welding torch reflected in the Cyclopean eye of the goggles, and the photolamp in the bits of glass that marked the eyes of the fetish. And since white is never more effective than when contrasted with black, I surrounded these glaring "eyes" with darkness.

Explore the potential of artificial light at night

Left: Sankaty Head lighthouse on Nantucket. Above: Ferris wheel. Although there are as many hours of night in a year as there are of day, not one outdoor photograph in a thousand is made after sunset. But the photographic potential of night is just as great as that of day, and photographers making use of this can bring home pictures that are as beautiful as they are unusual. A whole new world awaits their exploration.

Capture the beauty of available light

Left: Art criticism in a barn on Cape Cod. Right: Dinner and dance at the Waldorf
by candlelight. Both pictures are time exposures made entirely by available light

286

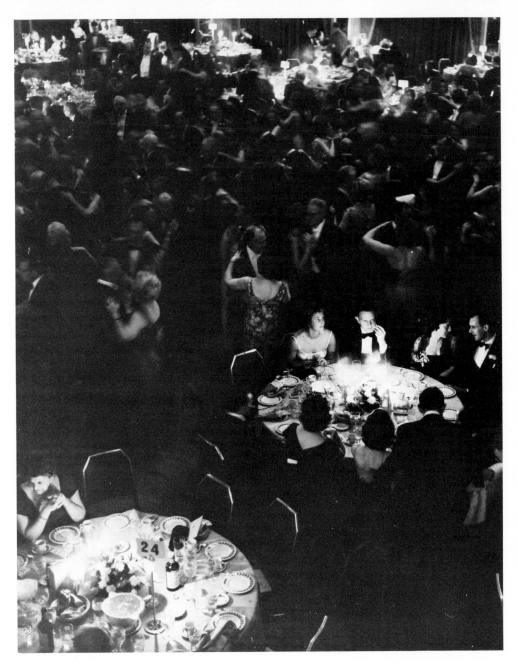

without additional shadow fill-in illumination which, in my opinion, would only have infringed upon the mood of the scene. Unavoidable deficiencies in the gradation of the negatives were easily corrected in printing. Using flash in situations like these would be as insensitive and obnoxious as firing a gun in church.

287

Preserve the mood and "atmosphere" of the scene

Above: Inspection of plate glass at Corning. Right: Drop forge. Strange and beautiful forms of light can be found almost anywhere. It is up to the photographer to recognize such pictorial possibilities and preserve the characteristic mood of such scenes by keeping additional illumination to a minimum or, better still, dispensing with it entirely. Here, nothing would have been simpler than "filling-in" the shadows with auxiliary light, but it would have destroyed the subject's mood.

Keep an open eye for all phenomena connected with light

Reflections in a shop windowpane in London. I found these mannequins irresistible—these wistful ladies imprisoned behind glass mirroring the outside world of buses, trees, and sky. It is light-induced phenomena like these which can make a photographic walk in the city exciting—the search for the unexpected, the hope for a surprise.

291

INDEX